Contents

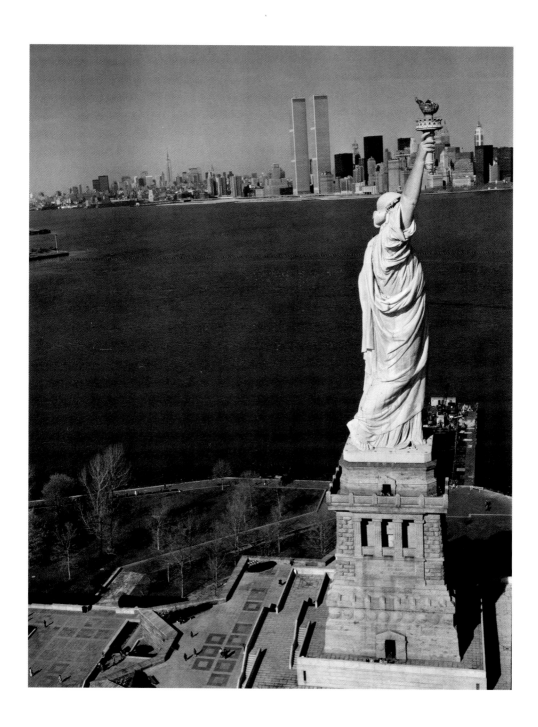

Introduction

Folk Effects

Photography and the USA is written out of a conviction that – in ways both large and small – there has been a symbiotic connection between the medium of photography and the nation that has emerged as the world's remaining superpower. In ways to be substantiated as we proceed, it is definitely the case that Americans have always been prominent in photography and, at least since the Second World War, have dominated the world image economy: the production, selection and transmission of photographic images of all kinds. And this has happened on such a scale that to some – including Roland Barthes in his essay on the American origins of 'The Family of Man' exhibition that was mounted in numerous venues around the globe during the 1950s – it has seemed that photography has served as an actual projection of the economic, political and ideological power of the USA.[1] Whether or not such a causal and one-to-one connection between the nation and the medium is justified, the link itself exists. That is, we are not speaking simply of photography *in* the USA – the emergence and development of the medium as an industry, art and hobby – or of photography *of* the USA – the efforts, some of them actually government-sponsored, as in the case of the frontispiece image, to capture, record or commemorate the peoples, landscapes and ways of life of the nation – though, of course, both feature here. In the approach adopted, in the selection of topics for discussion and in the analyses of specific images, the focus, indeed the stress, is on photography *and* the USA.

1 Aerial view, looking northwest, of the Statue of Liberty, taken by Jack E. Boucher in 1978, with the then relatively new twin towers of the World Trade Center on the horizon. This image is one of many in a sequence devoted to Liberty as part of the documentation of significant engineering projects conducted by the Historic American Engineering Record (HAER) of the U.S. National Park Service.

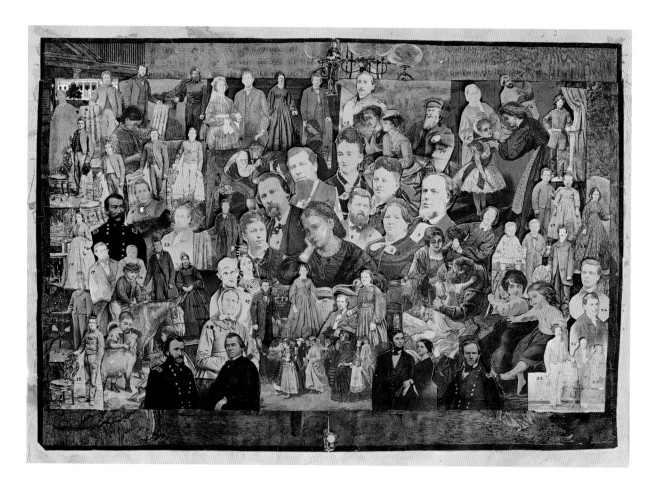

2 Untitled photo-collage by an unknown maker, c. 1870, albumen print.

In the late nineteenth and early twentieth centuries, before the U.S. acquired the actual political, economic and military might of today, it already exerted marked ideological power. This was a period when both photography as practice and a plethora of photographic images were becoming ever more readily available to ordinary people. It was an ambience in which numerous photo-collages were produced. One celebrated example comprises a group of 30 blueprint photographs, mostly of landscape scenes, printed on cloth and sewn together to make a pillow. It is reminiscent of a patchwork quilt, a form of needlework that, in the U.S. at the time, was produced by individual women and, out of sociability, by

communal groups. Some of these photographic collages were profession-
ally made and embraced only the famous, most obviously portraits of u.s.
presidents, or members of the cabinet, or the signatories to the 1862
Emancipation Declaration, which had 'freed' slaves held in rebel territory.
Others, mostly put together by amateurs, depicted such groupings as
the individual members of a graduating class or, more commonly, an
assemblage of the creator's assorted relatives. The latter could be seen
as a family album done not as a book but in one plane.

 A particularly intriguing version of a family collage was made in about
1870 by a woman, now unidentifiable, who placed her own depiction – in
the guise of a grieving widow – at the centre. Seeming to radiate from that
centre, and ink-marked with the letters A to H, are photographs of people
who were probably the unknown maker's immediate forebears. Many of
the surrounding portraits have been numbered, 1–40, and it is tempting
to think of them as the maker's extended family and friends. Presumably
there were once written keys to the identities of all these figures. Scattered
among them are photographic portraits of eminent personalities, such
as Ulysses S. Grant (in army uniform prior to his presidency) next to
President Andrew Johnson (bottom left) and Abraham and Mary Lincoln
next to one of Lincoln's Civil War commanders, General William
Tecumseh Sherman (bottom right). Some of these portraits are well
known and are by acknowledged practitioners (Sherman's, for instance,
is usually credited to the most renowned u.s. photographer of his gener-
ation, Mathew Brady). Also interwoven among the family portraits are
drawings cut from popular prints or magazines, all of them domestic or
bucolic scenes – a mother dressing her daughter, a boy with his pony, etc.
– and I read them as quasi-allegories that animate the total picture with
received wisdom about the stages of life.

 A collage by nature constructs relationships between its parts, and
the portraits, while in an orderly pattern, jostle one another, some of
them breaking the inner edge of the picture frame to simulate a *bas-relief*
effect. The famous figures are set alongside ordinary people. The ordinary
people appear ennobled by their parity with the celebrated. The collective
identity projected here – emphasized by the fact that what we see consti-
tutes, in turn, a photograph of all these images in just two dimensions,

20 inches (50 cm) wide – is both familial and national, a vernacular demonstration of democratic ideals.

Although now lost to us because we know nothing of its maker, this collage was originally also a species of autobiography. Of late, autobiography through photography – what one critic terms 'phautobiography' – has become a matter of critical concern. In a sense, an autobiographical dimension has always been there: we may recall those autobiographies by photographers that have centralized photographic metaphors, such as Edward Steichen's *A Life in Photography* (1963), where the title indicates that the life itself might be registered *through* images. More recently, Nan Goldin has courted notoriety by frankly testifying in her photographs to the destructiveness of AIDS and drugs in her intimate life. It should be remembered that, as in the case of this collage, there might be an auto-biographical element to the images featured in this book that must largely remain unspoken.[2] All told, this collage is *both* highly individualistic, even idiosyncratic, *and* expresses aspects of the larger culture that surrounded it. Throughout *Photography and the USA* our focus will be similarly doubled.

Photography, the most pervasive system of communication after language, includes much that is 'art', and perhaps this collage so qualifies. But it also takes in commercial production – advertising images, fashion work, sports pictures and the like – as well as scientific photography, press pictures and, the largest component of all, the personal, the countless camera images made by you, me and every other Tom, Dick and Harriet. Also, more than has generally been the case with other forms of expression, in photography there is much traffic between the various public and private realms of the medium: advertising photography borrows iconography from official records and venerated artwork; art photographers seek the freshness of seemingly untutored snap shooters or, at another time, the glossiness of commercial productions; and parents, almost all amateurs, taking likenesses of the kids, arrange them as they have seen children posed in the windows of professional portrait studios or in the pages of illustrated celebrity magazines. Photography is voracious, promiscuous and changeable. Recent (re)conceptualizations of it essentially reinforce what many have long intuited: the medium, like a language, has a special spirit, or 'genius', of its own.[3]

Moreover, images that start out as art may fall from fashion almost as easily as old postcards, and family albums can become collectible. The medium's products are unstable, moving between different categories over time, with their changing status – sometimes their very 'meaning' – contingent upon the viewer. A startling instance, subject to ongoing debate, is provided by the horrific 'amateur' pictures of prisoner abuse made by u.s. Army personnel at Abu Ghraib in Iraq and endlessly circulated on the internet. They have provoked a storm of conflicting responses, some averring that they represent the enactment of 'official' u.s. government policies, some that they depict rogue acts completely unrepresentative of the u.s. or its army (the then Secretary of State for Defense, Donald Rumsfeld, categorized what they showed as 'Un-American'), some that they present acts that should be construed not as torture but as a rougher form of the hazing that has traditionally characterized American men's club initiation ceremonies. It definitely was *the images* that sparked the fiery debate, in that during the same time-span other atrocities less documented by photographs passed almost without comment, but the debate itself led to relatively little analysis, beyond bemusement that they had been made, of the images themselves. One critic has observed that, despite their seemingly non-professional and folk origins, some of the pictures reference the iconography of high artworks, and this factor may have contributed to their purely visual effect.[4]

Another striking American example of the instability of photographic meaning is the collection of sexually explicit images of New Orleans prostitutes made by E. J. Bellocq in 1912, or thereabouts (illus. 3). The photographer Lee Friedlander, who rescued and reprinted these pictures in 1970, helped to subvert any categorization of them as either art or pornography. This particular unnamed woman, whose undress may signal her availability, has nevertheless composed herself for the camera, seems at ease in a manner that defies sheer objectification, and the print has a technically superior finish not usually associated with under-the-counter material. Virtually nothing is known about Bellocq as a person and, perhaps because several of his pictures are doubly mysterious – in that their subject's faces were scratched or painted out with no ready

explanation – his surreal legacy has intrigued appreciative viewers and triggered the imaginations of novelists and filmmakers.[5]

One of the claims pressed by *Photography and the USA* – often implicitly rather than in explicit statement – is that American photography as a whole has been notably open to the ordinary person in two ways: it has characteristically been concerned to portray common life, folk *experience*, and it has recorded, for its own sake, much folk *expression*, not only vernacular buildings, sculpture, roadside hoardings and the like, but folk expression through photography itself. (This book's brevity precludes comparisons and contrasts with other national traditions.) This claim applies as much to art photography – itself but a small proportion of the total output – as it does to other aspects of the medium. To give but a single example now, Walker Evans, perhaps *the* most individually influential photographer of the American twentieth century, devoted much of his first show, 'American Photographs' (1938) at the Museum of Modern Art in New York, to studies of such subject-matter, and Alan Trachtenberg claimed he ties '"photographs" to "American" by evoking the nameless craftsmen of the past, and by making their craft his own'. It is not accidental that throughout Evans's life he collected, collated and categorized an enormous array of very ordinary photographic postcards.[6] Essentially, although our lens cannot frame as many areas of the medium as would ideally be desirable, the aim is to be as wide-angled as possible, and only in the book's final chapter does the focus shift wholly to art photography as such. To show what I mean, let us look at three images of children, two from the nineteenth century and one taken in 1985.

Twin Infants in Coffins (1886) by Charles Van Schaick is a post-mortem portrait (illus. 4). Such imagery, made during a period of high infant mortality, was not unusual, and Van Schaick, a prolific commercial photographer in Black River Falls, Wisconsin, must have captured the market for such pictures in his town – along with hundreds of portraits of the living, landscapes, townscapes, depictions of business premises, local fairs and much else. Michael Lesy, concentrating disproportionately on Van Schaick's post-mortem portraits, such as this one of the deceased Robert and Janet Fitzpatrick, configured Van Schaick's archive as documenting the deeply constrictive nature of American small-town life. In

3 *Storyville Portrait, New Orleans*, c. 1912, gelatin-silver printing-out paper print from a negative by E. J. Bellocq.

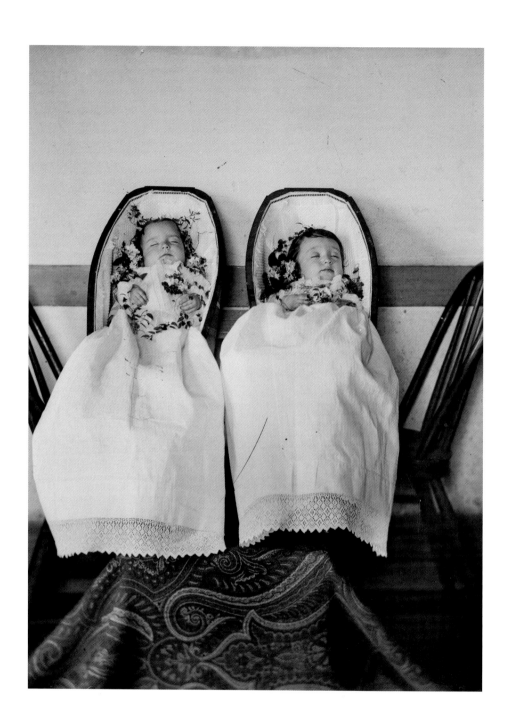

4 Charles Van Schaick, *Twin Infants in Coffins*, 1886, modern print from glass negative.

his cultish *Wisconsin Death Trip* (1973) he presented the pictures in the context of newspaper stories, extracts from near-contemporary fiction and other documents that spoke of grimness, crazed desperation, obsession with death and frustrated lives. Susan Sontag, in her influential *On Photography* (1977), rightly bemoaned the fact that – at the time her book was being composed – the rehabilitation of 'old photographs, by finding new contexts for them, [had] become a major book industry', and she characterized Lesy's book as 'rousing, fashionably pessimistic polemic, totally whimsical as history'.[7] Sontag's arguments seemed persuasive in the 1970s, and with regard to *Wisconsin Death Trip* – in which Lesy sometimes cropped or solarized Van Schaick's images to achieve very ahistorical effects – they still convince. He was not actually addressing the history of small-town Wisconsin in the decades either side of 1900; he was alarmed by his own era, with its traumatic Vietnam War, the public corruption of the Nixon presidency and the rise of a supposedly 'silent majority' obsessively bent on suppressing what they claimed were the 'liberal' excesses of the 1960s.

Clearly, in reiterating a claim for the revelatory power of photography – as *Photography and the USA* does – it is vital to see images in their original contexts, mainly by paying attention to their construction and first use, even though they may also sometimes seem to encapsulate enduring preoccupations. Our second child picture, by an unidentified photographer, *George B. Billings Rego, Boston, Massachusetts*, depicts a tableau that, like the post-mortem portrait, was made *for* the photograph; the resulting image constitutes its own *raison d'être*. It was probably not commissioned by the child's mother and father, in that (especially compared to the post-mortem portrait) it does a poor job of capturing their infant's particular features. Given we know that this baby was named by his Portuguese parents after the director of the new Boston immigration centre in which, during 1900, he was the first child to be born, it seems most likely that immigration officials commissioned it. If, as critic Walter Benjamin famously claimed, 'the image is dialectics at a standstill', whoever had it made produced a synthesis: both the baby and the flag represent a promise.

Here we turn to our third child image. Photographers who might otherwise be most readily designated as artists have often led the way in

5 Unidentified photographer, *George B. Billings Rego, Boston, Massachusetts*, c. 1900, cyanotype print.

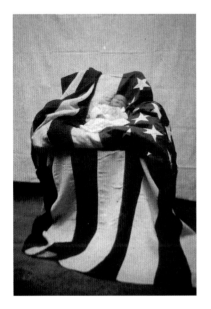

15

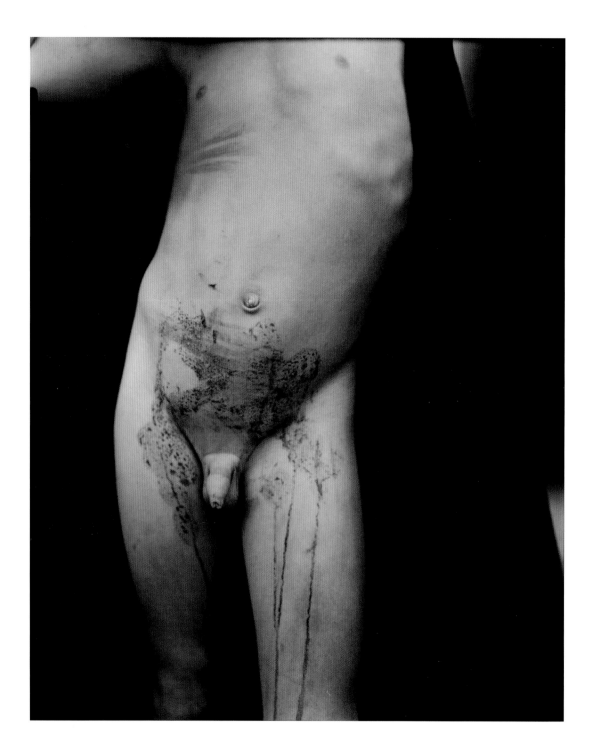

openness to the multifarious nature of the medium. One of them is Sally Mann. Among her most compelling work is *Immediate Family* (1992): extremely intimate depictions, through the years, of her own three children – play-acting, sometimes unclothed or soiled, vulnerable yet also bumptious – against the backdrop of the rural summer spaces of her inherited Virginia family home. In *Popsicle Drops* (1985), her naked son Emmett is depicted from the chest down, his lower torso and thighs stained by dribbled melt from the ice lollipop he must recently have consumed. The fact that the frame excludes his head and takes in only undifferentiated darkness behind him denies the viewer a sense of scale. Emmett's body, especially as posed, thus acquires the look of sculpture: while actually young flesh marked by a summertime pleasure, it is also classical, bearing the signs of age.

Such framing and visual referencing – and in other images the use of markedly natural symbolism (a mud ditch as 'womb' and the like) – declare these photographs works of art. Yet they also inherit vernacular traditions of the family album: pictures taken to underline the children's varying heights and development, to coincide with gatherings of extended kinfolk or rites of passage. Also, in certain cases – such as *Hayhook* (1989), in which a girl-child hangs naked from a hook – they can be uncomfortable to view. Some critics, in fact, have seen such Mann images as approaching pornography: *too* intimate, intrusive and exploitative. I do not find them so, but they testify to photography's power to provoke in the public sphere.[8]

Photography and the USA, as already intimated, follows in the wake of Geoffrey Batchen and other photographic historians who have devoted themselves to embracing as fit for study the more private, the more commercial and the more vernacular aspects of the medium. In line with this approach, I was very struck, from its title on in, by *The Photograph and the American Dream, 1840–1940*, the exhibition catalogue by Andreas Bluehm and Stephen White published in 2001 to coincide with a show of the same name based on White's own photographic collection that was mounted at the Van Gogh Museum in Amsterdam.[9]

The Photograph and the American Dream features much vernacular camera work, including the collage discussed earlier. Among the portraits,

6 Sally Mann, *Popsicle Drips*, 1985, gelatin silver print. Taken with a 10 x 10-inch view camera, this study of Mann's son was incorporated into *Immediate Family*, which in its totality, while about childhood, also represents the American South as a rural idyll.

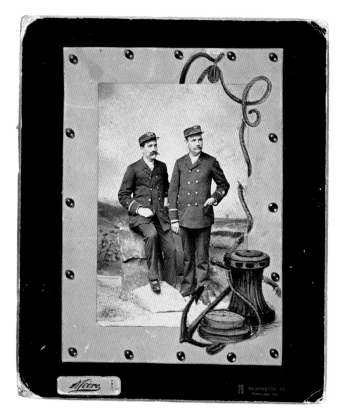

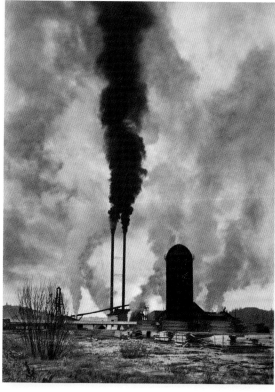

it includes canonical pieces by such figures as Walker Evans (some of whose output will be discussed in chapters Three and Four), but it also offers likenesses of forgotten and lowly people taken by little-known studios and individuals. Certain of these, such as *The Captain and the Mate of the 'Kassald', Columbia River* (c. 1886), with its delightful hand-drawn capstan and string woven through it like a ship's cable, presumably to stress the 'nautical' in a very material manner, are truly folk artefacts. The two men depicted – people who possess quite strong features – are for us, who no longer recognize them, only their social types. Of land-scapes, we get an aerial view of lower Manhattan's skyscrapers seen within swirling clouds that is attributed to the most celebrated woman photographer of the 1930s and '40s, Margaret Bourke-White, but included too are images by such lesser-known camera workers as Adolf Fassbender:

7 Elbridge Moore, *Captain and Mate of the 'Kassald', Columbia River, Oregon,* c. 1886, albumen print, with added string and rivets.

8 Adolf Fassbender, *Industry of the West,* c. 1935, silver print.

his 1935 depiction of an industrial chimney out West spewing very thick black smoke into the highest sky speaks dramatically of both manufacturing might and, to the eyes of today, environmental degradation.

This demotic approach to what – as I shall claim more fully later – is the most democratic of media, amply illustrates the *cultural* work photography has performed. In the case of immigration, for example, *The Photograph and the American Dream* vouchsafes us greater insight into both workaday and celebratory aspects of immigrants' experience: the crowded deck of a newly arrived immigrant ship as deliberately depicted in 1906 by Edwin Levick, at one of the crests in the waves of mass immigration; a group of 'new citizens' pledging allegiance to the

9 Edwin Levick, *Immigrants on an Atlantic Liner (SS Patricia)*, 1906, albumen print.

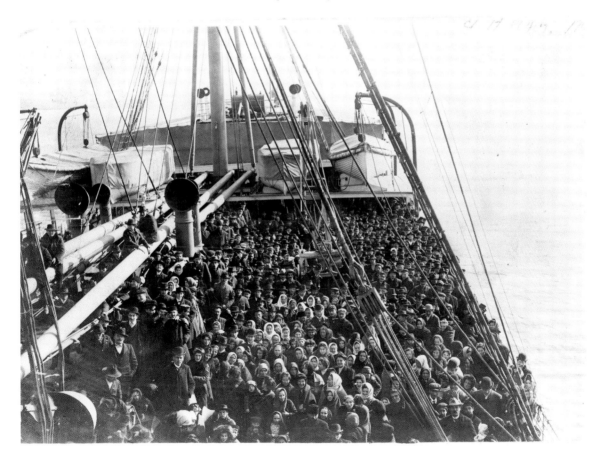

19

flag in Deadwood, South Dakota in the 1890s (illus. 91); or, as we have seen, the first baby to be born in a new processing centre. Photographs here are certainly not neutral records, but cultural signifiers with effects. As the catch-all title of *The Photograph and the American Dream* readily indicates, if somewhat simplistically, the images in it reflect and construct identification with the USA and with what the editors believe are the nation's prevailing values.

The United States of Aspiration

All nations have their myths. It could be argued that they are particularly important in a predominantly settler state with disparate and ethnically diverse populations that must be integrated into a 'new' nation with its own institutions, beliefs, cultural mores and such symbols as Liberty (frontispiece). Indeed, that it was 'new' made the first American myth: Native Americans or Indians had inhabited the continent, including what became the USA, for millennia; 'Indians did not come to America', as the saying goes, 'America came to them'. Ho-Chunk photographer Tom Jones II, like other Native American artists, has taken up this notion, in his case by subverting the patriotic song 'My Country, 'tis of thee', presenting it as both tragically and comically ironic for Indians. Later we will look very briefly at earlier representations of Native Americans in photography against which Jones was implicitly rebelling, and we will at once be aware that Indians were seen as the dominant culture *wished* to see them and that this barely changed until Native people themselves got behind the camera.

What of photographs of those who did come to America, like the crowds on Edwin Levick's incoming ship? It could be said that we see a pattern similarly set: if in a much less one-to-one fashion than was the case for Indians, the medium was primarily harnessed to the interests of dominant groups – though perhaps I should really be saying the interests of mainstream society. Indeed, after 1890, when – as Frederick Jackson Turner's celebrated capitalization on the U.S. Census figures has it, the 'frontier closed' – there is a sense in which immigrants formed the new

line of difference.[10] And, as in the case of the Western Frontier, which as everyone knows was a 'moving' frontier, this line of difference was not a fixed entity – either in life or in photographic representation.

In both lived experience and photography, 'becoming American' was frequently a fraught process. Even after the predominant constituencies of immigrants changed during the 1880s – away from northern European and largely Protestant nations to the Catholic and Jewish populations of southern and eastern Europe – that is, to peoples apparently more 'alien' to the Anglo-Saxon Protestant hegemony – there was also an acknowledgement of the *need* for a supply of labour to serve the interests of the already settled, however contested that need was. (And, of course, it *was* contested.) Also, whereas Indians were only reluctantly expected to become 'citizens', at least until recent times, immigrants almost always were.

This is the broad context for the many notable attempts to 'discover' what makes the USA tick, almost all of them assuming that there *is* an

10 Tom Jones II, *My Country 'tis of thee (These Colors Will Not Run)*, 2004, C-type print. This is the first in a sequence of ten images.

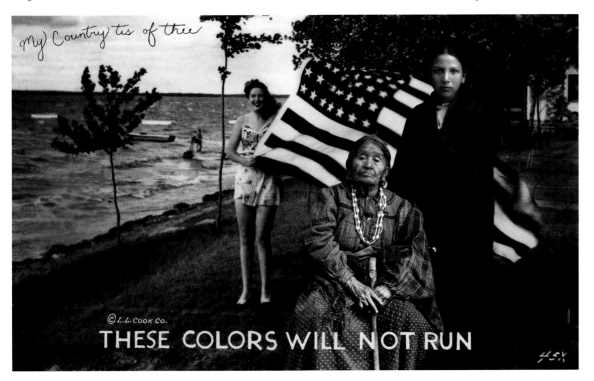

My Country 'tis of thee

© L.L. COOK CO.

THESE COLORS WILL NOT RUN

American difference, many of them assuming the persistence of a unique American culture based on exceptional economic and political conditions, even a unique American 'character'. J. Hector St John de Crèvecœur famously asked, in 1782: 'What, then, is the American, this new man?' Such efforts reached their summit in the 1950s, when in the dawning era of evident superpower status for the USA, the intellectual urge to understand the nation underlay the emergence of American Studies as a scholarly field then characteristically oriented to the tracing and advocacy of a variety of theses purporting to 'explain' U.S. history, artistic expression and social mores. Some revived Turner's 'frontier thesis', with its claim that exposure to the more 'primitive' conditions of the frontier, repeated over generations, had been the primary determinant in the making of a people no longer oriented to European standards. Some argued, on the basis of the country's abundance of raw materials, in-dustrial prowess and marketing success, that Americans were almost inevitably a 'people of plenty' whose past experience guaranteed 'progress' as the norm, thus endowing them with confidence in future success, both individually and nationally. Others insisted that the belief in equality and the pursuit of liberty and happiness, as enshrined in the Declaration of Independence (1776), were still controlling values. Still others claimed, as did sociologist David Riesman, that modernity, especially the conditions of business life, had made U.S. citizens less sure of themselves and more conformist in their behaviour; generally more 'other-directed' in their search for satisfaction in life.[11]

In his important book *The Promise of American Life* (1909), the political thinker Herbert Croly, who was later to found an influential weekly, *The New Republic*, locates the special gift of America *not* in frontier rejuvenation, progress, natural resources, industrial prowess, material abundance, technological endeavour, the rugged individualistic pursuit of happiness or general wellbeing, or indeed in anything actually experienced. Rather, he puts the emphasis on the *promise* itself. He quotes from the Harvard psychologist Hugo Münsterberg: 'Not the actual past binds the American to his countrymen, but rather the future which together they are building.' According to Croly,

11 Composite illustration made by Roy E. Stryker for Tugwell, Munro and Stryker's *American Economic Life* (New York, 1924), using photographs by Lewis W. Hine.

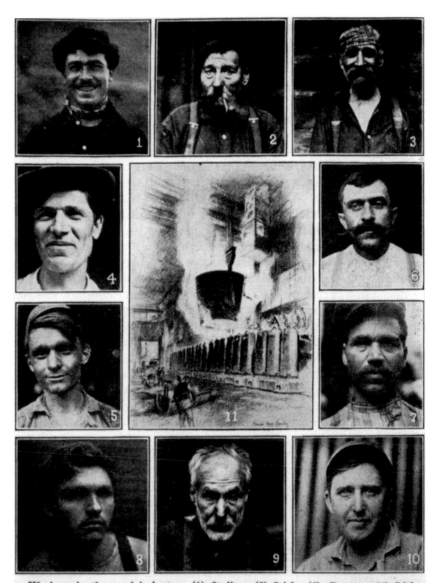

Workers in the steel industry: (1) Italian; (2) Irish; (3) German; (4) Lithuanian; (5) Polish; (6) Serbian; (7) Russian; (8) Slovak; (9) English; (10) American. (11) Interior of a steel mill. The difficulty of organizing large groups of men for collective bargaining is apparent when the different nationalities involved are considered. (Photos by Hine. Drawing by Vernon Howe Bailey. Courtesy Interstate Steel Company.)

[Americans believe] that somehow and sometime something better will happen to good Americans than has happened to men in any other country; and this belief, vague, innocent and uninformed though it may be, is the expression of an essential constituent in our national ideal.

In Croly's formulation of American exceptionalism, the American past has, 'a character all its own . . . from the beginning it has been informed by an idea. From the beginning Americans have been anticipating and projecting a better future.'[12]

Croly's book never mentions Indians and, of course, his formulation would almost necessarily exclude them. And, despite the fact that it was written during a peak immigration period, it doesn't *explicitly* tackle immigrant experience. However, there is a sense in which Croly's 'the promise of American life' – which approximates to what many have called the 'American Dream' – was aimed *at* immigrants. The 'American Dream' may be inchoate, as Croly intimates, encompassing ready access to wealth, utter individual liberty and, somehow, the good society or the exemplary 'city upon a hill', but it has exerted a hold over peoples' imaginations similar to that wielded in the Old World by such ideologies as socialism; indeed we might speak of it, if with caution, as 'Americanism'.

Maren Stange has shown how Roy E. Stryker – who was to go on to direct the FSA photographic unit to be discussed later – was advancing a strand of it when, for the book *American Economic Life and the Means of its Improvement* (1924), he deployed cropped images of steel workers made by Lewis W. Hine (illus. 11).[13] Stryker used the images to assert *both* the essential differences between members of the various newly arrived ethnic groups employed in the steel industry *and* the need for those differences to be dissolved. Note the huge hand-drawn cauldron in the centre of the display: it is as if the men, rather than the steel, will go into the cauldron. The display refers to another myth, the USA as a veritable 'melting pot', and in it these diverse men will be forged into new, composite and strong Americans.

Both words in the expression 'American Dream' have aspirational connotations. A striking indication of this peculiar amalgam of matter

and mind, experience and the wished-for ideal, appears in the caution to his fellow Americans administered in 1998 by the philosopher Richard Rorty. Obviously aware of the great stain of slavery, persistent racial discrimination and other abiding inequalities, he wrote:

> You have to describe the country in terms of what you passionately hope it will become, as well as in terms of what you know it to be now. You have to be loyal to a dream country rather than to the one to which you wake up every morning.

'Unless such loyalty exists', he continues, 'the ideal has no chance of becoming actual'. American history has inevitably been marked by numerous utopian ventures, including, especially in the early years of the Republic, the Shakers, who (despite the atypicality of their foundation by a woman, and despite the radicalism of some of their practices, principally their celibacy) have since come to seem, especially to artists and photographers excited by the expression of Shaker values in design, synecdochic of the nation's better nature. The Shakers were strictly egalitarian, pacifist, lived comfortably but as simply as possible, took in orphans to replenish their numbers and their small communities thrived spiritually, even economically, for nearly 200 years. In some of Linda Butler's Shaker views (illus. 12), made with an 8 × 10 inch (20 × 25 cm) view camera in the early 1980s at the end of their viable existence as communities, light itself seems to take on the clarity of a benediction.[14]

Walt Whitman, who from the 1850s onwards repeatedly claimed attention as a quasi-national bard determined to sing his country's songs in his long-lined verses, famously spoke (in the preface to *Leaves of Grass*) of 'the United States themselves' as 'essentially the greatest poem', as if by its very nature the nation pre-existed as aesthetic entity, creed, set of metaphors, even way of being, as if it was already a form of expression that he merely needed to transcribe. In a sense, to Whitman the nation per se was at one and the same time a utopian venture and the most human of institutions, to be apprehended in its entirety and diversity. In this Whitmanian stance, as certain scholars have perceived, there is an affinity with the omnivorous and, yes, essentially democratic nature

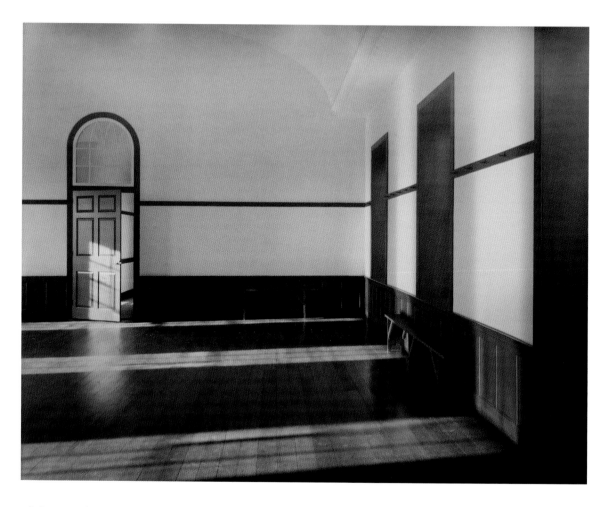

12 Linda Butler, *Bent Light, Pleasant Hill, Kentucky*, c. 1982, silver print.

of photography as a medium. There are other affinities, too. If, as we noted, photographic discourse has increasingly emphasized the medium's personal, commercial and vernacular dimensions, these were always preoccupations in Whitman's output. He lauded, with due conflictedness, U.S. business achievements, stressed the vernacular and, as in the following lines, assumed a link to the personal:

> I speak the pass-word primeval – I give the sign of democracy;
> By God! I will accept nothing which all cannot have their
> counterpart of on the same terms.
> Through me many long dumb voices;

Voices of the interminable generations of slaves;
Voices of prostitutes, and of deformed persons;
Voices of the diseas'd and despairing, and of thieves and dwarfs;
. . .
Of the trivial, flat, foolish, despised,
Fog in the air, beetles rolling balls of dung.[15]

It is striking that in Sontag's meditation *On Photography*, whenever she treats specifically American photographic endeavours, Whitman serves as touchstone. Not surprisingly, given Whitman's utter openness to all, she was particularly perturbed by the limited range of subject-matter in the work of Diane Arbus as exhibited in the early 1970s – both Arbus's concentration on inherently 'exotic' figures, such as transvestites, giants and the heavily tattooed, and the way she created grotesques out of everyday people, whether a crying baby, a woman with a veiled hat or an overweight matron, often by deliberately looking too close and squeezing them into the frame. Sontag writes:

> All her subjects are equivalent . . . and making equivalences between freaks, mad people, suburban couples and nudists is a very powerful judgment. . . . The subjects of Arbus's photographs are all members of the same family, inhabitants of a single village. Only, as it happens, the idiot village is America. Instead of showing identity between things which are different (Whitman's democratic vista), everybody is shown to look the same.

Clearly, Sontag viewed the progress of photography in America as the inevitable descendant of the earlier marriage of consumerism and technology to the Whitmanian imperative to see the beauty of the world in any 'iota' of it, however trivial. There had been, she thought, a decline from Whitman's ideal. Photographers could capture any aspect of life as a supposed exemplum of the whole but, as she puts it, 'without Whitman's delirious powers of synthesis, what they documented was discontinuity, detritus, loneliness, greed, sterility'. The collection of assorted images, each with no significant meaning or relation to the others, was an act

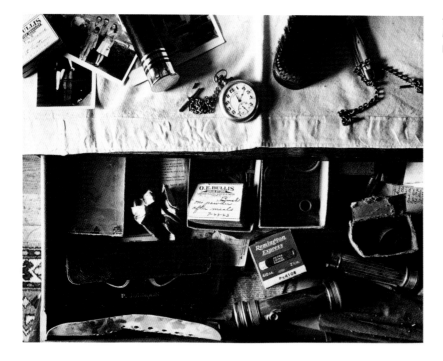

13 Wright Morris, *Dresser Drawer, Ed's Place, Near Norfolk, Nebraska, 1947*, silver print.

of surrealism. 'The best of American photography has given itself over to the consolations of Surrealism', she claims, 'and America has been discovered as the quintessential Surrealist country. It is obviously too easy to say that America is just a freak show, a wasteland.' 'What we have left of Whitman's discredited dream of cultural revolution', she concludes, 'are paper ghosts and a sharp-eyed witty program of despair'.[16]

Of course, as a critique specifically of Arbus, Sontag's judgement, while compelling, is too narrow. We might take Arbus's images as constituting social comment on u.s. society, as Sontag essentially argues, and they do exert such power. The figure in *Boy with a toy grenade, Central Park, New York* (1962), his face apparently tightened in rage and readiness, does seem to depict more than just a child and his plaything. Certainly, the degree of blank jingoism registered in the figure and badges of the young man in *Boy with straw hat waiting to march in pro-war parade, New York* (1967) has to be interpreted within the context of the divisiveness of American politics and society at the time. (It could also be read as a

14 Carrie Mae Weems, Untitled work ['Ebo Landing'], from the *Sea Islands Series*, 1992, gelatin silver prints with text panel. In its exhibition form this work is 5 feet tall and 20 inches wide (152 × 51 cm).

foretaste of the ever-greater partisanship of the subsequent so-called 'culture wars' that still rend the nation.) But, at its most penetrating, Arbus's work actually invites empathy of the sort displayed by Whitman towards the 'prostitutes', the 'deformed persons', the 'dwarfs' and the 'despised' of the earth. True, Arbus does not speak 'for' such subjects – as Whitman claimed he did (adopting a posture that today may seem overweening and patronizing) – but she sought them out, and the fact that we are made to look *so* closely disorients, makes us ever more aware of their *otherness*. But, at the same time, this intense nearness demands a response, seeks recognition that these *others* are human too.

With respect to Sontag's critical stance on photography more generally, it is worth saying that underlying much of her pessimism in *On Photography* is a justifiable questioning of photography's assumed ability to record reality itself: often she sees the photographic image as an evasion, a substitute for actual human experience. The same charge could, of course, be levelled at all art forms – from the novel to the radio play – in that art is *not*, after all, life. Certainly, in contrast to Sontag, what practitioners of other arts, perhaps especially in the u.s., have revered about photography is, precisely, its assumed access to reality itself. The narrator in Marilynne Robinson's novel *Housekeeping* (1981) is entirely typical when she says, *à propos* 'people in old photographs', 'we did not see them through a veil of knowledge and habit, but simply and plainly, as they were lined or scarred, as they were startled or blank'. It was such a recognition that, earlier, led novelist Wright Morris to produce sharp, uncluttered Nebraska photographs for *The Inhabitants* (1946) – inscribed to 'The Inhabitants, Who know what it is to be an American' – and for his extraordinary photo-novel *The Home Place* (1948). As in the latter's *Dresser Drawer*, a still-life, the photographs give clarity and texture to the stuff of living. Needless to say, in philosophical terms, this art-life question is too large and extraneous an issue for treatment here, and it is interesting that some of the more probing photography of recent years, in a sort of reversal, has deployed words to underline the reality beyond the reach of the camera image per se. *Ebo Landing*, made in 1992 by the African American photographer Carrie Mae Weems, for example, relies on written text to penetrate the historical experience of slavery.[17]

Photography and the USA asserts that it is truly fitting to think of the realities designated by the two referents of its title as profoundly linked. Stephen White has even claimed a profound existential relationship: 'photography seemed to seep into the very pores of the American being'. Each chapter proceeds in roughly chronological order, and while the book may be read as a brief history of, or an introduction to, American photography, as a short work it neither aims or claims to be comprehensive.[18] Chapter One is a cultural reading of American contributions to developments in photographic technology, primarily during the medium's first century, linking them to other facets of U.S. society. Chapter Two looks at ways in which photography has intersected with some of the major themes of American history, including the Western frontier, immigration, race and racism, the rise of the city and the growth of consumerism. In chapter Three the focus is on selected key episodes in the American documentary tradition in photography. American art photography, seen again primarily from the perspective of cultural history, provides the main subject of discussion in chapter Four. In a nutshell, the book is about photographs, and it pays attention, as far as space permits, to certain ambiguities of American ideology and history. It is also about the complexity of 'reading' photographs in the American cultural context. Whether we look at technologies, histories, documentary or artistic emblems, the assumption throughout is that the reciprocity, indeed the synergy, between the medium and other aspects of American culture has been so insistent and dynamic that it cannot readily be denied.

Technologies

Mechanization Takes Command

Much of the technological development of photography, down to the comparatively recent copyrighted production of such digital software as Adobe Photoshop and the like, has taken place in the USA. Before Louis Jacques Mandé Daguerre in France and William Henry Fox Talbot in England invented photography as such, Americans were the first to patent many of the best magic lanterns. Daguerre had his precursors in the United States just as he had them in Europe – among them Samuel F. B. Morse, the painter and celebrated inventor of telegraphy – and, when the news of the Frenchman's success spread throughout the Western world in 1839, either Morse in New York or the relatively obscure Joseph Saxton of Philadelphia soon took the earliest-known American daguerreotypes. Saxton's, a small murky exposure of the exterior of Philadelphia's Central High School, still exists, a treasured item in the collections of the Pennsylvania Historical Society.[1] By the following year, Morse's friend, the chemist John W. Draper, had succeeded in making the world's first daguerreotype portraits. Soon aesthetically notable works were produced, including the Boston studio productions of Albert S. Southworth and Josiah Hawes. In 1850, many decades before Hawaii was annexed by the USA, they depicted two Hawaiian leaders with visible respect (illus. 15). Within only ten years a veritable photographic *industry* was under way, primarily based on daguerreotype portraiture, a little later on the wet collodion process (in which the glass paint was coated with sensitizing chemicals and exposed while still wet),

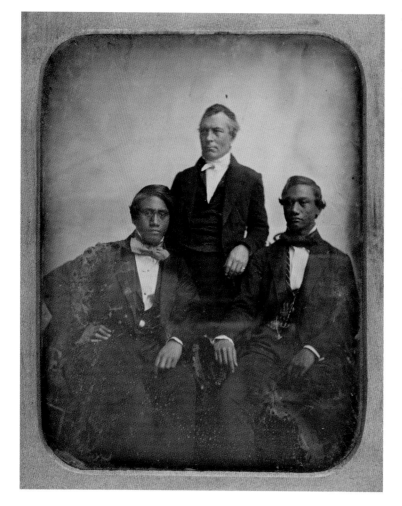

15 Albert Sands Southworth and Josiah Hawes, *Hawaiian princes, Alexander Liholoho and Lot Kamehameka, with Gerrit Parmele Judd*, 1850, daguerrotype. The daguerreotype process in effect combined negative and positive to create non-reproducible images.

and in this sphere, at least, the USA would not need to look overmuch to Europe again.

In 1850 William and Frederick Langenheim of Philadelphia secured the U.S. rights to Talbot's inventive process, which of course – in allowing the reproduction of numerous positives from each negative – ultimately proved *the* way to go in photography. One of the images they sent Talbot in their campaign to show him what they could do was a study of the erection of a watchtower at the new 'progressive' Pennsylvania

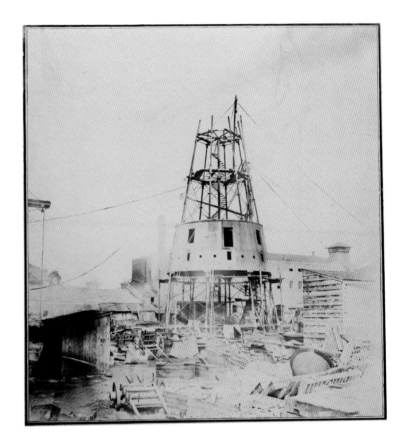

penitentiary. They also made the first successful photographic lantern
slides, thus ensuring that in towns and villages across the Republic –
and then around the globe – people in the mass could sit down together
to see examples of the new medium. By 1851 there were at least 50 portrait
studios in New York City alone and, in 1853, the *New York Daily Tribune*
estimated that three million daguerreotypes were being produced there
that year. Massive ones by Mathew Brady and others were shown at the
Great Exhibition in London's Crystal Palace in 1851 and John A. Whipple's
moon picture, with its high level of definition, was among the American
medal winners (illus. 17). What gave the u.s. daguerreotypes their tech-
nical superiority was the preparation of the plates before they were
chemically coated to make the silver surface light-sensitive: they were

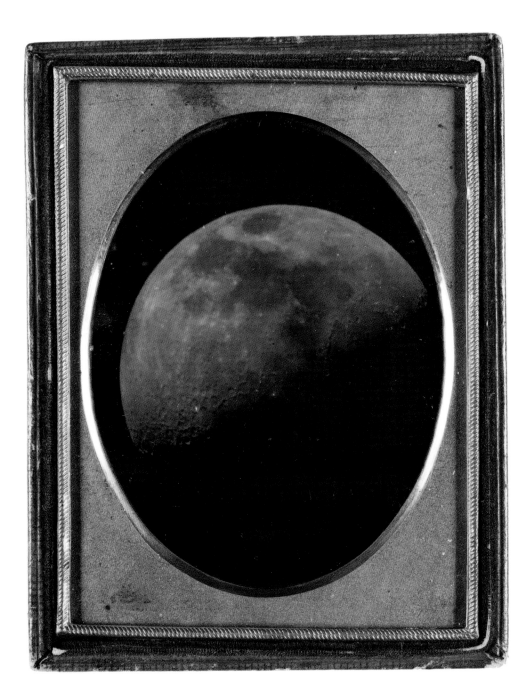

17 John A. Whipple, daguerreotype of the moon, c. 1850.

machine-polished and galvanized. Horace Greeley, the New York news-paperman credited with the fateful injunction 'Go West, young man' and who later chronicled the Civil War, trumpeted the impression made by the American pictures: 'In daguerreotypes, it seems to be conceded that we beat the world.' Photographic histories have tended to concentrate on the sheer technical prowess of the American photographic practitioners, or on the way the exhibition marked the artistic recognition of Brady or Whipple. But if we look at the photographs in relation to the other notable American exhibits – which included (alongside Hiram Powers's sculpture *The Greek Slave*) the Colt revolver, the awesome McCormick reaper, Goodyear rubber goods, Alfred Charles Hobbs's parautoptic permutation lock (basically the first combination lock), and super-efficient sewing machines – we can appreciate that the received view is too narrow.[2]

In 1950, in a centenary essay looking back at the British reaction to the American exhibits, the intellectual historian Merle Curti risked a broader judgement. He named the recurring features of these exhibits – 'utility', 'comfort', 'appeal to the great masses', together with (he implied rather than stated) scale and replicability – and he surmised that Europeans realized that 'Americans had an eye to the mass market'. Curti did not specifically single out the American photographic exhibits at the Great Exhibition, but he might well have, because even Greeley, in singing the praises of the daguerreotypes as already quoted, added the telling phrase: 'we beat the world *when excellence and cheapness are both considered*'.[3] In other words, their significance was not so much their artistic worth or technical attainment but that the esteem they received was consonant with American impact in other spheres. Curti identified the signs of the emergence of the USA as the dominant power in what was to become the next phase of capitalism. If tentatively, he registered the initial stage of a *process* – a process that was a complex interweaving of the technological, economic, aesthetic and cultural.

We should keep this notion of societal process in the back of our minds as we look at further instances of American technological and commercial development in photography. In 1856 the first ferrotype patent in the United States was granted to an Ohio chemistry professor, but in no time this method – an elaboration of the popular wet collodion

35

technique but using a thin sheet of iron instead of glass, coated with black enamel – was being exploited so blatantly on such a wide scale that the patent was immaterial. The ferrotype's importance resided in its short exposure times, relative ease of use, and its extraordinary cheapness (even if superior studios thought of it as *just* cheap and nasty). It was a technique also capable of improvement, and thus lasted several decades, and it was employed by numerous itinerant photographers. This meant that very ordinary people could afford its 'tintype' imagery and, since it was a process that did not permit retouching, its results were a bequest of faithfully raw portraits of many of the lower orders of society who might otherwise have escaped the camera's eye.

The American general public saw examples of these and other processes in the immense photographic displays at the various major expositions, such as the Philadelphia Centennial Exposition of 1876. Ultimately, it is more significant that many photographs were taken on stereoscopic cameras, and that stereographs in series with such titles as *Tom Thumb and Wife*, *The Civil War*, *Niagara Falls*, *American Whaling*, *American Industry* and *Alaska after the Gold Rush of 1898*, were sold in thousands. Stereoscopic cameras and their 'three-dimensional' images – first on glass, then on paper – were first produced in Europe but caught on in an unprecedented way in North America when improved upon and marketed by the Langenheim brothers in the late 1850s. The viewer often gets a sense of looking *into* a scene because the photographer, as in the case of *Broadway on a Rainy Day*, chose a vantage that would stress the lines of perspective receding into the distance. The early, rather awkward and bulky stereoscopes for viewing and optically combining the two images on stereographs were considerably enhanced by the writer and physician Oliver Wendell Holmes in 1859, and soon stereographs, when produced industrially, became a feature of virtually every settled American home (illus. 20). Holmes himself was also a perceptive if extravagant theorist of the new medium. In a series of articles for *The Atlantic Monthly* he argued, among other things, that photographic representation of reality was a separation of 'form' from 'matter', and constituted the most significant of all human achievements. He predicted that 'forms', photographic images, would ultimately become more treasured than their subject-matter.[4]

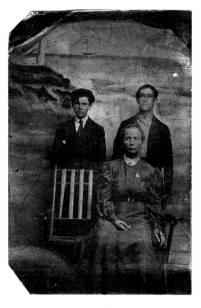

18 Ferrotype portrait of anonymous family, undated, by an unknown photographer. An explanation for the empty chair is provided by words inscribed on the back of the tintype: 'father passed half month ago'.

19 One half of a stereoview from the E. & H. T. Anthony Company, *Broadway on a Rainy Day*, c. 1860.

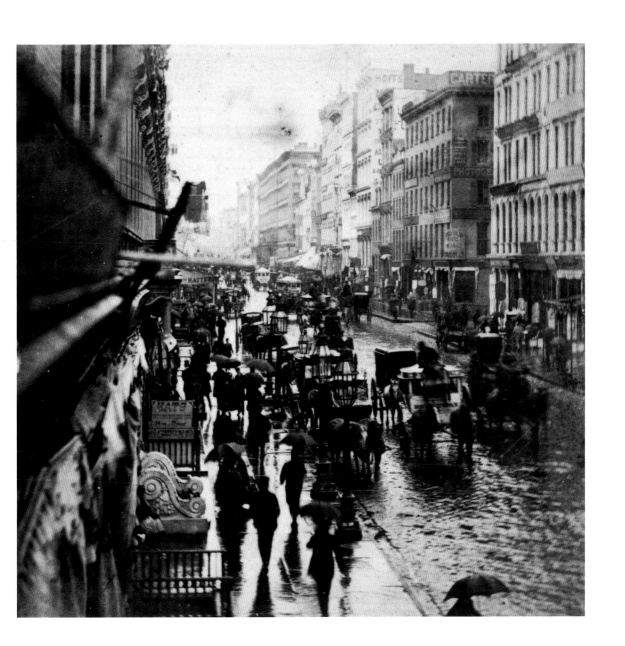

TO BE WITHIN ARM'S REACH OF DISTANT COUNTRIES IT IS ONLY NECESSARY TO BE

WITHIN ARM'S REACH OF THE UNDERWOOD STEREOGRAPH TRAVEL SYSTEM

20 Printed illustration of stereo viewer from the Underwood & Underwood company catalogue, c. 1913.

A further notable episode: the successful endeavours of Eadweard Muybridge (born Edward Muggeridge in Kingston upon Thames, Surrey, England) to become the first person, perhaps as early as 1872, to photograph – under the watchful eyes of the West Coast railroad tycoon Leland Stanford – motion in series. Muybridge's bounding horses, the exact movements of each of their four legs accurately captured, and his humans engaged in numerous physical activities, including boxing, heralded the advent of the more fluid record of motion itself that moving pictures were to provide for the twentieth century. Whether we look at one Muybridge image, taken out of sequence, or the continuity of a whole sequence, the experience is mildly uncanny. The grid pattern of the flat background that Muybridge often used to encourage precise analysis of bodily movement tends to threaten to 'tame' actions that – partly because they are often performed in the nude – we seem to be seeing for the very first time. Sometimes his subjects are extreme – a crippled child walking on all fours, for instance – but even when they are undertaking such humdrum motions as ascending stairs, walking, throwing a ball or carrying a basket, we *are* truly seeing them for the first time. Muybridge was an inveterate experimentalist: he made 360-degree photographic panoramas of San Francisco and, in 1880 – while immersed in camera

studies of movement throughout the animal kingdom that were to pre-occupy him for the next decade – he demonstrated his zoopraxiscope, a device for projecting photographic images in motion.[5]

The mass mechanization of the reproduction of photographs was an American invention of the early 1880s. There already existed European processes capable of mechanically reproducing camera images – some of them, such as the Woodburytype, of much delicacy, precision and beauty – but they were typically expensive and unsuited for use in every-day journalism. Working for the *New York Daily Graphic*, Stephen Henry Horgan created the first viable half-tone reproduction process – essentially

21 Eadweard Muybridge, 'Boxers', from his book *Animal Locomotion*, 1887, collotype. Muybridge used a battery of cameras and triggered the release of their shutters in sequence to obtain these photos.

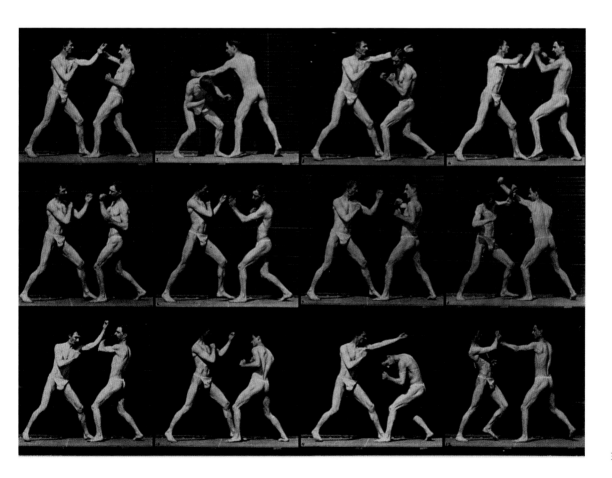

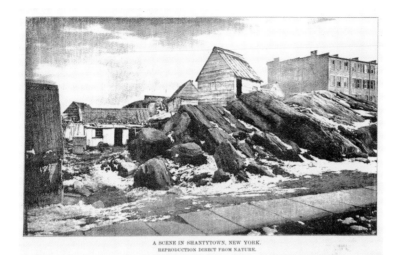

A SCENE IN SHANTYTOWN, NEW YORK.
REPRODUCTION DIRECT FROM NATURE.

22 Unidentified maker, *A Scene in Shantytown, New York*, a half-tone print from the New York *Daily Graphic*, 4 March 1880. It is notable that this very early effort at photographic realism in print depicts a slum scene.

a dot screen technique able to print images directly alongside text – and over the next two decades variations of his system became the norm in American newspapers and magazines. Half-tone reproduction in books soon followed, and by the turn of the twentieth century, Edward Wilson, the veteran chronicler of photography, could claim in his *Wilson's Photographic Journal*:

> In no other country are . . . illustrations so important a feature of everyday life as in America . . . [The] printed matter of every sort with which we are literally deluged at every turn, depend[s] largely for [its] interest upon illustration.[6]

Incorporating Kodak

William Welling has listed numerous other American 'firsts' in photography during the nineteenth century: using glass as a negative base, publication of the first photographic manual aimed at amateurs, and so on. And, of course, innovations that occurred in Europe were rapidly introduced into the United States, sometimes becoming even more

pervasive there than in the Old World. For example, in 1860, C. D. Fredricks introduced the *carte de visite*, patented by the Frenchman André-Adolphe-Eugène Disdéri, and it is arguable that its appeal and utility, because of the marked extra stress on upward mobility in American society, were greater than in France. Holmes referred to their diffusion, which soon took in virtually every public figure, as 'the social currency, the sentimental "green-backs" of civilization'.[7]

Dr Herman Vogel, the prominent German practitioner, readily admitted in 1883 that 'scientific men' in America generally saw the applicability of photography to numerous fields where their European

23, 24 *Cartes de visite*: Harriet Beecher Stowe, *c.* 1865, and Ralph Waldo Emerson, *c.* 1870. Stowe, author of *Uncle Tom's Cabin* (1852), and Emerson, transcendentalist philosopher, essayist and lecturer, were both much-travelled public figures with a use for their *cartes de visite*.

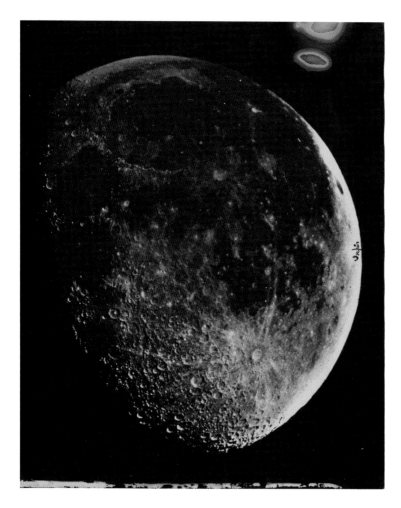

25 Henry Draper, *Moon*, 1863, cyanotype.

counterparts often failed to do so. And this was especially true in the cases of science and technology themselves. Two examples, one from the nineteenth century, the other from the twentieth century, are Henry Draper's 1863 photographs of the moon and Harold Edgerton's 1931 adaptation of stroboscopic flash to capture motion at high speed (illus. 27). Draper, son of the pioneering daguerreotypist John Draper, condensed the reflected 15½-inch (40-cm) image obtained by his powerful telescope and then made an enlarged copy of that original picture measur-

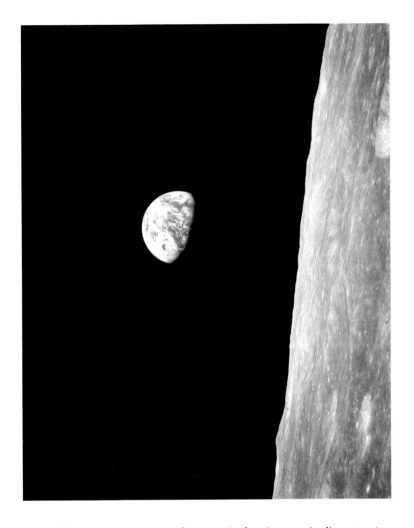

26 Photograph taken by Frank Borman, Jim Lovell or William Anders (the Apollo 8 crew), *Earthrise, from Apollo 8*, 1968, colour print. Although *Earthrise* is often printed horizontally, this is its original orientation.

ing, at the extreme, an extraordinary 50 inches (127 cm) in diameter. At this size it was possible to distinguish mountains and other lunar features with a clarity – and, of course, in a manner – that enabled extended study and discussion. Copies of Draper's moons were widely circulated among the world's astronomers and were lithographically reproduced in middle-brow journals such as *Harper's Weekly*. In a similar way to the extraordinary spacecraft images produced and circulated by the u.s. National Aeronautical and Space Agency (NASA) a century later, such

as the one of planet Earth taken from the moon's orbit, Draper's moons thus contributed both to scientific knowledge and to the growing popular appreciation of astronomy.

If Draper's achievement was telescopic, Edgerton's was micrographic. Because aficionados of photography often see the results of Edgerton's work in an artistic context – illustrated in *The Photographer's Eye* (1966), John Szarkowski's groundbreaking aesthetic appreciation of the medium, for example – it is easily forgotten that the breathtaking images he produced – whether a drop of milk hitting the surface of a bowl of milk, a golf ball impacting a telephone book at 225 feet (68 m) per second, a bullet stopped as it pierces an apple, a bar of soap, or a playing card – were tantamount to by-products of scientific inquiry. Muybridge-like, in the quest to see phenomena invisible to the naked eye alone, Edgerton, a trained electrical engineer working at the Massachusetts Institute of Technology, combined the camera with the stroboscope. He used controlled flashes of intensely bright light set to coincide with previously unheard of exposure times, a millionth of a second in some cases, so that the resulting images seem, if impossibly, to have 'stopped' events in mid-track. Here, too, there were popular and commercial dimensions, in that folios of Edgerton's images were seen by thousands in the pages of the picture magazine *Life*, and the widespread use of the flashbulb, developed a few years earlier at the u.s. General Electric Corporation, was promoted.

This catalogue of American technical innovation could be continued to at least 1963, when the Polaroid process to achieve instant photographs, invented by Edwin H. Land in 1947, became inexpensively available to anyone, and in colour. Or it might be sustained to embrace, as we have seen, the first photographs of our world taken from the vantage of the moon, in 1968. Or to include the production of faddish holographic cameras to take illusionistic 'three-dimensional' pictures in the late 1970s – or even to 1996 and the introduction of the Advanced Photo System (APS) using a 24 mm format. But, from the broader perspective of cultural history adopted here, the single most significant American contribution occurred much earlier: it was the opening of George Eastman's factory in Rochester, New York, in 1880.

27 Harold Edgerton, *Bullet through Jack of Diamonds*, c. 1955, dye transfer print. Despite the scientific provenance of this image, its subject-matter symbolically invokes the 'Wild West' and American gun culture more generally.

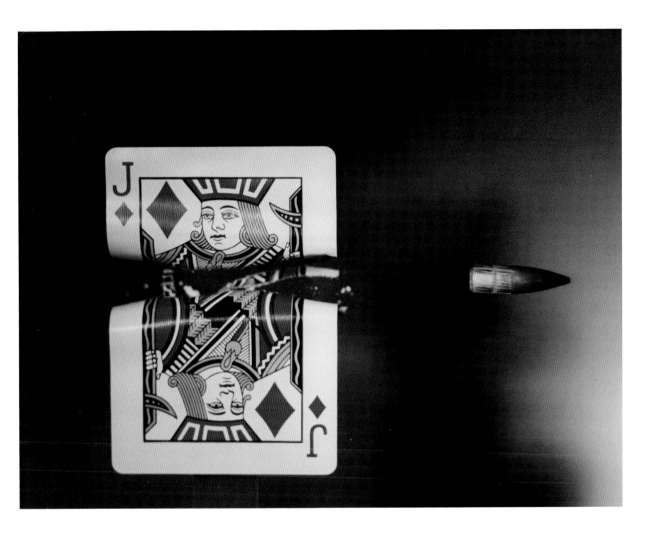

By 1888 Eastman had plagiarized the invention of celluloid for film patented by his compatriot, Hannibal Goodwin, and produced the first roll film in time to equip his new, inexpensive Kodak camera. It was this which made photography the first of the technologically advanced visual media to become a truly mass medium; as such, like film and television, its evolution may be seen as part – and as a symbol – of the country's ever-increasing commitment to the mass production of consumer goods. As with film and television later, the high technological development of photography was a facet of 'Yankee know-how', and emphatically linked to commerce. Thomas Edison's renowned labours in refining cinemato- graphy, inventing the gramophone and patenting a light bulb, were simply parts of a career dedicated to improving industrial processes. The development by Eastman and his company of a series of increasingly cheaper and simpler Brownie cameras was of the same order: customers would typically send the camera back to the factory for film development and printing and have it returned refilled with film: as Kodak's famous slogan promised: 'You push the button, we do the rest.' What Siegfried Giedion in his important book *Mechanization Takes Command* (1948) declared as a general statement certainly applied in the case of pho- tography: 'From its first appearance in the eighteenth century down to its later and decisive elaboration between the two World Wars, the assembly line is an American institution.'[8] Thus, in one of those ironies typical of American capitalism, Eastman became a millionaire and millions of Americans (and others around the world) were able to record the details of their daily lives: photography as the most accessible – indeed, the most democratic – of all the arts was born. Eastman himself practised it, as may be seen in a snapshot of him – pointedly wielding one of his company's cameras – on board a steamship bound for Europe on company business. The integrated corporation was the economic powerhouse of the late nineteenth century in the USA, then internation- ally; it was the precursor of the multinational corporation so familiar today. Kodak was such an entity no less than Ford and Standard Oil, and wielded enormous financial power. As a huge and ubiquitous cor- poration, its advertising was remorseless, urging consumers to realize that every occasion in life was a fit subject for photography: 'A vacation

28 Fred 'Chappie' Church, *George Eastman holding a No 2 Kodak on board the USS Gallia Crossing the Atlantic*, 1890, albumen print. Church, who used a Kodak himself for this image, was Eastman's attorney, and they were on their way to open a new facility.

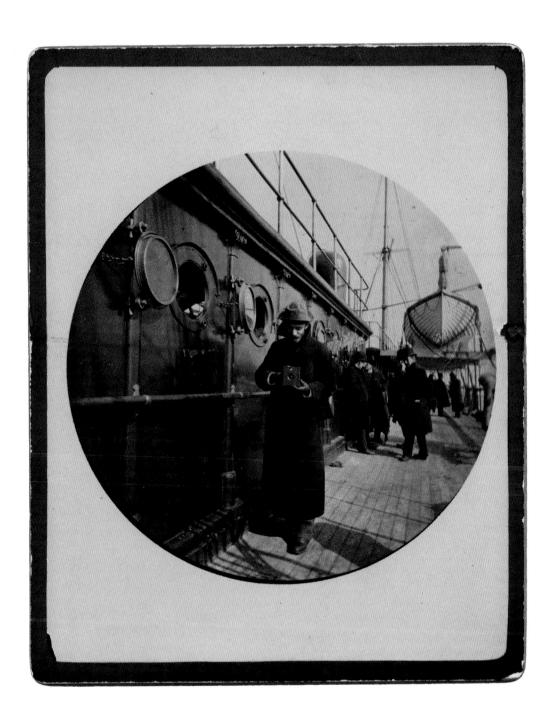

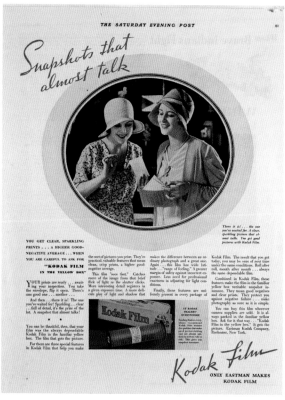

without a Kodak is a vacation wasted'; 'There are Kodak stories every-where'; and a photograph of a man fishing is captioned 'KODAK – Caught on the "Fly"'. Perhaps most effectively, Kodak could even guarantee immortality: 'Snapshots remember – when you forget.'[9] Kodak was thus part of the very fabric of *both* Western popular culture in general and camera culture in particular throughout the twentieth century. Its advertising reveals its especially symbiotic relationship to the mores of mid-twentieth-century American society. In such advertisements as the one here evoking the coming of age represented by the award of a degree at commencement, aspiration and photography appear to go hand-in-hand. It is no accident that, in the final decade of the century, Kodak also introduced the first digital camera.

29–32 Four printed advertisements for Kodak:
'Snapshots that almost talk', 1930,
'Secret Agents', 1943,
'Keep Commencement memories', 1949,
'Put summer in your pocket', 1952.

In 1925 an immigrant from Siberia who had trained as a photographer in Berlin, Anatol Josepho, raised the necessary capital to manufacture the first automatic photo-booth, the photomaton. Soon, over 7,000 people a day were queuing on Broadway to have the chance to orchestrate the movement of their own faces for a strip of eight photographs, and such booths began to open everywhere (illus. 33, 34). When, in 1927, businessman and diplomat Henry Morganthau – someone who later became one of President Franklin Roosevelt's most trusted advisors during the Great Depression – bought the American patent rights from Josepho for one million dollars, *The New York Times* reported him as saying that it would allow his new company to make 'personal photography easily and cheaply available to the masses of this country'. He continued with a pointed analogy:

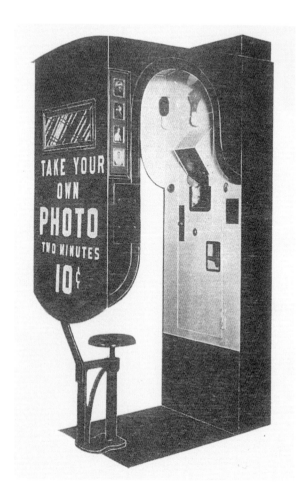

We propose to do in the photographic field what Woolworths has done in novelties and merchandise, Ford in automobiles, and the chain store in supplying the necessities and luxuries of life over widespread areas.[10]

It is precisely aspects of the medium like these interactions with mechanical and industrial modernization that most excited some of its American practitioners and proponents. Paul Strand – himself a major figure in art photography – wrote in 1922, for example, that American

artists, unlike Europeans, should have no fear of 'the new God, the
Machine', but should positively exploit all its resources. The camera, a
small machine, was, he thought, an appropriate means of expression for
a people attuned to the modern era in the manner he believed Americans
to be.[11] Strand himself, in his early career, also made close-up studies of
gleaming machines, including an Akeley movie camera, and they are
often framed to force the viewer to acknowledge the abstract geometry
of the machine. At about the same time, Strand's contemporary Paul
Outerbridge did an extreme close-up of a crankshaft, and Ralph Steiner

35 Paul Strand, *Akeley Motion Picture
Camera*, 1923, platinum print. As Strand's
work on the Whitman-inspired city docu-
mentary *Manahatta* (1922) testifies, he
was almost as familiar with the mecha-
nisms of film cameras as still ones.

51

one of typewriter keys. Such beliefs and practices contributed to the formation of an approach to photography that, if not uniquely American, was distinctively so. It was an approach in which the mechanical nature of the camera was fully accepted and its use virtually proclaimed by the qualities of the resultant photographs: recognizable and sharp images, unmanipulated, and taken directly, head on, as it were. This is the so-called 'straight tradition' that dominated American art photography until the recent past, and to which we will return.

Illustrating the Nation and the World

Later u.s. contributions to the medium include the development of photographically illustrated news magazines, which promoted a new form, the photo-essay or -story. We have noted that photographs became more and more common in publications, so it is not surprising that they began to have their own publications. In the United States this develop-ment took place in the 1930s, with the establishment by Henry Luce of *Fortune* in 1930 and *Life* in 1936. Luce's ambition for *Fortune* was to 'reflect Industrial Life in ink and paper and word and picture as the finest skyscraper reflects it in steel and architecture'. *Life*, like the slightly more liberal *Look*, founded in 1937 by Gardner Cowles, Jr specifically to rival Luce's *Time-Life* publications, was aimed beyond the business community at the general public. Photographs were intended to be – and were – the key to their popularity.[12]

As news magazines, they obviously relied on pictures that captured the events of the day: a 1936 sequence showing the variety of steps in the new dance craze, the Lindy Hop; sculptures intended for the 1939 New York World's Fair; a Pearl Harbor resident, in 1941, watching the Japanese bomb u.s. warships; a Congressional candidate addressing his electorate in 1942; three dead American soldiers on a Pacific beach in 1943; 'Survivors behind Barbed Wire, Buchenwald' (1945); or, in the same year, the crater made by the first atomic bomb in the New Mexico desert. But often the appeal of the pictures was as much a matter of *form* as content. The sequence that Margaret Bourke-White – then the only

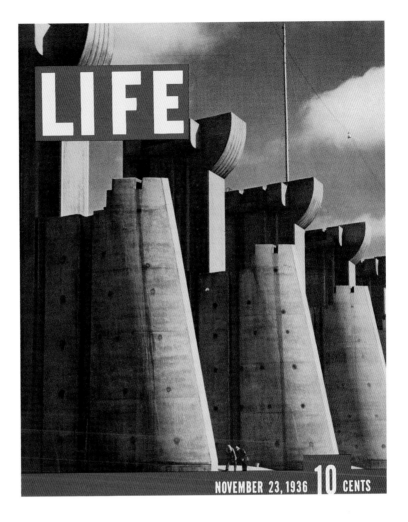

36 Margaret Bourke-White's photograph of Fort Peck Dam, Montana, on the cover of the first issue of *Life* magazine, November 1936.

staff photographer at *Life* – took for the very first issue of the magazine depicted the construction of the huge hydro-electric dam on the Missouri River at Fort Peck in Montana. The sequence did show some of the workers and some of the processes involved, but its concentration was on the almost abstract beauty of giant pipes and the dam's monumental concrete buttresses. In another early issue Martin Munkacsi captured Fred Astaire, tellingly from behind, in mid-dance routine. And, while the caption to an Ansel Adams landscape in April 1944 – 'March sun and

wind start to break up the ice on the lakes in the California mountains'
– speaks of a recent occurrence, the composition of the picture itself
represents nature as ever-abiding, beyond mere human time.

The photographically illustrated magazine had arrived in Europe
earlier. In Germany *Berliner Illustrirte Zeitung* and *Münchner Illustrierte
Presse* (*MIP*) emerged in the 1920s. At their most successful, each sold
over two million copies at only 25 pfennig each. As Gisèle Freund noted,
Stefan Lorant, the editor of *MIP*, developed something new, 'the idea of
the photo story': he 'began to fill entire pages of the magazine with groups
of photographs on a single subject'.[13] In France a Hungarian émigré,
Lucien Vogel, founded *Vu* in the early 1930s, but with insufficient funding
to enable him to give enough space to his flair for layout and pictorial
impact. Thus it could be argued that, while Europeans invented the
picture magazine, the Americans at *Life* and *Look* marketed it each week,
often on the back of unashamedly sensationalist pictures, to an ever-
larger audience. By 1950, about half the U.S. population read at least one
issue of *Life* in any three-month period. (It should be said, too, that in the
years after the rise of Nazism, some of the Americans who succeeded in
photojournalism were in fact transplanted Europeans, such as Lorant.)

One reason the Americans were so successful was that editors and
photographers understood their readership, and if photojournalist
Arthur Rothstein is correct, that understanding meant that they fully
appreciated their culture's deep faith in individualism. He wrote:

> No matter how large a mass audience may be, it is composed of
> individuals. People do not receive any form of communication en
> masse. If you are reading a magazine . . . watching television, listening
> to a radio broadcast, or seeing a film, you may be part of a mass
> audience, but the message you receive is personal and direct, an
> individual matter. That is, one does not edit for, broadcast to or
> advertize to a mass. Every message, commercial or otherwise, must
> be directed to individuals.[14]

This philosophy was made visible in the photo-story – in *Life* typically
a grouping of approximately a dozen images of varying sizes around a

theme, usually following one person, a single family or a specific group. That is, we also see a kind of individualism played out in front of the camera. Reliant on the reader's empathy, the photo-story depicted episodes in the experience of a particular individual or grouping and implicitly (sometimes explicitly) claimed them as representative.

In 1938 Horace Bristol, accompanied by writer John Steinbeck, followed a family of 'Okies', displaced from their Oklahoma farm in the 'Dust Bowl', looking for work in fertile California. Often in dire straits – one sequence of images depicts them reduced to tent living – they became individuated enough to serve as models for the members of the Joad family featured in Steinbeck's epic novel *The Grapes of Wrath* (1939). Franklin, Indiana, stood in for much of the nation when it was the scene for an upbeat December 1940 story on 'A Small Town's Saturday Night'. In the postwar period, a feature following one (named) young woman's week – from her daily splash of a morning bath in her studio apartment, through her subway ride to the office and her frantic

37 Horace Bristol, *Living in Government Supplied Tent*, 1938, silver print. This is one of many images Bristol made of a muddy FSA migrant camp in California.

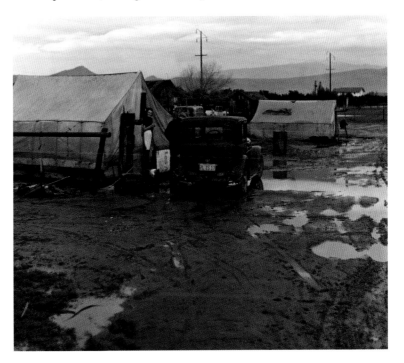

day there, to intermittent romantic trysts – encapsulated, it claimed, 'The Hopes and Fears of Countless Young Career Girls'.

After the Second World War, when being up-to-the-minute with news was simply expected, and non-print forces, especially television, became increasingly powerful in meeting such desires, *Life* and *Look* understandably opted more for 'the news behind the news', and with this ultimately liberating shift the photo-story was able to reach its expressive peak. A major exponent was W. Eugene Smith, who had already established himself in photojournalism by the intensity of his images of war. While ever capable of the single arresting photograph, he strove instead for the meaning and emotion generated *between* images in a sequence. Photographic historians have habitually rated three of his stories – *Country Doctor* (1948), *Spanish Village* (1951) and *Nurse-Midwife* (1951) – as masterpieces of the form. Although Smith fought for a greater say in the photographic selection, captioning and layout of such contributions to *Life*, and was restive under its editorial control, his photo-essays, if not quite as readily as those of more journeyman figures, should be seen as the outcome of collective, even corporate, endeavour.[15]

Doubtless many readers of the illustrated magazines came to recognize Smith's name. A name they *had* to absorb was Margaret Bourke-White. A colourful figure, she was sometimes able, with the connivance of *Life*'s editorial staff, to make *herself* part of the story, as in her wartime coverage of the Soviet Union, the photographic highpoint of which was a full-page portrait of Stalin, with a note on her access to him. She marked the advent of the celebrity behind the camera. In her earlier career she had dramatically photographed New York's skyscrapers by kneeling on one of the gargoyles protruding from the Chrysler Building 800 feet (244 m) up, with nothing but air beneath her – a pose in which she was herself photographed. She had been regularly retained by *Fortune*, liked to present herself as both hard-bitten and glamorous, and at *Life* was readily able to do so, if sometimes uneasily from a current perspective – as in her depiction of victims of the 1937 Louisville flood, or the liberation of Bergen-Belsen concentration camp or the perils of gold mining in apartheid South Africa. In her autobiography, *Portrait of Myself* (1963), Bourke-White frequently admitted that such projects were ethically

38 Contact sheet of some of the images made by W. Eugene Smith towards the creation of his 'Country Doctor' photo-essay for *Life* magazine, September 1948.

fraught, but the stories themselves, because they appear all too straight-forwardly, occlude the difficulties she recognized and therefore sometimes seem to exploit her human subjects.[16]

Another and very different regular cameraman for *Life* was the African American photographer Gordon Parks, who was often despatched to cover issues in the developing world; hence his remarkable feature in 1961 on the life of the youngster Flavio da Silva, a resident of a gigantic *favela* or shanty town outside Rio de Janeiro. In this instance, public identification with the sick Flavio on the part of *Life*'s readership was so pronounced that funds were raised to bring him to the USA for medical treatment and schooling. (This kind of response also points up a disturb-ing aspect of such adherence to individualism: by definition, structural and societal causes tend to be ignored and, as was the actual eventuality in the case of Flavio, who was separated from his poverty-stricken but loving family, compassion alone can be a poor basis for decisions affecting a person's whole future orientation.)[17]

In 1939, when Lucia Moholy, a Czech émigré photographer from Germany to Britain, published an inexpensive and best-selling Pelican Special for Penguin Books to commemorate *One Hundred Years of Photography*, she devoted the final chapters to press photography, from Horgan's trailblazing in 1880s New York down to her own time. As the former partner of Lázló Moholy-Nagy, the photographic practitioner-theorist who was one of the 'masters' of the Bauhaus (which – with her involvement as a teacher – had spearheaded modernization and Modernism in Germany), Moholy possessed authority, and what particu-larly impressed her were the ever-increasing speeds at which photographic images could be reproduced, and the ever-increasing distances over which they could be transmitted, especially after the inauguration of wire services in the late 1920s. In 1935, to the great commercial benefit of tabloid newspapers, the U.S.-controlled Associated Press Wirephoto network was established and regular national and transatlantic trans-mission began. These developments, as Moholy saw, resulted in public consumption of an 'astronomical' number of images. As a force, she declared, they 'represent immense power'. Stating that the aim of her book was to 'establish the connection between photography and life,

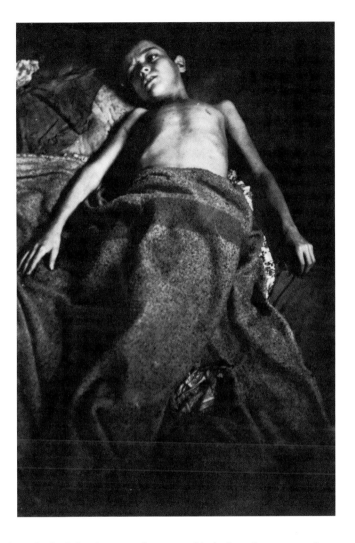

39 Gordon Parks, *Flavio da Silva during an asthmatic seizure*, 1961, gelatin print. The composition of this image subtly echoes high art's iconography of the Crucifixion.

and to describe [its] development from . . . a kind of magic art . . . to the status of a world power', she concluded on a prophetic note:

> Life without photographs is no longer imaginable. They pass before our eyes and awaken our interest; they pass through the atmosphere, unseen and unheard, over distances of thousands of miles. They are in our lives, as our lives are in them.[18]

In fact, for a period, before television took over, still photographs became *the* major means by which Americans represented themselves to each other, and to the rest of the world.

Photography thus became tantamount to what Moholy called a 'world power' as the USA became an actual world power. At the least, after the wholesale destruction of so much of Europe during the Second World War, American photographs achieved dominance, in Sontag's term, of 'the image world'. The correspondence between streamlined production lines, rising mass consumption, modernity and photography signals why the medium has been so important in – and for – the USA. Of course, the same correspondence became true during the more recent industrial ascendancy (and partial decline) of Japan: whereas in postwar European cartoon imagery the American was the national 'type' identified by the possession of at least one camera, a similar iconography later signified the Japanese businessman when abroad, even if he carried a Canon rather than a Kodak. The parallel between the USA and Japan may suggest the dominance of economic over geographical factors in the determination of culture. But this particular cultural pattern is one which was first traced in the United States, at a period of critical transformation in her history; and, as a consequence, photography has probably had a more profound effect there than anywhere else. Photography, cinema, television and the world wide web were all invented by Europeans, not Americans. Yet, as C. W. Ceram wrote, 'What matters in history is not whether certain . . . discoveries take place, but whether they take effect.'[19]

On the other hand, as Don DeLillo showed in his prescient novel *White Noise* (1984), with its generic college town, its Professor of Hitler Studies who doesn't need to know German, its lack of distinction between dialogue among characters and the endless 'dialogue' of television and radio and, most pertinently from our point of view, its evocation of 'a tourist attraction known as the most photographed barn in America' – in effect an attraction *only* because it is known as one – location, as such, has lost its significance. In the state of constant 'white noise' adumbrated in the novel, the only figure not thoroughly other-directed is the toddler, aptly named Wilder, who by miraculous fluke steers his tricycle safely

40 John Jensen, cartoon for *Punch*, 1981. This drawing by Jensen depicts the British photographer Lord Snowdon addressing a caricature American outside the Brighton Pavilion in England.

across the roaring freeway.[20] The 'image world' – which in the last 60 years witnessed as an aspect of itself the stupendous growth of reliance on photography for advertising, and which was immeasurably expanded by digitization – cannot be adequately described, but in what follows we will continue to probe some of its features.

Histories

Archive Issues

Technological developments were not isolated. They should be seen
as expressions of American culture more broadly – with its 'can-do'
attitudes, reliance on mechanization and much-vaunted faith in tech-
nological solutions to even the most intractable problems of society.
It is no surprise that the intensity of u.s. photo-technological activity
during photography's first hundred years was mirrored in the social
exploitation of the medium. Photographic likenesses even appeared
on marriage certificates. The potentialities of the camera were so readily
appreciated that, for countless different commercial, official and per-
sonal reasons, thousands of photographs were taken. Those that have
survived provide a priceless resource for anyone interested in recaptur-
ing the American past: the experience of a society expanding, industri-
alizing, transforming; but also the degradation – and determination –
of Native Americans who stood in the way, and of African Americans who
suffered through the slavery period and beyond. These photographic
records help us visualize the physical details, the precise environments
of both everyday life and historic achievements, but they also tell us
more. Since – in the perceptive phrasing of Conor Cruise O'Brien – 'The
whole imaginative and intellectual life of a culture is one interacting
field of force', photographs are shot through with cultural presumptions
that can be difficult to decipher, but reveal much about the minds of
photographers, their employers, their patrons and, often, the people
who consumed them.[1]

41 Marriage certificate for W. P. McIlwain and Josephine Elder, incorporating tintype photographs; authorized in West Freedom, Pennsylvania, in August 1874.

As early as 1843 Edward Anthony set out to capitalize on the new medium by photographing all the members of Congress. The ubiquitous Mathew Brady began in 1845 to collect photographic portraits of notable figures of his time, some of which appeared as engraved copies in his *Gallery of Illustrious Americans* (1850). A decade later, after his election, in praise of what is probably the first campaign photograph, Abraham Lincoln could quip, 'Mathew Brady and the Cooper Union speech made me President'. The three-quarter-length portrait, emphasizing his height, also certainly grants him a sombre dignity worth heeding at a time of extreme fractiousness (illus. 42). Even before Brady's little army of photographers set out more or less systematically to record the Civil War, the earliest photographs of war anywhere were made of episodes in the Mexican-American War of 1848. The volume and variety of the Civil War pictures contrast with the fascinating but more haphazard photographic forays into the near-contemporary Crimean War by the enterprising Englishman Roger Fenton.[2]

Less dramatically, journeymen photographers made daguerreotypes of the California gold rush in 1848; an unknown portraitist captured Caesar, the last slave owned in New York; a New York policeman started

the first official photographic rogues' gallery of 'mug shots' in 1858, and by the end of the century such portraits frequently appeared on posters offering rewards for fugitives from justice. Sojourner Truth, the African American Abolitionist and feminist, traded on her renown as a self-made activist by marketing her own *carte de visite* image, which carried the legend 'I sell the Shadow to support the Substance – Sojourner Truth'. In 1866 the entrepreneurial Carleton Watkins took photographs of the natural wonders of California's Yosemite Valley for sale to tourists (illus. 63). By the late 1890s it was possible for E. A. Hegg to make a near-comprehensive album of the scramble for gold in the Klondike. One of his images is so framed as to give an indication of the miners' material

42 Mathew Brady, *Abraham Lincoln (then candidate for the U.S. presidency, before delivering his Cooper Union address in New York City)*, 1860, gelatin silver print.

43 Wanted poster, incorporating a photograph of Charles Read by an unknown photographer, c. 1890s.

64

44 E. A. Hegg, *Klondikers with supplies at the scales preparing to ascend Chilkoot Pass, March 1898*, modern print from glass negative.

needs, the climatic conditions, and – in the line of climbing men in the middle of the image, ascending one ice-step at a time – the human endurance required to survive. Darius Kinsey spent a lifetime recording the gigantic trees and the logging industry of the Pacific Northwest, from the turn of the twentieth century onwards often employing equipment of a scale appropriate to the timber being felled (illus. 45). Eugene Omar Goldbeck realized he could make massive panoramas not only of land-scapes but of human subjects, and in 1926, in the wake of the first wave of anti-immigration laws, seized the main chance and made one, over three feet (90 cm) in length, of all the members of the newly established Border Patrol.[3]

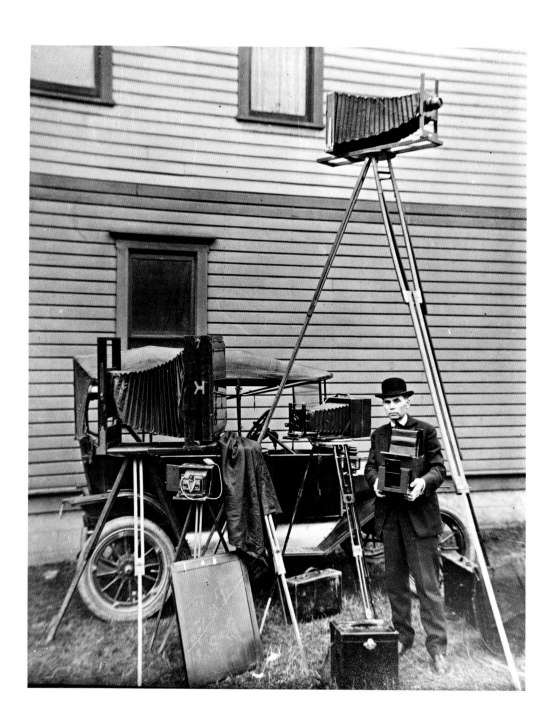

45 Darius Kinsey and his cameras, as photographed by a Kinsey studio employee, c. 1914; silver print.

Also, as we have seen with reference to the rise of Kodak, ordinary Americans were able, through the availability of cheap cameras and because of their relative affluence, to photograph each other on an unprecedented scale. A vast mass of photographic records of American life thus came into existence – pictures of common people already forgotten by the wider world, of places and things to hand, and many snapped by someone anonymous. We can gaze into the toothless faces of two elderly sisters, at the contented look of a plain woman surrounded by her five children, at the pert grin of a saloon girl – faces, expressions and, yes, stereotypes – that the light of more than a century ago preserved. It is possible to follow the varieties of taste and necessity in dress, hair-styles, beards and moustaches through years, regions and occupations: an Eastern city gent with a carnation in his mouth, a hirsute blacksmith whose hammer is forever prepared to strike sparks from the shoe on his anvil, a prospector and a gunman with the tools of their trades in their fists, or a group of pioneer Nebraskans showing us the watermelon they were about to eat – even the cards they held for poker – on a particular afternoon. There are photographs presenting a range of jobs in remarkable detail: a corset manufacturer surrounded by her wares; a Western telegraphist, his little machine on a box at the foot of a telegraph pole, an armed escort around him, in the middle of an expansive emptiness; a woman stenographer in an office otherwise reserved for men; and, of course, the omnipresent photographer himself, sometimes itinerant, with his horse-drawn dark room, his massive camera and his air of seeming to know what he is about.

There are people's amusements: a family musical group, early pin-ups, a river baptism, a balloon meet, a saloon by a lake in the middle of nowhere bearing the notice 'Ladies without bloomers are not allowed on the beach'. It is relatively easy also to find photographs of houses – the sod homes of pioneers contrasted, for example, with the cluttered living rooms of the Eastern seaboard. Some of these places and structures have now vanished utterly (such as small Western townships), some have changed beyond all recognition (like the Cincinnati waterfront), and some are preserved at a pivotal moment (Brooklyn Bridge newly opened, the Capitol under construction, a court out West still situated

in a tent). Then again, there is the land itself – forest, prairie, desert, mountain, river, lake and tilled field – and the indigenous inhabitants of that land, the Indians. Archival images amount, in short, to visions of a terrain, a nation, an era, and convey much about the majority of people who – as John Kouwenhoven, a pioneering scholar of American vernacular culture, expressed it – 'lacked the habit of scribbling'.[4]

The particular images I have just evoked really exist, but I did not encounter them directly in an archive or randomly in a variety of archives (though to do so, especially since the inception of the internet, is perfectly possible), but in a coffee-table compilation aptly titled *American Album*

46 Alexander Gardner, *A Sharpshooter's Last Sleep, Gettysburg*, 1863, albumen print.

that was published several decades ago, in 1968, by the respected illus-trated magazine *American Heritage*. A problem with compilations of this sort is that they usually do not – and, often, cannot – give the context for each image reproduced; in other words, while the photographs, as the editors claim, are undoubtedly 'documents of American life', it is not certain precisely *what* they document.[5] Often lavish in design and pro-duction, such works can all too easily present the point of view towards past eras – often a nostalgic one – held by their compilers, a point of view that is also, of course, constrained by *its* moment. (*American Album*, for example, barely touches on the presence in the American nineteenth century of Hispanic Americans – something editorially unthinkable today in a work of such scale.) It would be more enlightening to determine, as I shall later try to show, how the original viewers of such images saw them.

There is another issue: this summary so far, like *American Album*, has treated archival photographs as if they offer not only ready but transparent access to the past. In fact, of course, they are often far more problematic. A celebrated and perhaps extreme instance is provided by two images taken by Alexander Gardner on the Gettysburg battlefield and which appeared in his two-volume *Photographic Sketchbook of the War* (1866): *A Sharpshooter's Last Sleep* and *Home of a Rebel Sharpshooter*. Despite their captions – which in the case of the first claimed the man was 'lying as he fell . . . [his] cap and gun . . . evidently thrown behind him by the violence of the shock' and which in the second said the photographer had 'found in a lonely place the covert of a rebel sharpshooter, and photographed the scene presented here' – the images depict the *same* man. Therefore, as William A. Frassanito observed, for one or other of these pictures, or both, the body and other things, notably the rifle, *must* have been moved for the photograph.[6] The question of 'truth' in such images, the limitations that should or should not be observed by practitioners of what we now call 'documentary', have been much debated. The critical lesson from our perspective is the need to be ever watchful, to interrogate, insofar as it is possible, each image – and not only ones taken in war, where the likelihood of staged fabrication is all too great.

The sheer volume of archival imagery poses further problems. First, whether we are readers of compilations or viewers in archives, we generally

have little or no idea just *how* representative what we see is; there are so many thousands of surviving images that our generalizations are bound to be based on but a tiny selection. For example, another book, *The American Image*, published in 1979, contains some 200 photographs chosen from over five million then in the u.s. National Archives. According to a 1990 guide, there were then over *eight million* to take into account, and by now this figure may have virtually doubled.[7] Even if we were able to go through the National Archives for ourselves, we would certainly be swamped by such a quantity of images.

Second, making a selection is therefore necessarily fraught. If pressed to choose just five images to represent slavery, segregation and the Civil Rights Movement, my eye might light on the following: a much-reproduced photograph of the whipping scars of a former slave that brings to mind Sethe, in Toni Morrison's novel *Beloved* (1987), who speaks of the dreadful pattern of her own scars as 'the tree' on her back;[8] one showing enforced and legalized segregation in the South after official Emancipation, with black people granted inferior facilities to whites (illus. 79); another dealing with lynching, the particularly terrifying form of extra-legal repression of African Americans that spread beyond the South (between 1880 and 1968

47 Wood engravings of 'A Typical Negro', Gordon, a runaway slave from Mississippi with whip-scars on his back; and, on the right, Gordon as a recruit in Union Army uniform; made for *Harper's Weekly*, 4 July 1863. The engravings were based on photographs by McPherson & Oliver of Baton Rouge, Louisiana.

48 Demonstrators with ropes urging a new national crime commission to deliberate the designation of lynching as a specific crime, Washington, DC, 1934, gelatin silver print; a press picture marked for use. The demonstration was organized immediately after National Guards in Selbyville, Tennessee, had to brandish machine guns against a mob threatening to lynch a black man unjustly accused of rape.

almost 5,000 people were lynched in the USA); and two Civil Rights photographs, one evocative of the movement's trust and idealism, the other suitable for practical propaganda use.

Such a selection would demonstrate photography's involvement in this major theme of American history. Whipping was common on Southern plantations, even for such lowly 'crimes' as slow work, and the Abolitionists, given the use of images like the one of Gordon here, had no need to sensationalize it. It is difficult to talk with any ease, and rightly so, about the startlingly prolific imagery of lynching. Before jeering and joking crowds of whites, including families on a macabre day out, black individuals were hung, burnt, castrated, mutilated and exhibited. As shown by the extraordinary exhibition 'Without Sanctuary' (2000),

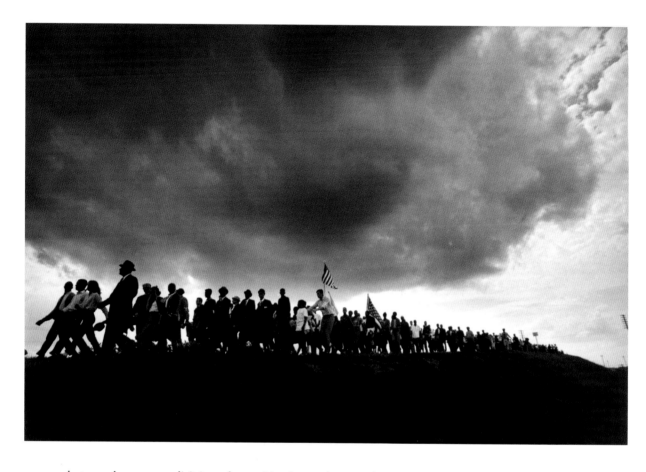

photography was complicit in such atrocities, its results sometimes
even sent as postcards. These practices – both the lynching itself and
the photographic exploitation of it – testify to the depth of a prevalent
inhumanity and a shameless racism in a swathe of U.S. society. This
larger attitudinal context is evoked in the press photograph reproduced
on page 71. Apparently taken by an unidentified Keystone Agency camera-
man, it depicts activists for the National Association for the Advancement
of Colored People demonstrating the vicious nature of lynching simply
by standing with nooses around their own necks.

When James Karales photographed the five-day Selma to Montgomery
March for *Look* in 1965, he was deliberately trying to capture something

49 James H. Karales, *Selma to Montgomery March, Alabama*, 1965, gelatin silver print.

more than the scene before him. He was after the very spirit of the Civil Rights Movement and, despite the duration of the march, let alone the overall length of the struggle, given the nature of the medium, it had to be done in a moment: 'I concentrated on the marchers every day . . . On the last day I saw this cloud . . . Then the people and the landscaping came into perfect view. I shot three frames. I almost missed it.' And the fact that Danny Lyon permitted a poster to be made of his image of a menacing Mississippi Highway patrolman speaks for itself. Interestingly, the image relies for its effect not only on a vantage point that makes the viewer look up at the patrolman but on the prior circulation of this kind of imagery – note the patrolman's stance, his helmet, even his grizzled skin – to represent such Southern authority figures as inherently hostile.[9]

At the same time, there is something much *less* than self-evident in my selection: while these five highly charged images do not *mis*-represent history, if we were to restrict our attention to them alone we would risk simplifying the diverse experiences of a whole people, themselves a substantial segment of the u.s. population, to a kind of tabloid exposure. Our procedure could become dangerously reductive. One means of combating such reductiveness would be to investigate much more assiduously the full

50 Danny Lyon, University of Mississippi campus, 1962, silver print. This was the campus where James Meredith tried to register as the first black student.

73

range of the archive of relevant photographs, including the exploration of incontestably important African American practitioners, such as James VanDerZee, Roy DeCarava or Carrie Mae Weems (illus. 14). Another would be to appreciate, as in the exhibition 'African American Vernacular Photography' (2005), the camera's interaction with everyday black subjects. This exhibition catalogue speaks of such photographs as depictions of 'aspects of social life that, while never free from oppression, at least began to rise above it'. As historian Robin D. G. Kelley puts it:

> You'll discover in the gaze and gestures of ordinary African Americans a complex and diverse community too busy loving, marrying, dancing, worshipping, dreaming, laughing, arguing, playing, working, dressing up, looking cool, raising children, organizing, performing magic, making poetry to be worried about what white folks thought about them.

(As the exhibition itself shows, Kelley might well have added another action to this litany: 'taking photographs'.)[10]

Caveats such as these should be borne in mind through the following short examinations of a selection of topics currently acknowledged as central to U.S. history.

American Themes

Not every such theme was photogenic. An important one somewhat resistant to photography, for example, is the formation of a specifically American tradition of democracy, with its emphasis on individualism. But even in this case, where the chief concern is a philosophical and political abstraction, there are some photographic records, such as portraits of prominent (and obscure) defenders of democratic values (illus. 42), or depictions of town meetings, or of courtrooms (illus. 84) and other material institutionalizations of the tradition. In the main, however, for major matters there exists a plethora of archival photographs.

The USA is often described, in apt shorthand, as 'a nation of immigrants' and, sure enough, the Library of Congress, the National Archives

and other repositories contain thousands of photographs that registered the unprecedented influx of peoples and the stages involved: pictures of the crowded steerages of immigrant ships (illus. 9); official 'mug shots' of newly arrived men and women; bird's-eye views of the immense waiting hall at the Ellis Island processing station; close-ups of medical inspections there; and sympathetic portraits of hopeful incomers by amateur Augustus Sherman, otherwise employed there as a clerk. Once landed, cameras continued to track them – to lodging houses and dormitories that catered for particular ethnic groups, to the intensely congested immigrant 'ghettos' of New York and other eastern cities, and on to the railroads with rudimentary carriages specifically designated 'immigrant trains' that conveyed new arrivals from Philadelphia to Pittsburgh and jobs in the steel works, and from ports in the East to the farmlands of Ohio and beyond. A subgenre of immigrant photography was the death portrait sent 'home' from

51 Photo View Company image of an immigrant house for Scandinavians, New York City, c. 1890, albumen print.

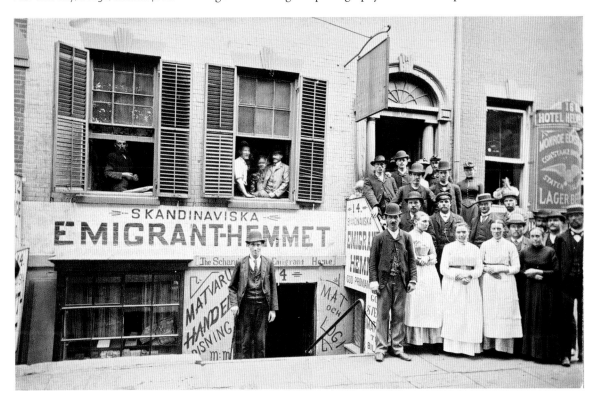

the New World by a surviving immigrant relative. On the verso of one such image, depicting a young Polish woman, an inscription identifies her as Elisabeth: 'when she died she was 24 years, 3 months, and thirteen days old'.[11]

Pictures of members of factory groups on day outings, each wearing the 'Old World' traditional costumes of his or her ethnic group, testify to immigration's contribution to the USA as also 'a nation of nations'. We see this, too, in views of trade union strikers wielding placards written in Italian, Yiddish, German and Russian. Obviously, 'immigration' means much more than the mere physical process of New World entry and occasionally, as we are seeing, the camera was at least able to hint at such larger meanings. In the 1970s and '80s, James Newberry captured, in colour, inter-generational features of Chicago's 'immigrant' life and Don Bartletti,

staff photographer for the *Los Angeles Times*, began perceptively to chron-
icle border issues in San Diego County, California, and beyond. One of
Bartletti's photographs depicts migrants from Guatemala who slept just
above the freeway intersection at which they daily sought labouring jobs
from drive-by contractors. The image sans caption could not convey
their 'story' to the viewer, but its framing alone grants a visual sense of
their vulnerability.

Photographic archives of similar size document other abiding
themes. In the case of the rise (often literally) of the American city, for
instance, Boston was depicted from the air (the cameraman in a basket
suspended under a gas-filled balloon) as early as 1860. The grain elevators

54 Don Bartletti, *Highway Camp,
Encinitas, California*, 1989, silver print.

and extensive stockyards of Chicago were frequently photographed. One of the earliest of New York's skyscrapers, the Flatiron Building, built in 1903, became iconic partly as a result of the efforts of art photographers to capture it. These included Edward Steichen who, in at least one instance, represented its awesome height but in such a manner as to make it seem part of an undisturbed, almost Old World, scene (illus. 55). 'Skyscraper' view cameras were invented specifically to counter the 'leaning' effect seen in images of tall buildings made by ordinary cameras. In major cities throughout the nation, tenement rooms crowded with furniture and, especially, their human occupants, slum streets and alleyways, and the Salvation Army ministering to the needs of the poor, were subjects of image series that contrasted with ones of gleaming factories, offices, warehouses and other workaday buildings. John Gutmann, a photographer then newly arrived from Germany, was fascinated by the very ease with which elevator parking structures, in the 1930s, were being canted ever higher; one of his photographs looks upwards at the receding decks of cars (illus. 56). Other series depicted the grand edifices erected to celebrate corporate and civic prestige and the verdant prospects of urban parks. City transportation systems, especially streetcars and, in New York City, the elevated railroad, constituted particularly popular subjects, and the frequent depiction of the actual construction of buildings and bridges implicitly expressed American dynamism.[12]

Often associated with the growth of the city, the rapid and extremely large-scale industrialization of the USA, its business development in the form of the ubiquitous corporation and the unquenchable consumerism first most avidly experienced there (and which was to become, perhaps, *the* dominant feature of economically 'advanced' societies in general), all gave rise to a richness of photographic imagery, much of it directly or indirectly sponsored by industrial and business companies themselves. The immense General Electric (GE) corporation, which was dedicated to power generation and supply as well as the manufacture of a range of electrical items – from the light bulb through domestic appliances to mammoth industrial machines – was, as David Nye has shown, remarkably assiduous in photographically recording all of its procedures, whether research and design, production and sales, political lobbying,

overleaf:
55 Edward Steichen, *Flatiron Building*, 1904; an early colour half-tone.

56 John Gutmann, *Elevated Garage*, Chicago, 1936, gelatin silver print.

or advertising and exhibition (illus. 57). This was also a matter of ideo-logy: GE was at the forefront of efforts to create a corporate ethos, from top to bottom, and this included both social activities (parties, bowling, basketball) and a variety of 'Americanization' rituals for immigrant workers, all of which were photographed for in-house use – and ultimately for the GE archive.[13]

The Woolworth Building, the New York skyscraper that the company of the 'five and dime store' built in 1913, was actually known as 'the cathedral of commerce'. This was partly because of the Gothic style of its architectural embellishments, but also because it seemed consecrated to the worship of a new order of enterprise. In 1926 Henry Ford completed the building of his extensive up-to-the minute automobile plant in greater Detroit, Michigan, and immediately photographers, such as E. O. Hoppé and Charles Sheeler, were showing an interest in the scale and aggressive grace of its structures: Hoppé for his huge picture book *Romantic America* (1927) and Sheeler for the N. W. Ayer advertising agency. Hoppé captioned one of his views 'Where Mechanism Serves Mankind'. Needless to say, there was an almost seamless connection between industrial development and photography for advertising purposes. Thus Steichen was retained

by the J. Walter Thompson Agency through the inter-war years, producing extravagantly elegant images of such products as the Packard motor coupe, while at the same time wielding enormous influence as the head of fashion photography for *Vogue* magazine. An image that captures the allure of consumerism, almost internalizing it, is Tony Ray-Jones's *Auto Show* (1965), made during this British photographer's formative sojourn in the u.s. (illus. 59). His car interior gives visual form to the ideal of automobile freedom and well-upholstered ease, and the fact that the photograph's vantage point seems to be from inside the car allows the viewer to register that, at least in the eyes of the auto show visitors, the car truly is an object of desire.[14]

The persistence of regionalism in the USA (especially in the South, both before and after the Civil War, which was itself, of course, a tragic consequence of overriding regionalist interests) is often underestimated by non-Americans, who – perhaps blinded by the undoubted political, economic and cultural power of the nation when seen from beyond its borders – tend to think of 'America' as seamlessly monolithic. But in fact the continental vastness of the USA means that even today, in these times of easy travel, most Americans have a visual image of the country, perhaps

58 E. O. Hoppé, 'Where Mechanism Serves Mankind' (Ford Motor Factory, River Rouge, Michigan), reproduced from a photogravure in *Romantic America* (New York, 1927).

even a national self-image, formed via the camera – television, the cinema and, of course, photography. And before relatively cheap transportation, this was even more so; people *had* to rely on pictures. Moreover, before photography, the connection between physical reality and picture was definitely more tangential. As Robert A. Weinstein and Larry Booth put it: 'Consider this: in the nineteenth century, let us say 1825, a Maine fisherman had no convincing notion of what his fellow citizen in Kentucky truly looked like.' Unreliable prints of paintings and drawings of the West and the Deep South were widely distributed through the Eastern states, and Currier & Ives purveyed thousands of lithographs of genre views of American life around the nation.[15]

59 Tony Ray Jones, *Auto Show, Daytona, Indiana*, 1965, colour print.

Photographs, as lithography developed technologically and aesthetically in the hands of such figures as Francis D'Avignon, came more and more to fulfil this transmission function. As is the case with other themes, ordinary people and journeymen photographers contributed to the huge stock of Southern regionalist imagery: immersion river baptisms, cotton on the branch, tobacco drying, Mississippi steamboats, reunions of slaves from particular plantations, group portraits of penitentiary chain gangs in typical striped uniforms, and indelibly Southern sites, whether the wrought iron balconies of New Orleans' Vieux Carré or the Palladian splendour of Thomas Jefferson's Monticello. And, of course, there were portraits of people – not just of family members who could be almost anyone anywhere but famous Southern figures, perhaps caught unawares.[16] The obsessive memorializations of the Confederate dead have a peculiar force. In one, the widow of the leading Southern general Thomas J. 'Stonewall' Jackson is ritualistically posed by his grave with an entourage consisting almost entirely of women. In the tableau they form, it is as if they had all been widowed, with no prospect for their whole generation but the graves that almost entirely enclose them.

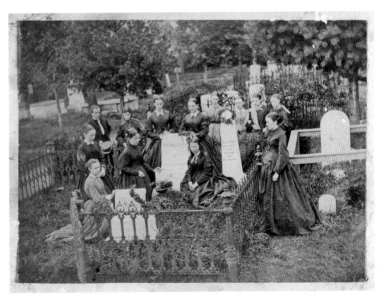

60 Unknown photographer, *Stonewall Jackson's Grave, His Widow Kneeling*, c. 1870s, albumen print. On the verso this image is speculatively credited to C. R. Rees & Co., Richmond, VA.

Capturing the West

Westward expansion, together with the concomitant resistance of Native Americans, was famously claimed by historian Frederick Jackson Turner as *the* determinant in U.S. history. He played down immigration and the other major themes sketched here, even race. He went so far as to ascribe what he dubbed the 'striking characteristics of the American intellect' – 'coarseness and strength . . . acuteness and inquisitiveness; that practical, inventive turn of mind, quick to find expedients; that masterful grasp of material things, lacking in the artistic but powerful to effect great ends; that restless, nervous energy; that dominant individualism, working for good and evil, and that buoyancy and exuberance which comes with freedom' – to repeated exposure to a moving frontier.[17] It is a theme with much camera involvement, and I want to look at it in slightly more detail than has been possible so far.

The principal collective agents (following the era of the independent mountain men) in the settlement of the trans-Mississippi West deliberately employed photographers to record their activities – whether they were government explorers, army surveyors and fort builders, the manufacturers of wagons for the trails westward, the great railroads which

62 Timothy O'Sullivan, *Sand Dunes, Carson Desert, Nevada,* 1867, albumen print.

87

connected the centres of population or the ranchers who initially settled the intervening acres. Eventually, of course, professional photographers themselves, sometimes initially as itinerant portraitists, set up shop in the mining camps and new towns of the region and, finally, amateur photographers could arise. As Sontag phrased it: 'Faced with the awesome spread and alienness of a newly settled continent, people wielded cameras as a way of taking possession of the places they visited.'[18]

Thus it was that men like John K. Hillers could photograph 'all the best scenery' on the second descent of the Colorado River with John Wesley Powell's 1871 expedition, that W. H. Illingworth could depict the line of General George A. Custer's expeditionary force entering the Black Hills, sacred to the Sioux, in 1874 (one of the events which triggered the fateful Battle of the Little Bighorn two years later), that Arundel C. Hull and others could portray the progress of the railroad lines across plains and obstructive mountains, that F. M. Steele could picture cowboy life on the trail at the turn of the century, or that Edward H. Latham, a u.s. Indian Service doctor by profession, could depict the life around the Agency at which he resided on the Colville Reservation in eastern Washington.[19] His depiction of the reservation blacksmith and his Indian assistant (illus. 61), though a portrait of the two men, is documenting u.s. government Indian policy, which was intent on training Indians in farming and trades to provide new livelihoods, but also with the aim of eradicating traditional ways of life. The marks burnt into the door are the brands allocated to individual Indians in their new roles as cattle farmers.

It was almost inevitable that magnificent Western landscapes would be produced, if often as a by-product of more utilitarian pursuits – and they were, by Hillers, Muybridge and many others. A good deal of the processing then had to be done in the field; for instance, before the advent of the dry plate in about 1877, the view camera's massive glass negatives had to be evenly coated with chemical, then exposed and developed while still wet. For this reason there is particular poignancy in Timothy O'Sullivan's 1868 depiction of his own u.s. Geological Survey photographic wagon isolated on an enormous sand dune in the Carson Sink, Nevada. The wagon's tracks in the sand may indicate that he heroically

63 Carleton Watkins, one half of a
stereograph of Yosemite from the
Mariposa trail, issued in 1879.

drove it up there for the picture. As we have seen, Carleton Watkins
was one of the first people to train a camera on the extraordinary land
formations to be found in what is now Yosemite National Park. And he
was so successful that his views of such landmarks as El Capitan, Sentinel
Dome and Bridal Veil both set the standard for others, such as Muybridge,
and – because of their popularity with both the public and critics –
became virtually the definitive Yosemite views. He took one early on
– the equivalent to a movie establishing shot – that he actually titled
The Best General View, and did a near replication of it for commercial
purposes in a later stereograph. In 1884 F. Jay Haynes was appointed
'Official Photographer of Yellowstone National Park'. This enabled him
to establish a summer studio there and to produce a flow of images that,

like Watkins's views of Yosemite, established a visual awareness country-wide of the USA's first National Park.

This tradition continued well into the late twentieth century in the person of Ansel Adams. Adams made countless pictures of Yosemite, held an annual summer workshop there for many years, and in 1946 received a Guggenheim Fellowship specifically to make National Park views. One of the finest of his National Park pictures depicts the jagged Teton Mountains towering above a superb curve of the silver-lit Snake River. Whereas some of the earliest Western landscapes were results,

64 Ansel Adams, *The Tetons and the Snake River, Grand Tetons National Park, Wyoming*, 1942, silver print.

65 Eliot Porter *Osprey – Padion haliaetus corolinensis – Penobscot Bay, Maine*, 1954, dye transfer print.

ironically, of the ultimately exploitative remits of government surveys, Adams's images became strongly associated with wilderness preservation, especially as embodied by the influential Sierra Club, at whose behest some of them were produced. Adams's slightly younger companion in such parallel interests was Eliot Porter who, like Adams, became a Sierra Club director. It is almost impossible to draw a line between Porter's still landscapes and his nature studies: whether black and white or colour, there is a delightful interplay between a tendency towards blocks of almost flat shades, as in an oriental print, and a reverence for the

autonomous reality of individual objects, whether aspens quaking in the wind, a single leaf bearing caterpillars or an osprey in flight.[20]

The titles and captions to Western works are intriguing, and Roland Barthes, among others, has shown that the addition of words complicates the already complex. Sometimes the caption is useful – and usually crucial – to complete the meaning of the image. A good example of this is John C. H. Grabill's photograph titled *Villa of Brule: The Great Hostile Indian Camp on River Brule near Pine Ridge, South Dakota*, which he copyrighted in 1891. It depicts a large encampment of Indian tepees and, in the foreground, a group of ponies standing in and drinking from a partly frozen river flowing just below the photographer's camera. It could be almost any nineteenth-century Plains Indian gathering were it not for the clue in the caption – *Great Hostile Indian Camp* – which makes it possible for historians to identify it as, literally, the last freely chosen large encampment of Brule, Oglala and other Sioux at the end of the Ghost Dance period and immediately after the notorious army massacre of Big Foot's band at Wounded Knee. In other words, this picture – taken by the same historically minded commercial photographer who captured *The Last*

66 John H. Grabill, *Villa of Brule*, 1891; modern copy of an albumen print.

67 Unknown photographer, stereograph issued by Underwood & Underwood titled *A Wonder to the Primitive Inhabitants*, and showing a Santa Fe railroad train crossing Cañon Diablo, Arizona, c. 1903.

Run of the Deadwood Stage in 1890 – testifies to the final free days of the Sioux nation for, soon afterwards, they were encircled by General Nelson A. Miles and transported back to the reservation.[21]

Sometimes, however, the caption, as Barthes puts it, 'invents an entirely new signified which is retroactively projected into the image, so much so as to appear denoted there'.[22] One popular stereo-card depicts two Indians, one a boy with a bow and arrow, looking from the foreground of the image towards the horizon; there, a train steams across a high trestle bridge that spans the canyon in which they stand. The stereo-card carries the following printed caption: *A Wonder to the Primitive Inhabitants*. Without the caption there are a number of different ways to read the image itself; it could be said to speak of the coexistence of ancient, tribal ways and modern technology; or, of the train as an intrusion into the lives and habitat of an aboriginal people; or, again, of the train fitting more appropriately into the landscape than the people it supersedes; or . . . The caption, that is, serves to interpret the image.

A significant aspect of such stereographs – as important as their three-dimensional quality – is precisely that they usually had captions on the back (sometimes long ones) that were evidently intended to instruct. They were mostly produced and distributed by commercial companies using photographs derived from a number of different photographers (sometimes within the same series) and their captions were rarely the work of the maker of the image itself. The caption writer was

thus engaged in an act of image interpretation and – though there were maverick companies and caption writers – the resultant captions usually present what is likely to have been the preferred reading of the culture of the time. All told, these pictures-with-words provided not so much information per se as an education in, and reinforcement of, the cultural values of the time. It could be argued that many of the stereo-card series should be seen – and analyzed – as examples of self-instruction in Americanism.

An obvious instance of pictorial transmission of cultural values is to be found in another frontier photograph, this time not a stereoview. On 10 May 1869, the tracks of the Union Pacific and Central Pacific Railroads met at Promontory Point, Utah. Leland Stanford drove in a golden spike to celebrate the achievement: for the first time, the continent was joined end to end by a single means of transport. There are several widely reprinted photographs of the event but the full, un-cropped version of the most popular of them, by Andrew J. Russell, official photographer for the Union Pacific, shows a mass of jubilant figures clustered in front of, around and on two engines which have steamed to a halt confronting each other: unity within competition or

68 A. J. Russell, *Golden Spike Ceremony, Promontory Point, Utah*, 1869, albumen print.

vice versa. The faces in the crowd are too distant to be easily discerned as individuals and the viewer may at first think that this is solely because the photographer was keen to portray the sheer size of the crowd. But there is also a vast expanse of sky: clearly, the photographer retreated until he could just hold within the frame the stars and stripes that unfurl from a stick atop a telegraph pole to the right. So this feat of capitalist investment and civil engineering is an event of national significance and was literally seen to be so. Not surprisingly, Whitman – who probably saw the photograph – wrote his epic poem 'Passage to India' (1871) partly to laud the pivotal nature of the event in the life of the nation. Whitman's epic, despite the warmth of its universalist embrace, is more than tinged by imperialist assumptions. And so is the photograph: it does not include either the Irish or Chinese labourers who had raced to meet each other from East and West or, of course, any of the Indians across whose lands the tracks were laid and to whom it signalled dispossession.

Photographers such as those mentioned here both recorded aspects of the West and, consciously or unconsciously, created an iconography of it that has retained its potency, especially as replicated in the Western film. For instance, William Henry Jackson's celebrated image titled *North from Berthoud Pass* (1874) fuses time and space: it has little to say about the specific geographical nature of Berthoud Pass but it is a classic and romantic evocation of Westering man; the figure moving off into the unknown even wears headgear that could be mistaken for a tricorn hat of the Revolutionary War era. Although, in actuality, he was plain Harry Yount, hunter for the Hayden Survey, in the image he is a kind of founding father obeying the injunction of his nation's 'manifest destiny' to subdue the alien and awesome continent as he advances into the future.[23] The stillness of such images gives the impression that careful photographers habitually represented the landscapes of the West as a series of awesome arenas fit for severe, even ultimate, conflicts.

Not surprisingly this Western iconography, in becoming a kind of orthodoxy, invited subversion and, especially from the late 1960s onwards, such demythologization often occurred. Lee Friedlander's famous 1969 view of Mt Rushmore (illus. 86), for instance, almost ignores the mountain to concentrate on the tourists looking at it and,

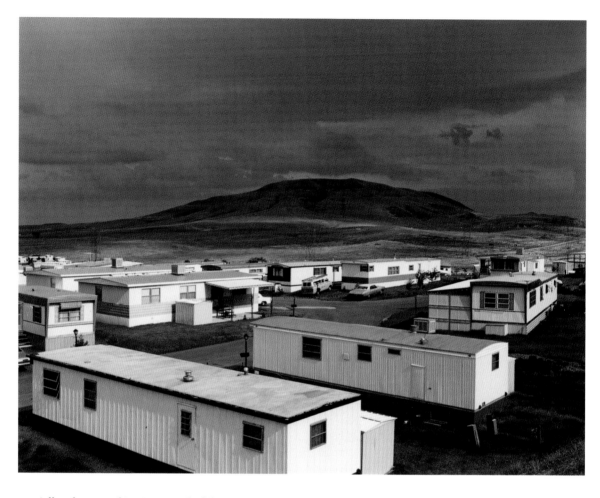

crucially, photographing it, several of them separately framed, as it were, by the windows of the visitors' centre. Jim Alinder did something parallel in his Rushmore Series of 1973: there the carved mountain monument is sometimes barely visible, displaced to the margins of the frame, while mobile homes or a family picnic occupy the central focus. Most obviously, the extensive and aptly named Rephotographic Project paralleled cele-brated nineteenth-century landscape views with ones taken from the same vantage point 'today', often thus emphasizing current environmental degradation. Robert Adams and other so-called 'New Topographics'

69 Robert Adams, *Mobile Homes, Jefferson County, Colorado,* 1973, silver print.

70 John Pfahl, *Moonrise over Pie Pan*, 1977,
Ektacolor print.

photographers, such as Lewis Baltz, were overtly political; they commented upon the contemporary West itself and were concerned to undermine the notion that its natural grandeur would always counteract waste: suburban developments, industrial estates, shopping centres and their attendant parking lots. In Adams's *Mobile Homes, Jefferson County, Colorado*, the skyline of a range of the Rocky Mountains becomes no more than a backdrop to the non-descript stationary caravans. John Pfahl produced landscapes full of majesty – of, for example, the Garden of the Gods in Colorado – but ever so subtly diminished by being seen

through the visible frame of a trailer window or the slats of a blind. One of his many 'altered landscapes' (illus. 70) actually (and jokingly) references Ansel Adams's famous *Moonrise over Hernandez, New Mexico* (1944). And it does so with both a technical virtuosity and an obvious beauty of its own.[24]

three

Documents

How the Other Half Lives

Often, as we have noted, photographs did more than merely record historical events: they were part and parcel of them. Like punctuation in sentences, they were integral to the meaning of the events, constitutive. The present chapter underlines this constitutive function by looking at a range of photographs taken from several distinct junctures in the evolving American documentary tradition. I suggest that the institutional context for such images – whether national, corporate or 'official' in some other way – so determined their nature that they might be termed 'symbolic documents'. Through them we get a visual sense of some of the forces at work in u.s. society at the time(s) of their making.

At the turn of the twentieth century when, mainly in the East, photographers confronted mass immigration, the increasingly teeming cities and working conditions in the aggressive new industries, a complex process of image-making occurred. Two people in particular devoted significant portions of their lives to recording, and commenting upon, these phenomena: Jacob A. Riis and Lewis W. Hine. Riis was himself an immigrant, born in Denmark, who had lived through a period of hardship after his 1870 arrival in the United States. He became a crime reporter for New York newspapers and rapidly began to see poverty and slum conditions as major causes of criminal activity. He wielded a deft pen in articles that emphasized not social analysis but stories of individual tragedies. With the help of Theodore Roosevelt, first as head of the police board and later as Governor of New York and then

President, Riis mounted a vigorous campaign for housing reform. He believed that the way to get reform was by arousing people to the facts. 'The power of fact', he wrote in his autobiography *The Making of an American* (1900), 'is the mightiest lever of this or any day'. And, as Alexander Alland claimed, 'he saw in the photograph a supreme weapon of fact'.[1]

From 1888 onwards photography – usually Riis's own but also work he acquired from others – became part of his armoury and was deployed in newspaper pieces, lantern-slide lectures and extended essays. The initial appearance, in 1889, of some of his most famous pictures as the basis for line drawings in *Scribner's* magazine led to immediate demand for a whole book, *How the Other Half Lives* (1890): the first American account of social conditions to be documented mainly by half-tone pictures made from photographs (with some hand-drawn illustrations). In it there were portrayals of homeless boys sleeping rough, teenage gangs in their 'dens', cigar makers, tailors and others working in tenement homes, people living in windowless cellars or crowded attics, overfilled lodging houses and the like.[2] *Street Arabs in Sleeping Quarters* (*c*. 1888), like others of Riis' images, was re-enacted for the camera. In it, as elsewhere in his work, poverty is granted a picturesque and sentimental aspect. For the next ten years or so Riis used such images as magic lantern illustrations for extremely popular nationwide speaking tours.

Riis's efforts and photographs were certainly rewarded: notorious slums were knocked down, sanitary settlements were built, New York City's water supply was purified and Riis himself became perhaps the best-known reformer of his generation. Some of the pictures possess a naked kind of force, the power of directness: all these people did, indeed, sleep in this constricted space. But it is important to realize that there is a strong voyeuristic element to them. In such well-known images as *Mullen's Alley, Cherry Hill* (*c*. 1888), the people photographed are separated from the viewer (and the photographer) by a largish expanse of empty foreground space and are caught, so to speak, at the opening of a dead-end alley. In visual terms, they are 'The Poor', 'the other half' (illus. 72). Such an impression is at one with that created by many others of Riis's photographs, with what is known of Riis's photographic methods, and –

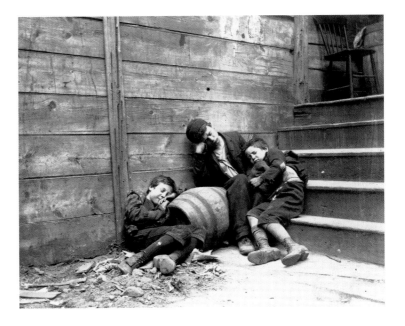

71 Jacob A. Riis, *Street Arabs in Sleeping Quarters*, c. 1888, albumen print.

though in artistic terms he may not have been conscious of it – with his fundamental ideology. Many of his images were made at night, with flash. Sometimes his sleeping subjects would be awakened by the sudden blaze that exposed their miserable circumstances, and he was able to enter many 'criminal' haunts precisely because he was a police reporter accompanied by a policeman. Riis 'voiced no protest against the arrangement of society which consigned masses of men to mean lives', wrote the perceptive historian Robert Bremner. 'His was no cry for social justice, but a call to the propertied classes to bestir themselves lest the crime engendered in the slums . . . invade [their] comfortable quarters.'[3]

In the past, the efforts of Riis and Hine were sometimes crudely yoked together. Certainly both wanted to modify the attitudes of the American public but the patronage available to them, like their approaches, techniques and impact, was significantly different. Hine was a sociologist and reformer who, like Riis, certainly wanted his photographs – whether on posters, in books, pamphlets or magazines – to move people and produce change. When he began, in 1904, he was especially concerned

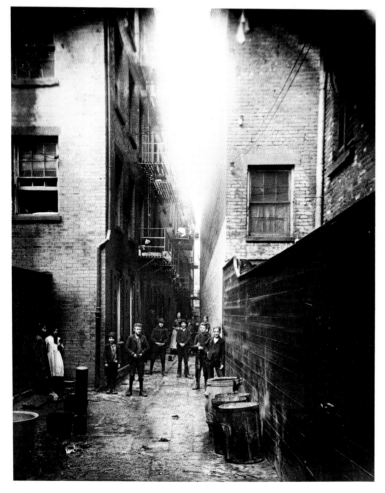

to document the conditions under which some two million American children had to work, and for many years, if intermittently, he photographed for the National Child Labor Committee (NCLC). In the first decade of the century he trained his camera on hundreds of immigrants as they suffered the hopes, humiliations and traumas of being processed through Ellis Island. He went on to do intensive work for *The Pittsburgh Survey* of industrial life, a profound sociological investigation sponsored by the Russell Sage Foundation that was published in six volumes between 1909 and 1914, and for such organizations as the Red Cross,

including a year in Europe during the First World War. For much of his career he made graphic images for his book *Men at Work* (1932), including (in the year prior to its publication) vertigo-inducing shots of the construction of the Empire State Building, then of course the tallest building in the world.[4]

Hine called his approach 'social photography', and Alan Trachtenberg has stressed this phrase to mean 'that the photograph itself performed a social act, made a particular communication'.[5] (Essentially, I am claiming that almost all the images discussed in this chapter performed a social act.) Several of Hine's photographs involve the viewer through the use of 'fictional space'. In *Dannie Mercurio, Washington, DC* (1912), for example, Dannie, a boy news-vendor, 'moves' towards the viewer on a line of paving stones while a comfortably-off woman moves away from him at right angles. The fact that the frame also contains the woman – and, in the background, a couple of roadways at oblique angles to each other – allows the picture to be read as cultural information, even news. The ways of the haves and the have-nots, the old and the young, even the past and the present, are diverging. The picture usually titled *Climbing into America* (1908), in informational terms merely a shot of immigrant men ascending a staircase somewhere in the Ellis Island facility, can be read as similarly symbolically freighted. Of the two central figures, the man 'above' has a better suitcase, looks more alert and is clothed and styled in an altogether more 'Americanized' manner than the heavily moustachioed figure on the steps below him. Or again, consider his 1905 image, *Madonna of Ellis Island*. A 'Mona Lisa' woman holds a baby on her lap while a slightly older child gazes adoringly at the baby; the background to this trio consists of a huge arc of glass and steel, but is also subtly reminiscent of cathedral stained glass. Clearly, this is an image that can only be fully appreciated if its symbolic connotations are borne in mind.

In other words, despite the fact that Hine took many thousands of photographs and that, like Riis, he sometimes used flash (as he did in most of his Ellis Island pictures, including his *Madonna*) there is little or nothing of the voyeuristic in his work. His portrait subjects look into the camera and seem to seek interaction with the viewer as fully dignified

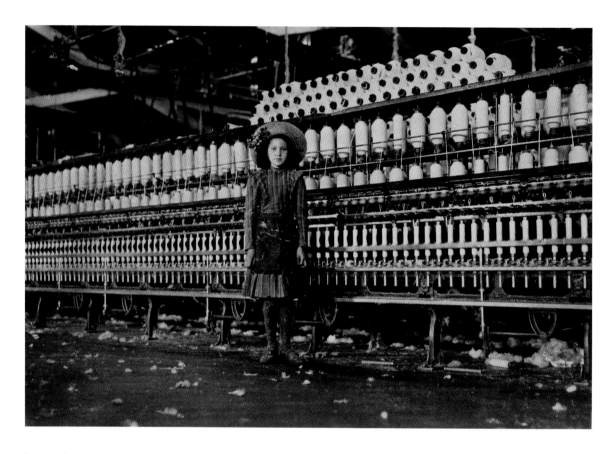

73 Lewis W. Hine, *Young Spinner in Cotton Mills, Roanoke, Virginia*, 1911, albumen print. The archived print is annotated 'Said fourteen years old, but it is doubtful'.

human beings, however poor or exploited. Even when this is not quite the case – in, say, the depictions of young girls prematurely aged by malnutrition and heavy labour, or whose spines have been permanently twisted by attention to demanding machines – there are often signs of their humanity within the frame. In his 1911 *Young Spinner in Cotton Mills, Roanoke, Virginia*, for example, the girl has proudly donned a very individualistic hat. The framing of the image to take in the full scale of the machine speaks of labour generically, but the hat particularizes.

Some of Hine's images, such as *Retarded Children*, were conceived as typological studies; this one was originally titled *Morons in Institution* and featured in his series *Institutionalized People*. But, despite this context, the boy and girl are seen from a slight distance, almost deferentially. It

is testimony to the image's respectful stance that Roland Barthes, who ignored the image's original function altogether when he addressed it in *Camera Lucida*, could claim that he 'hardly [saw] the monstrous heads and pathetic profiles'. He claimed that what he registered was 'the off-centre detail, the little boy's huge Danton collar, the girl's finger bandage'.[6] Thus, in the best of Hine's pictures, the viewer has to be an active participant in their interpretation if their full meaning is to be liberated. This is a result partly of his ideological position and partly of his conscious artistry. In his later life he would call his work 'interpretive photography'. For instance, he surrounded his pictures with the information of which, in a sense, they were part: statistics, polemical argument, narrative, other pictures. In the case of the studies taken for the NCLC, the viewer thus confronts, say, this particular child in the cotton mill *and* the greed of industry for maximum profit which demands her employment *and*, in all likelihood, his or her own passive acquiescence in the practice. The viewer is encouraged, that is, not simply to see but to *be* a witness.

The viewer's role as witness is also pivotal in work by Hine's near-contemporary Frances Benjamin Johnston, the first commercially successful woman photographer. Such were the demands of her varied

74 Lewis W. Hine, *Retarded Children*, c. 1920, gelatin silver print.

patrons that her output does not exhibit the continuities apparent in
Hine's, and one particular project, at the Hampton Institute, Virginia,
stands out. Commissioned by the head of the Institute, in 1899, to take
views which could be used to present its success as an educational enter-
prise – it was essentially a trade school for children of former slaves and
a smattering of Native Americans recruited from the new reservations
of the West – she produced what amounted to a coherent study that
could be satisfactorily exhibited as part of the u.s. entry devoted to
'Negroes' at the Paris Exposition of 1900. Most of the images are tableaux:
students, usually in their military-style uniforms, arranged to demon-
strate in one time-plane all the processes involved in carpentering a
staircase, in dressmaking, in mixing fertilizer. 'Before' and 'after' studies
show the results of a Hampton education, as in *The Old-Time Cabin*
versus *A Hampton Graduate's Home*, and views of classroom instruction
in progress.[7]

Two of the classroom scenes are particularly interesting. One,
Literature – Lesson on Whittier, shows a male African American addressing
the class, perhaps reading a poem by John Greenleaf Whittier, a writer

75 Frances B. Johnston, *Literature –
Lesson on Whittier*, 1899, platinum print.

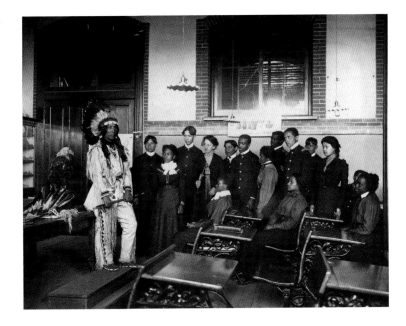

indelibly marked by his fervent work in support of the Abolitionist cause, the ultimate success of which the (predominantly African American) students are beneficiaries. Behind the young man, on the blackboard, is a drawing of a small home – presumably the cabin in which Whittier was born – and, also central in the background, a large portrait of Whittier in his eminence. Clearly, values are being communicated here, not only to the attentive students but also to the attentive viewer.

The other photograph evokes more of the pathos of then new policies towards Indians – nationally as well as at Hampton – than Johnston could have realized. The thrust of these was that, whenever possible and at whatever cost to them, Native Americans should be assimilated into the lower echelons of mainstream life. Titled *Class in American History*, the picture depicts a lone Plains Indian student standing at the head of the room, alongside such 'teaching aids' as an American eagle and a Frederic Remington print on the wall behind, to display his feathered regalia under the gaze of other students, both Indian and African American. It is a rich image, and much has been written about it.[8] I wish to draw attention to the inclusion within the frame of the

empty desks, which – probably without intention by the photographer – seem to urge us, as spectators, to enter physically *into* the picture, actively to decode the ambiguous 'lesson' of this class.

Of the several important photographers dedicated primarily to recording the ways of life of Native Americans, the most enterprising was Edward S. Curtis. Funded by banker J. Pierpont Morgan, and given moral support by Theodore Roosevelt, Curtis and his assistants made a photographic and written record (together with drawings, musical recordings and film footage) of over 80 different peoples west of the Mississippi who, according to Curtis's prefatory comments, 'still retained some semblance of their traditional ways of life'. He thus created *The North American Indian* (1907–30), a publication of twenty volumes of illustrated text accompanied by twenty portfolios of large photogravures.[9] Curtis's work – conducted during a most stressful phase of Indians' reservation experience, when many older folk anguished over memories of earlier and less restricted lives – is far from straightforward.

On the one hand, Indians are usually represented as deeply spiritual, totally at one with their environment and at some still point in the circle

78 Edward S. Curtis, *Mosa – Mohave*, 1903, platinum print.

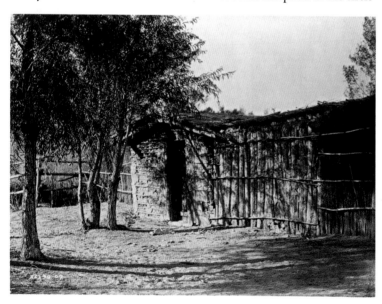

77 Edward S. Curtis, *Modern Chemehuevi Home*, 1906, platinum print.

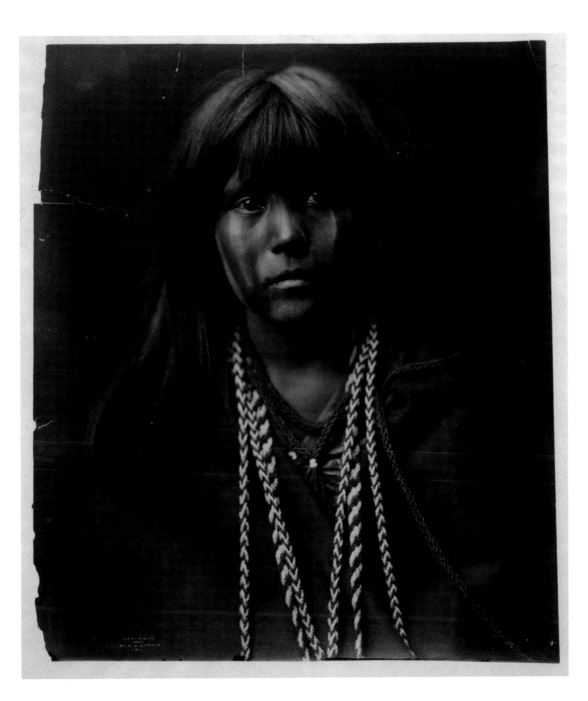

of their lives. Often they are so composed as to seem in a different
dimension to the bustle of this world – to be, in effect, simultaneously
above the flow of time, redeemed – yet also static, ossified into a strictly
'tribal' state. This is at one with the ambivalent objectives of Curtis's
patron, whose banking and oil interests ultimately required the West to
be thoroughly 'opened up' for exploitation, in effect leaving no room for
peoples seen as 'primitive' and inadaptable. Yet, despite many critical
notices to the contrary, in other Curtis depictions, modernity, in one
or another form, does intrude, and the indigenous people are shown to
have adjusted to it (illus. 77). More importantly, though Native subjects
were sometimes constrained to perform for Curtis's camera, in the formal
portraits many of them exert such a powerful claim on the viewer's
attention that their full humanity – and continuing *presence* – cannot
be denied. Curtis wrote of the young Mojave woman who was the subject
of *Mosa* (1903) that she was 'like a fawn of the forest'; but the sensitive
depiction of her undoubted shyness, by also implicitly stressing her
vulnerable humanity, does not demean her in the way that Curtis's
words alone might do (illus. 78).[10]

FSA

The major project of the twentieth century, so much written about that
it must receive shorter shrift here than it deserves, was that conducted
for the Farm Security Administration (FSA). Soon after coming to power
in 1933, Franklin D. Roosevelt appointed Rexford Tugwell, a professor
of Economics at Columbia University, to be his Assistant Secretary of
Agriculture. The sufferings of farmers in the agricultural depression
of the 1920s became almost catastrophic in the years following the 1929
stock market crash. In 1933 emergency programmes started to channel
money to farmers in distress, some of which evolved into the Resettle-
ment Administration (RA), with Tugwell as its administrator. He
appointed a junior colleague at Columbia, Roy E. Stryker, as head of
the Historical Section. In 1934 Stryker hired the first photographers,

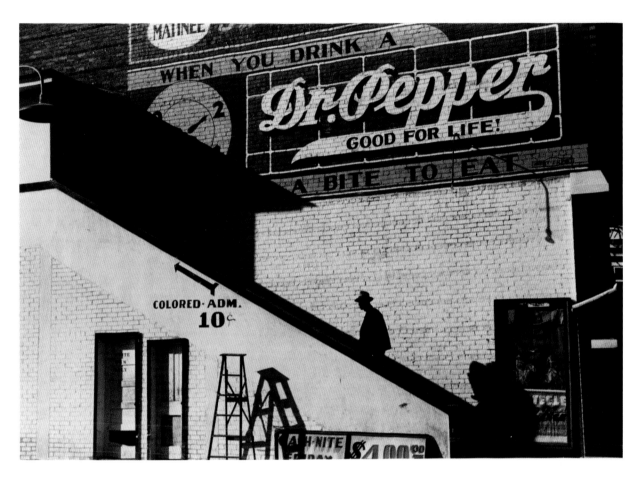

79 Marion Post Wolcott, *Negro man entering a movie theatre by the 'colored' entrance, Belzoni, Mississippi, 1939*; modern print from a nitrate 35 mm negative.

including one of his former graduate students, Arthur Rothstein. Over the years this photographic unit suffered many bureaucratic and political switches and changes. In 1936 the RA was established at the Department of the Interior, in December it was moved to the Department of Agriculture and, in 1937, became the FSA. Sometimes the funds were so low that only two photographers (usually Rothstein and Russell Lee) could be retained, whereas in more prosperous times the complement was six, even eight. Occasionally the economics of the operation dictated that photographers be seconded to (and paid by) other institutions – Rothstein went to government filmmaker Pare Lorentz, for instance,

Walker Evans to *Fortune* magazine (which later employed him as a key figure), and several others to the Tennessee Valley Authority.

By 1937 Tugwell was considered 'too radical' and was forced to resign. In the late 1930s various accusations were voiced: the FSA issued too much 'government propaganda', the unit's pictures were 'too depressing' or, as in the case of Marion Post Wolcott's renditions of racial segregation, too 'political'. (Wolcott's image of the segregated cinema, in both design and subject-matter, is a stark study in black and white; illus. 79.) In 1941 the unit was merged with the Office of War Information (OWI) and many of its photographers were drafted. Stryker strove, as always, to keep it going but, in a wartime atmosphere that encouraged the disproportionate depiction of the more smiling aspects of American life, its future was limited. Also, certain commercial photographic agencies viewed the extensive FSA files as a rival source of pictures and wanted them destroyed. Fortunately, in 1943 Stryker was easily able to persuade the poet Archibald MacLeish, then Librarian of Congress, to take them into the Library's care. Stryker went on to teach and, more importantly, to continue his work in the field of photographic documentation, this time for industry and big business. I give this (greatly foreshortened) account of how the project was implicated in government, even in bureaucracy, to counter the impression conveyed by the frequent sight, in numerous books and exhibitions, of a small selection of the FSA images alone: the impression that they float free of history.[11]

The conceptualization and range of the FSA photographic unit's activities had several sources, some of which were related to Stryker's personality and interests. He was certainly familiar with Brady's efforts to record the earlier national tragedy of the Civil War and he was probably aware of Curtis's massive Indian undertaking. He had enjoyed a personal friendship with Hine. He was well-acquainted with Margaret Bourke-White, at that time nearing the height of her fame as she collaborated with her then husband, novelist Erskine Caldwell, on *You Have Seen their Faces* (1937), a somewhat sensationalist effort to arouse the public conscience about the plight of small Southern farmers. He had been responsible for acquiring illustrations and, as was pointed out in the Introduction, *arranging* them for *American Economic Life and the Means*

of its Improvement (illus. 11). At the onset of the Depression Tugwell and Stryker were thinking about a book to be called 'A Pictorial Source Book of American Agriculture'; in a sense, this was a project that the FSA files could realize.

The chief aim of the FSA was the resettlement of farmers of limited means, through very low interest loans, on more productive, economically viable farms. The FSA was also concerned to resettle farmers in purpose-built suburban developments and subsistence housing on communal farms – the latter, because of its assumed similarity to contemporary Soviet efforts to collectivize farming, a controversial issue, as was the FSA's provision of government camps for migrant workers, as depicted

by FSA and non-FSA photographers, including Horace Bristol (illus. 37). The FSA was also involved in large-scale conservation programmes, in the fight against erosion and for more forestation. At first, all the Historical Section's photographs were intended to document the work of the Administration – its procedures, its clients, its problems and, of course, its successes. Thus Rothstein in November 1936, on location in Greenbelt, Maryland, would produce numerous pictures under the series title *A model community planned by the suburban division of the u.s. Resettlement Administration*. Note that the one entitled *Interior at Greenbelt, Maryland* has evidently been posed to stress communal interaction: the sparse furniture, as signalled by the chair blocking off the door, seems closer together than it would be in a lived-in room, and the two women have pointedly interrupted their separate acts to turn towards one another, as if in conversation (illus. 80).

But Stryker realized that more was possible. His own background in agricultural economics made him want the photographers to get at underlying conditions and causes. He was, therefore, ready to be influenced by others whose ideas were more far-reaching. One such figure was Robert S. Lynd, author of the renowned sociological study *Middletown* (1929), which delved into all areas of life in a typical Mid-West town, from the intimacies of love and religious belief to the use of public spaces, from the practicalities of manufacturing to the nebulous and collective aspirations of citizens. 'Shooting scripts' akin to the story-lines for *Life* photo-essays were evolved with such instructions as this:

> Pictures which emphasize the fact that the American highway is often a more attractive place than the places Americans live. 'Restless America.' Beautiful Highways . . . Elm, or Maples at the curve of the road . . . Lunch Rooms and Filling Station Truckers stopped to eat . . . Trailers on Road . . . People walking on road.

This may give the impression that there was a typical FSA (or Stryker) picture, but such is far from the case. There may have been *ideal* Stryker images; John Collier, an FSA photographer during the last phase of the unit's life, remembered that Stryker once told him to get a picture of

'the smell of burning autumn leaves'.[12] But, in actual day-to-day operation, the scripts and instructions served primarily as an invitation to the photographers to use their own eyes, *to interpret* what they saw.

And this was just as well, since several of them were mature artists with ideas of their own, and others, though essentially trained on the job, like Collier and Gordon Parks, were strong characters concerned to forge personal styles. Dorothea Lange – often since considered *the* archetypal FSA photographer – had made studies of conditions for migrant workers before joining the unit. Carl Mydans was an experienced journalist, and already skilled in the use of the relatively new, small format 35 mm camera. Evans, who at that time liked to take very considered images with a large view camera, was sufficiently recognized as an artist to have a show of his work, 'American Photographs', at the Museum of Modern Art, while he was attached to the FSA. Ben Shahn was already a significant painter and printmaker. The fact that such people rubbed shoulders, so to speak, no doubt indicates that they could have influenced one another and some were more prepared to please Stryker than others. But their own senses of themselves and the sheer mass of the pictures they took – over a quarter of a million – means that it is impossible, unproductive and absurd to isolate 'typical' FSA images, whether one of Lee's views of the desperately poor, Lange's famous portrait of an anguished *Migrant Mother* (1936), framed by the tousled heads of her children, or Shahn's black *Cotton Pickers* (1935), their enormous sacks trailing far behind them in the furrows, still to be filled.

There was always a potent artistic dimension to the FSA project. As well as Evans's 'American Photographs' exhibition, FSA images were featured in other art shows, including Willard Morgan's 'First International Exhibition of Photography' (1938). At least equally importantly, they were used as the pictorial basis for an innovative form, the book-length photographic essay, such as *12 Million Black Voices* (1941) by Richard Wright and Edwin Rosskam, 'a folk history' of the role of African Americans in American society, and *Let Us Now Praise Famous Men* (1941), the extraordinary product of James Agee's collaboration with Evans: a magnificent and idiosyncratic record in words and photographs of their

sojourn with three families of Alabama sharecroppers. Among the most enduring of such publications – in that, like the other titles mentioned here, it has been reprinted for the benefit of succeeding generations – is MacLeish's *Land of the Free* (1938), which features his poetry as a 'sound track' to the photographs.[13]

It is somewhat harder, from a present-day perspective, to determine the precise impact of the FSA images during the existence of the unit. Some were deployed in government reports issued by other agencies. Many, of course, were channelled to regional offices of the FSA itself to be used in brochures aimed at FSA clients, including the numerous farmers with limited literacy. The pictures and limited text, as in Lange's draft of a poster (illus. 105), had to catch the attention of such readers. Obviously, it helped if, even without text, the picture itself communicated: the low angle and the impossibility of discerning any individuality in the faces of Lange's subjects in her *Filipinos Cutting Lettuce, Salinas, California* (1935) makes it an almost archetypal image of anonymous back-breaking labour. Increasingly the pictures were also released to newspapers and

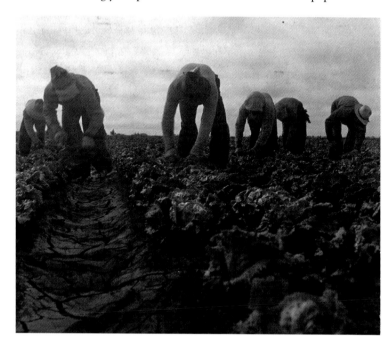

81 Dorothea Lange, *Filipinos Cutting Lettuce, Salinas, California*, 1935. Modern print from silver print.

magazines. Thus such work as Rothstein's renowned *Dust Storm, Cimarron County* (1936), showing a man and a blond boy running for shelter from obliterating grey dust, Evans's Mississippi flood pictures, certain of Lange's images of Mexicans and others recruited as cheap labour for the fields of California, or Parks' portrait of Ella Watson, an African American government office cleaner with mop raised, possibly in ironic salute to the flag behind her, were widely circulated, reprinted and seen. When Stryker could not prevent it, they appeared without credits to either the photographers or the FSA, but steadily credit, too, was secured, not only in such regular and sympathetic outlets as *Survey Graphic* and *u.s. Camera* but also in *Life* and *Look*.

A compelling feature of the FSA pictures is that they not only communicated 'downwards', so to speak, but they also circulated 'upwards' and 'around' what must be seen as folk artefacts, popular practices and 'ordinary' attitudes of the time. Sometimes they did this by *re*-presenting within the frame found slogans and notices, which then acted as internal captions, predisposing the viewer to interpret the picture a certain way. I'm thinking of Wolcott's many depictions of religious roadside signs in the 'Bible Belt', Collier's respectful presentation of the Catholic and Hispanic folk iconography on the walls of the Lopez family home in Trampas, New Mexico, and, at the onset of the USA's entry into the Second World War, John Vachon's many studies of the exteriors of modest houses hand-lettered with fiercely patriotic slogans. Lange, playing on the ideal of people being 'free as air', depicted a garage air pump, marked 'Air', on which had been chalked, in crude letters: 'This is your country. Don't let the big men take it away from you.' (This internal captioning aspect of FSA photography was also evident in the work of FSA contemporaries, such as John Gutmann.)

One of the finest of Evans's FSA images is his 1935 *Coal Miner's House, Scott's Run, West Virginia* (illus. 83). It depicts certain items of the house – an upended broom, a bent wooden rocking chair and, less noticeably, a crowbar – against an interior wall of the house which has been decorated with large advertising hoardings, including a Father Christmas Coca-Cola sign. Many viewers may be tempted to read the picture sociologically, as a set of social indicators: the crumpled cushion,

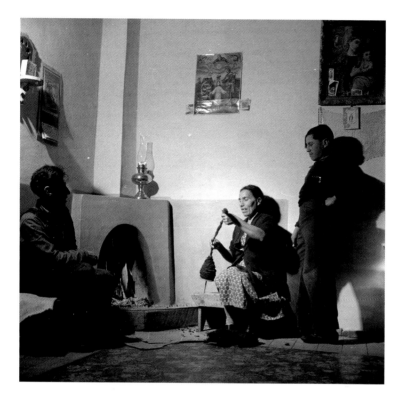

82 John Collier, *Trampas, New Mexico*, 1943; modern print from nitrate negative. A file note reads, in part: 'The temperature drops way below zero in winter, and all social life takes place around the fire. An evening scene in the home of Juan Lopez, the majordomo (mayor).'

the broken linoleum, the walls and ceilings patched and insulated with card from cardboard boxes – all these speak of poverty, even desperation. On the other hand, the broom, certainly the chair, even the crowbar, are beautiful functional objects, testimony to the skills of human hands. Some viewers will be likely to sense a symbolic overtone in the photograph: the Santa Claus figure (then recently appropriated by Coca Cola to signify its brand) seems to stand for a level of comfort and joy that is evident nowhere in the fabric of the house and, further, the other advertisement, showing a couple in academic gowns above the words 'BUY GRADUATION GIFTS HERE', hints at opportunities that the miner's material resources could not possibly purchase for his children. It is somewhat less easy to discern that these potentially conflicting readings – and doubtless others – are available because of the picture's collage-like two-dimensionality: it both offers the illusion

83 Walker Evans, *Coal Miner's House, Scott's Run, West Virginia*, 1935, silver print.

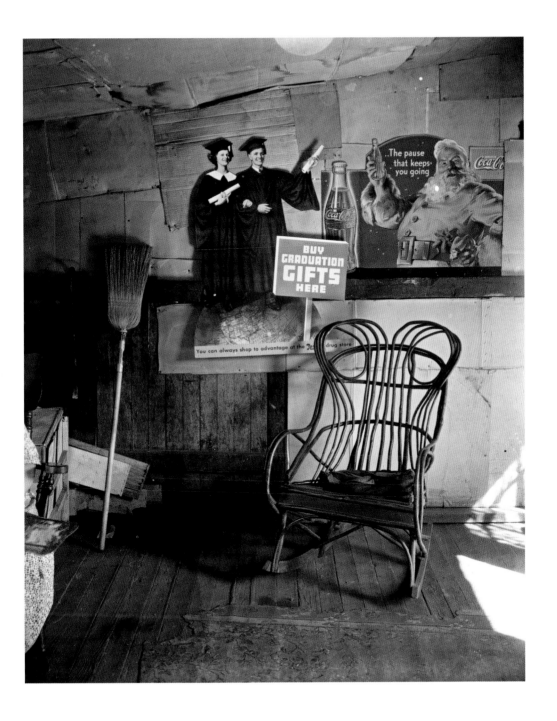

of depth (connoting *reality*) and denies it (by seeming to be a flat and somewhat bizarre *picture*).

Courthouses, Monuments and Ruins

After the demise of the FSA the notion of repeating its comprehensive undertaking did not die, but it proved more of an inspiration than an actual model. The Historic American Buildings Survey, which still flourishes, was founded as early as 1933 by the federal National Park Service (NPS) to collect measured drawings, written reports and, of course, photographs. In 1969, in association with the American Society of Civil Engineers, NPS established the parallel Historic American Engineering Record (HAER), and this endeavour has produced a very extensive file of images, predominantly photographs, many of them depicting National Monuments administered by the NPS, such as the Statue of Liberty (frontispiece). HAER holdings, like the FSA files, are housed at the Library of Congress. Perhaps the closest 'rival' to the FSA was the Court House Project. Funded (on a very lavish scale) by the whiskey manufacturers Joseph E. Seagram & Sons, Inc., directed by Phyllis Lambert and Richard Pare, and involving 25 photographers, the Court House Project was one of the biggest architectural photographic enterprises ever undertaken. It was started in September 1974 with the intention of photographing a large proportion of the county courthouses in the USA; by 1977 more than a third of the 3,043 buildings had been covered, thus creating a file of over 8,000 images and accompanying research correspondence, all of which were transferred to the Library of Congress as the project wound itself up. In 1978 a travelling exhibition based on the project began to circulate and the book *Court House* appeared, complete with essays by the directors, by two architectural historians and by a Massachusetts Supreme Court Justice.[14] For Seagram, it supported their production and marketing of a tasteful and matured product – one that, with due appreciation, could be at the centre of the nation's communal life.

The project made a fine record of buildings – many of them lesser-known ones – by such major American architects as Henry Hobson

Richardson, who had very nearly established a national style in the late nineteenth century, and Frank Lloyd Wright. It brought to notice numerous buildings of architectural merit and interest in regions, such as Texas, which until then had been virtually ignored by architectural historians. And, because of its scope, it documented both the diffusion and limitations of certain styles, such as the Neoclassic. Unlike state buildings – state capitols, governors' mansions, etc. – county courthouses were vernacular: they were built by people whose reference point was as local as the next county. Consequently, there was tremendous

84 Stephen Shore, *Greene County court house, Eutaw, Alabama*, mid-1970s, Type C print.

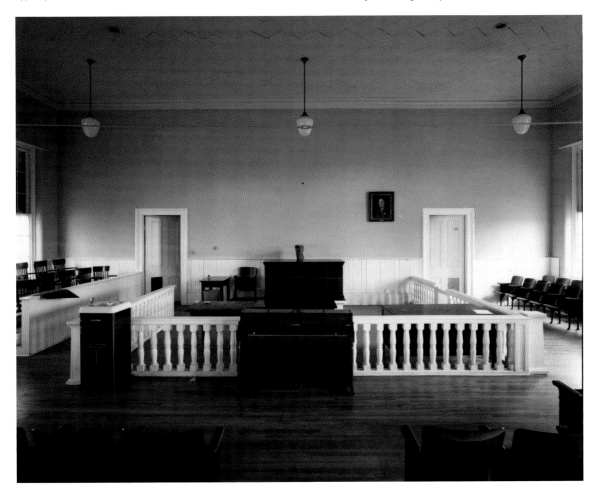

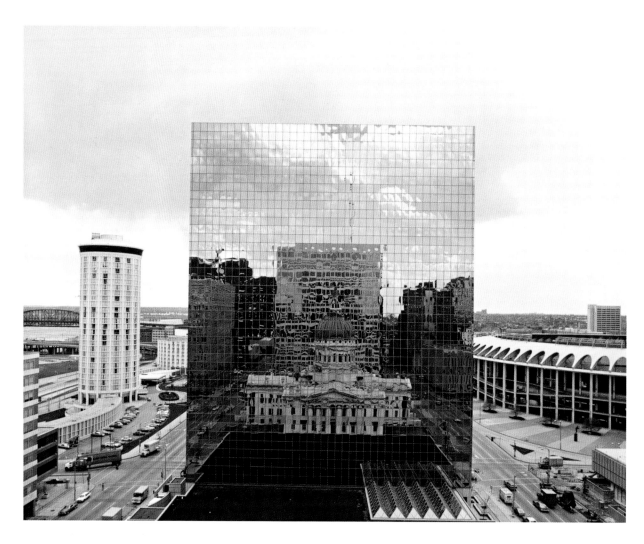

diversity in style and size. These buildings – with their land records, war memorials, registers of vital statistics, trial proceedings – were and are a monument to the particular aspirations, the economic status and the aesthetic sense of local people at specific times in their history. The photographs, therefore, often evoke such matters as, on the one hand, the persistence of sectionalism or, on the other – in the rejection of the Gothic style, for instance – a virtually national belief, associated with

85 William Clift, *Old St Louis County Courthouse reflected in the Equitable Building, St Louis, Missouri*, c. 1975, silver print.

the u.s. Constitution's separation of church and state, in the need to repudiate ecclesiastical associations in civic affairs.

Because the photographers captured courthouse exteriors, even views from the steps, windows or domes, the pictures register in many cases the post-Second World War decay of inner-city areas; in some of them the courthouse looks lost or abandoned. In other instances, an old courthouse is surrounded by expensive and beautiful commercial buildings; clearly it has retained its legal function while losing its civic or social role. Then again, of course, in numerous small towns it is possible to see that the courthouse was and is the *only* building with any distinction, the thing which makes this town stand out from a thousand others across the Republic.

Architectural photography presents problems of its own, and the photographers commissioned by the project – some of them veterans like Paul Vanderbilt, most of them young and just emerging into prominence at the inception of the project – attempted to solve them in ways most appropriate to themselves. Stephen Shore, for example, took numerous very still exteriors (and interiors) devoid of people, which nevertheless, in their rich colour and/or significant detail, reveal the human imprint of the buildings' users. On looking into his representation of the courtroom in the Greene County Court House in Alabama, for instance, the viewer will see, in its symmetrical arrangement, the quiet formality of the room, and may well also feel that a familiar drama is about to begin (illus. 84). William Clift had, perhaps, the talent with the best range for the project, and produced both marvellously atmospheric views of exteriors of relatively undistinguished buildings and sharply focused details, whether a particular cast-iron design, one bend in a well-crafted stairway or the display of cereal products exhibited in Bent County Court House, Las Animas, Colorado. His juxtaposition of the old and the new in his photograph of the St Louis County Court House reflected in a glass-walled modern business building is particularly striking.

A comparable enterprise that was much less reverential towards its subject-matter was Lee Friedlander's dozen years of work – almost haphazard at first – towards his large-sized portfolio *The American*

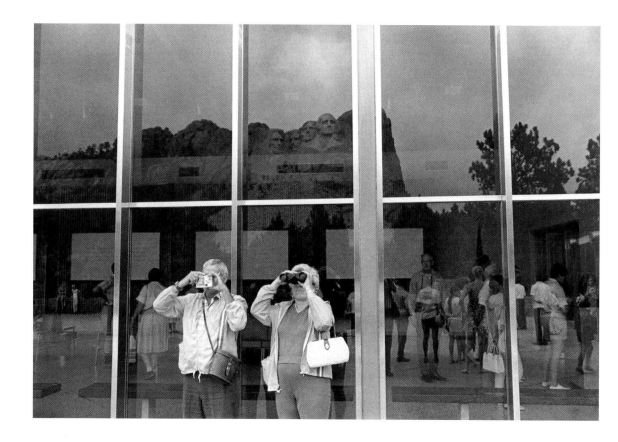

Monument. Brought out in 1976, the bicentennial of American independence, it was not intended to be documentary as such and was published by the Eakins Press Foundation, which had been established specifically to make available high-quality art that might not otherwise have escaped the studio. The folio printed 213 images selected from several thousand negatives made by Friedlander all over the United States, and constituted his 'memorial in photographs to the American Monument'.[15] There are statues of First World War doughboys, repetitive yet individual, from various parts of the nation; monuments to striking personalities in all walks of life, from a stone effigy of theatre impresario George M. Cohan idling in Times Square, New York, to Mary Dyer, Quaker, in Boston, to theosophist Emmanuel Swedenborg in Chicago, to cowboy film star Tom

86 Lee Friedlander, *Mt Rushmore, South Dakota*, 1969, gelatin-silver print.

Mix, his lonely horse silhouetted against the sky, near Florence, Arizona; replicas of Liberty erected by local Boy Scout troops; alarmingly varied versions of national heroes, especially Lincoln; the frieze to Robert Gould Shaw and the first black Volunteer Regiment that lay behind Robert Lowell's poem, 'For the Union Dead' (1964); monuments to firemen, ambulance personnel, school children, sailors, Elks, Justice and the Pony Express; numerous lone Confederate and Union soldiers; and set pieces from the Vicksburg and Gettysburg Civil War battlefields.

Many of these are seen head-on, but in the case of others, there is the definite air of humour or irony that we might expect from the man who had earlier presented strangely disturbing portraits of himself and pictures of trees so arranged that we witness not the orderliness of the natural world but a chaos of twisting branches, threatening twigs, or – in the case of *Yuma, Arizona* (1970) – a lone tree which seems about to invoke a dust storm.[16] For example, Father Duffy, the jingoistic Catholic chaplain to New York troops in the First World War, is depicted with the frame sufficiently enlarged to encompass the enormous Coca Cola sign and the fractured parts of other advertisements with which he is incongruously forced to share space in Times Square. Gutzon Borglum's enormous carvings of Lincoln, Jefferson, Washington and Theodore Roosevelt on the face of Mt Rushmore are presented as reflected from the plate glass of the viewing area below, with an overweight tourist couple occupying the foreground, oblivious of Friedlander's camera as they peer through binoculars and photograph the mountain. In such imagery, it is as if Friedlander was following the classic novelist Robert Musil in his much-quoted judgement that 'the main function of a monument is not to be noticed'. *The American Monument*, like the other visual documents treated here, is both a record and a vision.

New York's World Trade Center, as may be seen in the frontispiece to this book, was a proud structure – for many years the tallest in the world – that was always noticeable; and, if not before, when it was destroyed by Al Qaeda terrorists on 11 September 2001, it became a monument. The photographer Joel Meyerowitz, who enjoyed a reputation as a critically and commercially successful photographer – his *Cape Light* (1979) sold over 100,000 copies, an astonishing figure for a collection of photographs

– set himself the task of documenting the initial clearance and rehabilitation of what became known as 'the pile' at Ground Zero (illus. 87). In interviews Meyerowitz has spoken of himself as a 'street photographer' and, ahead of other serious art photographers, he espoused the superiority of colour over black and white for street work. 'Street photography' might conjure images of quickness, the unexpected and the capture of people taken off-guard, and some of Meyerowitz's work could be thus classified. But, more often than not, the surprise lies in how steady and 'natural' what is depicted seems, and this may be due to his frequent use of a large view camera. It is as if the subject-matter had a latency that needed only the exposure to complete. Also, his interest in archetypal architectural forms, such as the arch or the column, and in the way the fall of light on different planes almost abstractedly separates out and differentiates shades of apparently the same colour, gives his work a look of studious stillness.[17]

The destruction of so many people who were just going about their business, and the razing of the two towers in such a tremendously dramatic manner, was obviously traumatic, and the perception that the attack had national and international significance led to almost immediate calls for various kinds of commemoration. Meyerowitz was most concerned about the site itself and believed that it must be closely monitored. In interviews, claiming to have been inspired by the work of the FSA, he said that without photographic effort 'there would be no history', and he spent nine months, by both day and night, working at Ground Zero and its environs. He funded himself, to the tune of a quarter of a million dollars, believing that his outlay in the making of what turned out to be over 8,000 images would eventually be recouped by commemorative exhibitions and sales of prints. At the outset he was granted moral support by the Museum of the City of New York and, during the process, as the only photographer with a pass to Ground Zero, he earned the patronage of the NY Police Department Arson and Explosion Squad who, as readily as the Museum, understood the need for documentation of the securing, clearing and cleaning – and healing – of the site. He and his assistants periodically published some of his results in *The New Yorker* and other magazines, and more sponsorship came his way. He photographed many of the 800-odd people who worked

on the site, whether emergency service personnel who struggled with acknowledged heroism in the early stages, to crane operators, welders and other construction and demolition staff in later stages, and with all the attendant service employees and volunteers who worked throughout to complete the task.

Aftermath: World Trade Center Archive (2006), Meyerowitz's book collection, is arranged chronologically, following the sequence of work and his involvement with it. It is important to note that the book's pictures are interspersed with written text: brief profiles of people

87 Joel Meyerowitz, *The Ground Zero site from the World Financial Center, Looking East*, 2001, colour print.

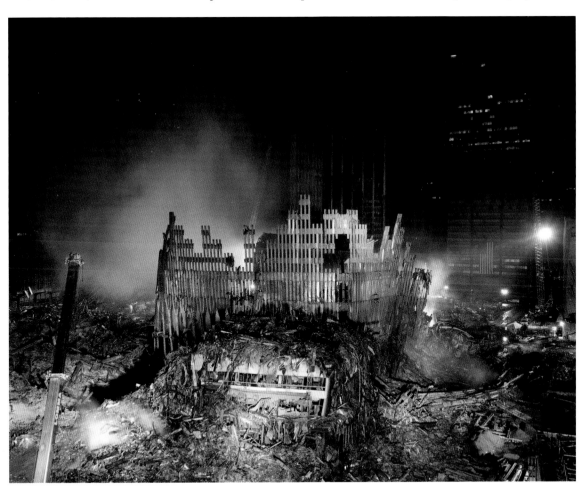

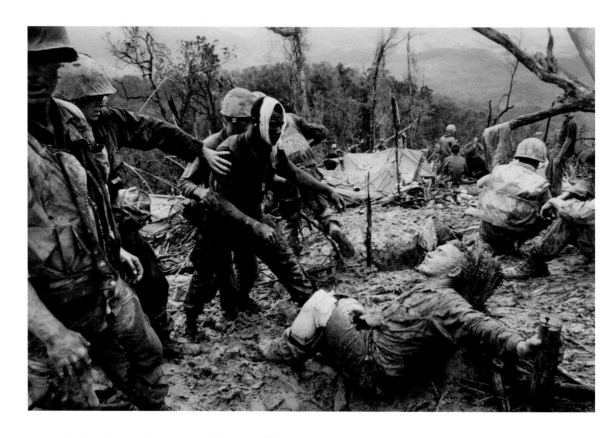

depicted; descriptions of processes of burning, lifting, shoring and
digging; anecdotes of Meyerowitz's own experience, such as feeling
the residual heat of the metal through his boots weeks after the attack.
Stylistically, the images are congruent with Meyerowitz's work in *Cape
Light* and subsequent projects, yet charged with drama: panoramas of
sublimely immense tangles of ruin, some with spray and smoke, a clutch
of workers with bright plastic bags full of dollar bills retrieved from the
rubble, a lone tree stump amidst bareness. There is a humanist surreal-
ity to these images somewhat reminiscent of the most striking Vietnam
War photography, such as Larry Burrows's image for *Life* of confused
and wounded soldiers in a barely held outpost. Peter Conrad, in a per-
ceptive short essay on *Aftermath*, pointed up its undoubted if perhaps
only partly conscious visual references to the iconography of Arma-
geddon, very evident in the blasted twistedness of the metal forms in
'The Ground Zero site from the World Financial Center, looking east'.[18]

88 Larry Burrows, *'Operation Prairie' in
Vietnam*, 1966, colour print.

But the totality of *Aftermath*'s impact is somewhat different. Between 2002 and 2005 the U.S. State Department funded foreign showings of an exhibition of a small selection of its images to help convey to the world the scale and shocking effect of the attack, but also the nation's essential resilience and concern for individuals. The exhibition was able to have this dual effect mainly because of the presence of the many images Meyerowitz made of the impromptu signs displayed near the Ground Zero site, such as the handmade banners on the fence at St Paul's Chapel: the admonition 'Courage' over a roughly painted star; a quotation from the Psalm 'WEEPING MAY REMAIN FOR A NIGHT BUT REJOICING COMES IN THE MORNING'; or the crudely appliquéd 'ASPIRE and PERSEVERE'. One

89 Joel Meyerowitz, *Hand-made Banners on the Fence of St Paul's Chapel*, 2001, colour print.

image frames two banners that, in themselves, seem hugely symbolic: the word 'GRACE' and the face of Liberty (illus 89).

Despite their differences, in all the projects sketched here there was an urge to document areas of American life, some of them perhaps otherwise insufficiently regarded, to create an undeniable record. Each also inevitably represented broader cultural assumptions and features of its time. And they did so, if to differing degrees, with a consciousness of the artistic potentialities of the medium. This consciousness constitutes both the context and the subject of the chapter to follow.

four
Emblems

Symbolism and Subversion

All countries and cultures, just as they have their myths, possess visual symbols, created in tandem with their unfolding histories. The USA, probably because it was 'the first new nation', as Seymour Martin Lipset observed, with a need to emblazon itself upon the world and upon the minds of its citizens, is especially rich in widely appreciated patriotic symbols: Liberty (illus. 1), Columbia, Uncle Sam and, if with heavy irony for indigenous people themselves, the befeathered Indian (illus. 76).[1] Particular structures, such as Brooklyn Bridge, the Empire State Building and the canyon-like cleft of Wall Street in New York City, the Capitol, the White House and the Washington Monument in Washington, DC, and the letters for 'HOLLYWOOD' above the freeway on the hills outside the Los Angeles 'dream factory', are just some of the metonyms for the nation. Others are certain natural landmarks – Niagara (illus. 90), Yellowstone's Old Faithful geyser, Yosemite Valley (illus. 63) – still others talismanic sites and objects such as Plymouth Rock on the Massachusetts coast, the Liberty Bell in Philadelphia, the Alamo Mission fortress in San Antonio and the bald eagle wherever. Presidential faces have had enduring currency, and not only on banknotes, as have the stars and stripes of the flag (illus. 5).

The flag has featured in ceremonies asserting nationality and has been at the centre of photographs of such ceremonies, as in one by an unknown photographer purporting to depict *New Citizens Taking the Oath, Deadwood, South Dakota*, made in the 1890s (illus. 91). This image is more than a record of something that would have occurred without it. Judging

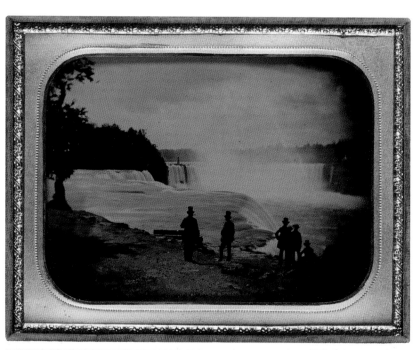

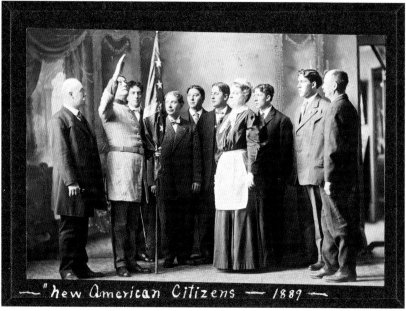

"new American Citizens — 1889 —

92 President George H. Bush delivering a speech on the meaning of the U.S. flag at the Iwo Jima memorial, 1989, by White House photographer David Valdez; colour print.

90 Platt D. Babbitt, *Niagara Falls*, c. 1860, collodion positive print.

91 Unknown photographer, *New Citizens Taking the Oath, Deadwood, South Dakota*, c. 1890, albumen print.

by the military man's outstretched arm salute, which was prescribed by its originator, Francis Bellamy, what we see here is the Pledge of Allegiance to the flag, first performed in 1892. The photograph, so obviously posed, was probably intended to demonstrate that the Pledge had reached the frontier region of South Dakota. Visitors to the USA frequently express surprise at the sheer number of flags, not just fluttering from government buildings but from private business premises and innumerable ordinary homes. For this very reason, the patriotic significance of 'old

133

glory' may be easily subverted, as it was, for example, in the many press pictures of an elderly African American woman, otherwise thoroughly abandoned by her government after hurricane Katrina in 2005, wrapped in it for warmth.

Needless to say, in keeping with its constitutive role, photography has been a major factor in the recognition and diffusion of all such symbols – and one of them, the huge Arlington bronze memorial, was actually sculpted by Felix de Weldon *from* a photograph: Joe Rosenthal's iconic image of marines raising the star-spangled banner on Mount Suribachi, when Iwo Jima island was retaken from the Japanese towards the end of the Second World War (illus. 92).[2] Another extraordinary interaction – which also, and not coincidentally, had the unavoidable patriotism of war as context – was the dynamic work of Arthur Mole and John Thomas.

During and just after the First World War, in a series of spectacular and carefully staged performances, they made 'living' portraits and emblems – *Living American Flag* (1917), *Living Portrait of Woodrow Wilson* (1918), *The Human U.S. Shield* (c. 1918), *Human Statue of Liberty* (1919) – in which thousands upon thousands of individual bodies, often troops, were arranged to create for the camera – raised high above them on a cleverly constructed platform – a tableau of the desired representation. A notion of 'community' was evoked in a double sense: the viewer, if suitably dazzled, knew that countless individuals could be discerned but saw them instead as melded into the larger whole that literally stood for the even greater whole of a national symbol or, even, the nation itself. At the same time – as Louis Kaplan has shown in one of the few discussions of these emblems – once ossified as image their 'life' resided in their symbolism, as such, at the expense of the actual breathing bodies conscripted into service.[3] Like elaborate dance routines or – if we make a more extreme and political comparison – like panoramic military tattoos, especially those staged by the Nazis, they ultimately tend to eradicate democratic rights and the will of the persons involved.

While few others of photography's representations of, and interactions with, national symbols are as spectacular as the efforts of Mole and Thomas, this book could have been constructed purely out of them.

Let me offer just a few examples from the 1950s and '60s. Elliott Erwitt, sent to Moscow in 1959 by the Westinghouse Corporation to cover a U.S. industrial fair, was fortuitously there for the famous 'kitchen debate' between Vice-President Richard Nixon and Nikita Khrushchev in which, gesturing at items in a model kitchen laid on by Macy's department store, Nixon miniaturized the Cold War by crowing about the superior standard of living achieved by capitalism in comparison with the meagre offerings of the Soviet regime (illus. 94). One frame of Erwitt's sequence, with Nixon very close up, in heavily jowled profile, so filled the front

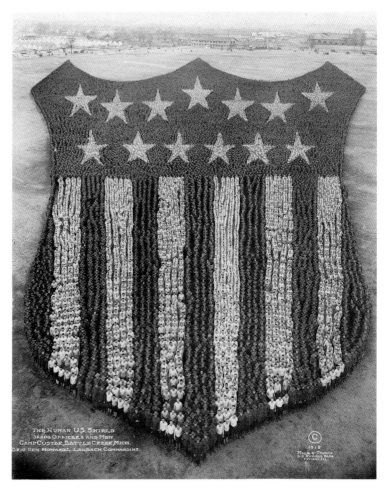

93 Arthur Mole and John Thomas, *The Human U.S. Shield*, c. 1918, albumen print. This tableau deployed 30,000 officers and men at Camp Custer, Battle Creek, Michigan.

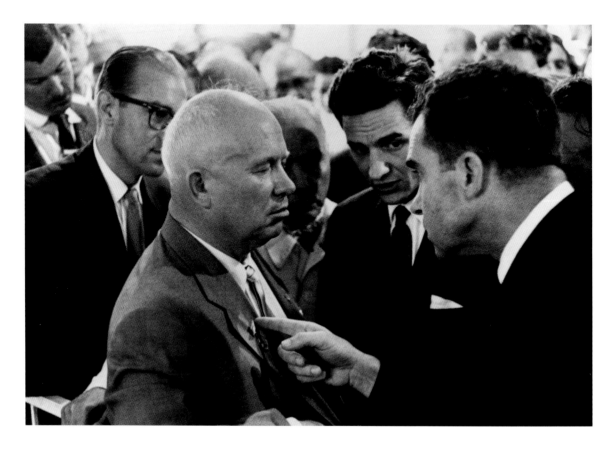

pages of newspapers that Nixon subsequently used it as a campaign
picture when he ran against John F. Kennedy for the presidency the
following year.[4]

 Because JFK's term of office was so brutally cut short, several images
of him have, of course, become iconic; one that communicates his promise,
perhaps more so in retrospect, is Jerome Liebling's glimpse of him at a
quiet moment on the campaign trail. More dramatically, Robert Jackson
caught the instant of the actual shooting, by Jack Ruby, of JFK's assassin
Lee Harvey Oswald. Towards the end of the decade, after the assassination
of JFK's brother Robert during his bid for the presidency, Paul Fusco took
a sequence of images, moving in every sense, from Robert's funeral train,
of the people – many of them evidently very poor – who waited and stood

94 Elliott Erwitt, Nixon's 'Kitchen Debate'
with Khrushchev, Moscow, USSR, 1959,
silver print.

95 Paul Fusco, *RFK Funeral Train*, 1968, colour print.

by the railroad tracks in respect. Fusco's project has a power not apparent in just one reproduction. It is not exactly cinematic – in that, although we sometimes see blurred movement at the sides of the images, each shot is a still salute – but it has a cumulative effect.[5]

Bruce Davidson's work was more laconic and ironic, especially the Harlem pictures collected in *East 100th Street* (1970). This book included a picture of an apartment wall with a portrait of JFK, honoured with homely decorations, juxtaposed against a window that opens onto a devastated empty lot; the little girl sitting on the window ledge is semi-naked, innocent, vulnerable, yet obviously lacking the future that the revered and decorated portrait symbolizes. This photograph is reminiscent of, and has a similar feel to, Robert Frank's *Parade, Hoboken, New*

Jersey (1955), where the star-spangled banner obscures the face of an anonymous woman standing in a window, failing to see out. This image appeared in the celebrated book of Frank's pictures, *The Americans* (1959), a highly personalized view of the country, from quiet courthouse squares in small towns to hostile teenagers, from segregated buses to a brass band at the 1956 Democratic Party convention.[6]

This final chapter is ultimately as much concerned with ways of seeing as with subject-matter as such, so I plot a course through a selection of photographs that, for the most part, are acknowledged works of art. The course is set by three coordinates: the straight tradition (which was frequently reinforced by literary interventions), disturbances of that tradition and, as so far, the potency of national visual symbols.

In the American Grain?

Much photography made in the USA may be construed, specifically, *as* American. In the Introduction we noted that – in accord with the arrival of the nation as a superpower – the post-Second World War era saw a proliferation of projects in pursuit of the Americanness of U.S. society and culture. There was an earlier episode of emergent cultural nationalism during the opening decades of the twentieth century, a search for what critic Van Wyck Brooks at the time dubbed 'a usable past', meaning a tradition that could orient the present. This episode witnessed the appearance of a number of books with such titles as *The American Spirit in Literature*, *America's Coming-of-Age* and the like. The poet William Carlos Williams coined the phrase 'in the American grain' to label his own contribution to the search. Though Williams was alert to photography, included such practitioners as Paul Strand and Charles Sheeler among his friends and later wrote appreciatively of the 'straight puritanical stare' in Walker Evans's *American Photographs*, his *In the American Grain* (1925) traced the genealogy of mainly written forms of cultural expression. The parallel in photography, as recognized by photography curator Terence Pitts among others, was the so-called 'straight tradition'.[7]

Straight photography had its intellectual roots in the Transcendentalist philosophy of Ralph Waldo Emerson (illus. 24), who famously urged his readers to abjure priests and other teachers, to seek their own 'original relation' with the universe. '*Right* means *straight*; *wrong* means *twisted*', he said. Being straight had thus both a moral and an aesthetic basis, and this conjoined connotation was carried over into photography.[8] The straight approach had its material antecedents in much plain 'record photography' of the nineteenth century, such as Platt D. Babbitt's considered view of Niagara (illus. 90), but its recognition by name was more circuitous.

From the beginnings of photography in the USA, some Americans had appreciated that the new means of communication could become a major aesthetic form. The first clearly acknowledged artistic achievement was that of the portrait makers, of whom the best known was the prolific Mathew Brady. At about the same time, in Boston, the studio of Southworth and Hawes was producing equally distinctive work. In 1850 they made, for instance, both a tender view of an anonymous young woman seeming to study the exemplary features of George Washington depicted in a painting behind her and, as we have seen, a sensitive study of Hawaiian visitors (illus. 15). The same year, they caught Harriet Beecher Stowe in a surprisingly diffident pose, and in 1851 they produced a suitably imposing portrait of the Massachusetts Chief Justice Lemuel Shaw, novelist Herman Melville's father-in-law. Very many other major American doers, thinkers and writers of the nineteenth century – from John Quincy Adams, president, and Edgar Allan Poe, poet and genre writer, through Asher Durand, painter, and Lewis Cass, politician, to Frederick Douglass, escaped slave and Abolitionist leader – sat for notable portraits, not only in the studios of Southworth and Hawes. Even reclusive poet Emily Dickinson and shy novelist Nathaniel Hawthorne submitted for their likenesses. Hawthorne was so fascinated that he made a daguerreotypist, Holgrave, one of the chief characters of *The House of the Seven Gables* (1851). 'While we give it credit only for depicting the merest surface', Holgrave says, 'it actually brings out the secret character with a truth that no painter would venture upon, even could he detect it'.[9]

Walt Whitman – as already implied – had a heightened camera consciousness. On the one hand, he could complain to Horace Traubel, 'I have been photographed, photographed, photographed, until the cameras themselves are tired of me'. On the other, remembering trade fairs he had seen, and in anticipation of the Philadelphia Centennial Exposition of 1876, in his 'Song of the Exposition' (1871) he allocated photography (both image and commodity) the prime position in one of his lists: 'The photograph, model, watch, pin, nail, shall be created before you.' He famously used a photograph of himself as the imprimatur and signature for the first edition of *Leaves of Grass* (1855). He titled a gathering of his Civil War prose sketches 'City Photographs', and so often his poems were overtly built on a series of exact visual impressions; for example, 'Sparkles from the Wheel', or 'Cavalry Crossing a Ford', with its 'Behold the brown-faced men, each group, each person, a picture', as if individually framed by the camera. Whitman frequently called for the rise of American artists capable of recording scenes that he himself was witnessing on his travels. Photographic artists were soon to take up the challenge, if implicitly rather than consciously, and later Edward Weston's camera illustrations to *Leaves of Grass*, gathered on Weston's commissioned journeys across the nation in the late 1930s, may be seen as one of the fullest twentieth-century responses to it.[10]

Other photographers revelled in this interaction with literature. Alvin Langdon Coburn pointedly followed directions from Henry James when he produced the pictorial frontispieces for the novelist's New York Edition. He also made autochrome studies of celebrated authors; the one of the elderly Mark Twain is obviously rich in pattern and colour, but these design elements do not detract from the characterization of the now-frail figure, partly through the objects in his hands, as both writer (the book) and sociable performer (the pipe). For the first two decades of the twentieth century Herbert Gleason meditated visually over Henry David Thoreau's Walden Pond near Concord, Massachusetts, and over other settings for Thoreau's own mid-nineteenth-century meditations on nature and life. Ansel Adams's first book was a collaborative project with novelist and poet Mary Austin, *Taos Pueblo* (1930), dedicated to one of the oldest Native American communities in the USA. Evans's

96 Alvin Langdon Coburn, *Mark Twain*, 1908, autochrome print.

first published photographs, of Brooklyn Bridge, were for Hart Crane's long poem *The Bridge* (1930).[11]

Southern fiction writer Eudora Welty wielded a camera for the New Deal's Works Progress Administration, just after she began to write. Poet Elizabeth Bishop was a gifted amateur photographer. Though her images remained largely unstudied, even unknown, until very recently, during the 1960s she planned to deploy selections of them as illustrations in one of her own prose works on Brazil, where she lived for many years. One

of her pictures depicts author Aldous Huxley and his wife Laura with Amazonian Indians. We cannot help but notice the nakedness of the Indians, but this is no conventional view like so many *National Geographic* images, in which nudity spells 'primitive'. Rather, it is notably free of such exoticism. We note Laura's camera; we may well be aware of her husband's disablingly poor eyesight and his many writings on perception; and these factors may lead us to deduce that this seeming snapshot may really be in part *about* looking.[12] And, as we have registered, Wright Morris made actual photo-novels (illus. 13).

In the 1940s, Helen Levitt – like Evans before her – planned a book with James Agee, and was able to deploy his perceptive essay posthumously in her collection of New York snapshots *A Way of Seeing* (1966). One of the things Agee picked up on was her frequent depiction of handwriting – kids' chalk marks, graffiti and other vernacular signs. Richard Avedon used the texts contributed by his writer friends Truman Capote and James Baldwin in selections of his celebrity portraits. Art Sinsabaugh made huge 'horizontal' shots of Midwest prairiescapes, most notably as his counterpoint to a 1964 publication of some of Sherwood Anderson's *Mid-American Chants* (which originally appeared in 1918). In 1999, Jeff Wall staged a photographic recreation of the underground chamber, powered by light stolen from the power company, inhabited by the un-named narrator of *Invisible Man* (1952), Ralph Ellison's symbolic novel of African American identity. Perhaps best known of all, from a photographic viewpoint, is Robert Frank's *The Americans*, with its accompanying free-form text by Beat writer Jack Kerouac.[13]

Though the inspiration of literature proved persistent, a fuller association between photography and painting was inevitable. For a start, painting seemed to provide a ready-made vocabulary. Some of its generic categories – most obviously landscape and portraiture – could be readily extended to contain the products of the newer medium. In fact, some nineteenth-century landscape photographers, including Carleton Watkins, influenced – and were overtly influenced by – landscape painting, especially works by members of the early native movement the Hudson River School. This was pointedly so in the work of John Moran and Charles Bierstadt. Moran was brother to the more famous Thomas Moran, the

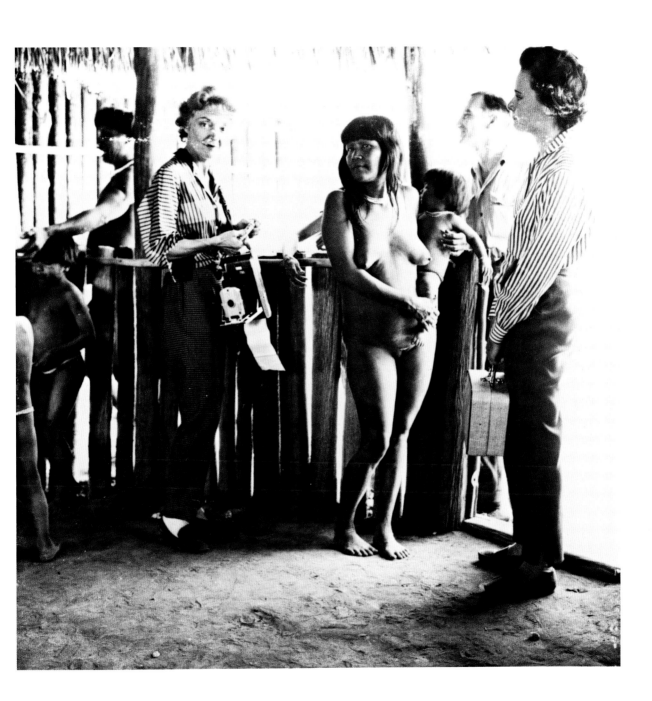

painter who accompanied photographer William Henry Jackson on Ferdinand V. Hayden's first survey, of the Yellowstone in 1871. Charles Bierstadt was painter Albert Bierstadt's brother and his widely circulated views of Niagara Falls may be profitably compared with Frederick Church's paintings of this sublime and nationally emblematic site.[14] However, such interaction between painting and photography seemed to some people to make the new art subordinate to the older, more respectable medium, to deny the legitimacy, even the possibility, of art photography developing values, techniques and qualities of its own. Even more important, though, was the perceived need to break the attitude that photography was merely concerned with the accurate recording of the world around, and to destroy its subservience to everyday practical – and, of course, commercial – uses.

The first American movement in art photography was the Photo-Secession, which began in 1902. As its name implies, it constituted a revolution in a number of ways. For its founder, Alfred Stieglitz, it was partly a declaration of independence from the group of largely amateur photographers who dominated the New York Camera Club (whose journal he edited) in favour of the full-time professional pursuit of photography. To some extent, it was analogous to the British Linked Ring, which, founded in 1893 (and including Stieglitz among its membership), stressed the 'brotherhood' of photographic artists. Like the painters and photographers of the German-speaking world who in their revolt against the Academy formed the Secession in 1898, Stieglitz wanted photography to be treated as one of the fine arts. To this end, he also founded the quarterly journal *Camera Work* (1903–17), which became one of the most influential little magazines the U.S. has produced. Besides cultural commentary, literary incursions by such avant-garde figures as Gertrude Stein and reproductions of drawings and paintings, it published photogravures by established members of the group, including Gertrude Käsebier and Clarence H. White, by major Europeans such as Frederick H. Evans and, crucially, by newcomers including, in its final issues, Strand. Edward Steichen's *Flat Iron Building* (illus. 55) first appeared in its pages. It also printed critical articles by emerging theorists of the medium, notably Charles H. Caffin and Sadakichi Hartmann.[15]

Equally important was the establishment by Stieglitz, with Steichen's assistance, of 'the little galleries of the Photo-Secession' (1905–17) at 291 Fifth Avenue (later simply '291'). Here, not only were there major photographic exhibitions, but shows of work by artists (often innovative ones) in other media: Rodin, Marsden Hartley, John Marin, Matisse, Max Weber, Picasso and Brancusi. In other words, it paralleled and reinforced the trends leading towards the liberation of American attitudes to art represented by the landmark 'Armory' show of 1913. The kind of photography favoured by Stieglitz – indeed, exhibited by him at 291, at the major shows he organized in 1909 and 1910, and at his later venues, The Intimate Gallery (1925–9) and An American Place (1929–46) – underwent a subtle but profound change in the course of his long career. At first he was concerned to champion 'pictorial photography', by which was then meant photographs which had no advertising, commercial, social or informative purpose, but were complete unto themselves as pictures. Early on this inclined towards what one critic called 'a protest against the niggling detail, the factual accuracy of sharp all-over ordinary photography'. 'Concentration, strength, massing of light and shade, breadth of effect', he continued, 'are the highly prized virtues'.[16] Sometimes this led to deliberate blurring at the printing stage, or even – in the case of Stieglitz's friend Frank Eugene and others – to the use of pencil and paint on the negative. In effect, this 'pictorialism' once more marked the assimilation of photography towards painting.

But, despite Stieglitz's love of painting and his desire for the highest artistic status for photography, his deepest instincts led him in his own practice to become what Caffin termed 'an exponent of the "straight photograph", working chiefly in the open air, with rapid exposure, leaving his models to pose themselves, and relying for results upon means *strictly photographic*'. Increasingly Stieglitz came to value those photographs – such as his own patterned and balanced view of some of a ship's complement of passengers in his well-known *The Steerage* (1907) – which proclaimed themselves as un-manipulated photographs rather than imitations of paintings, however lovely. In views from the window of 291, in studies of the hands of his second wife, painter Georgia O'Keeffe, in a series of cloud pictures he called 'equivalents' (illus. 98), he moved

towards an expression and evocation of emotion strictly through the formal properties of organic and man-made objects as framed by the camera. *Music No. 1* is literally more grounded than those of Stieglitz's 'equivalents' that show only clouds, which are so nebulous by nature; we have the house and the skyline, but even with these, as in listening to the abstractions of music itself, an act of imagination is called for. In essence, we try to identify within ourselves the appropriate equivalent response.[17]

98 Alfred Stieglitz, *Clouds, Music, No. 1, Lake George*, 1922, palladium print.

Straight Ahead

The cultural historian Lewis Mumford, as early as 1934, saw that Stieglitz, if not quite single-handedly, had established 'straight photography' as *the* mode for the contemporary era:

> If photography has become popular again . . . it is perhaps because, like an invalid returning to health, we are finding a new delight in being, seeing, touching, feeling; because . . . we have . . . learned Whitman's lesson and behold with new respect the miracle of our finger joints or the reality of a blade of grass: photography is not least effective when it is dealing with such ultimate simplicities For photography, finally, gives the effect of permanence to the transient and the ephemeral . . . perhaps photography alone . . . is capable of . . . adequately presenting the complicated, inter-related aspects of our modern environment . . .

Mumford linked Stieglitz's achievement to a broad conceptualization of the medium as sketched in the Introduction here:

> And this art, of all our arts, is perhaps the most widely used and the most fully enjoyed: the amateur, the specialist, the news-photographer, and the common man have all participated in this eye-opening experience . . . in [the] discovery of the aesthetic moment which is the common property of all experience.[18]

The career of Arnold Genthe, a Stieglitz contemporary, shows it might profit us not to be too rigid in our categories. He was born in Germany, migrated to the USA in 1896 and, before he became a naturalized American in 1918, had already acquired a sizable reputation. His means of livelihood was the portrait studio, in his hands, especially in his earlier years in San Francisco, a kind of photographic salon where the rich, the celebrated – and, of course, the talented – came to converse and to sit for their like-nesses. He achieved striking studies of such notables as musician Ignace

99 Arnold Genthe, *Fireman's Fight, San Francisco Earthquake*, 1906; modern print from an albumen print.

Paderewski and writer Jack London by capturing them – as he put it in his autobiography – 'in a carefully considered pattern of light and shade', using 'soft tones' at an unexpected moment when he could bring out 'essential features' rather than 'unimportant detail'.[19]

But it could be argued that Genthe's claim to lasting recognition has a firmer base in his work outside the confines of the studio – some of it impromptu, such as his oft-reproduced views of the aftermath of the same 1906 San Francisco earthquake that destroyed his own studio. As his friend Will Irwin remembered, Genthe had earlier frequented 'the shadows and recesses of [San Francisco's] China town', his 'little camera half-hidden', searching out the exotic, more alien aspects of Chinese life

– the seamed face of the merchant with his bodyguard, or 'slave girls', or a line of children each hanging onto the pigtail of the preceding one. Shaemas O'Sheel, who wrote the preface to Genthe's *The Book of the Dance* (1920), which included early colour work, believed that there was no 'arrested motion' in such pictures, 'but motion as it flows and is'. In fact, like the pictures in his *Isadora Duncan* (1929), although they have a flickering, half-seen quality that makes them seem ethereal, these views are rather static.[20]

Genthe's photographs were featured in Stieglitz's 1910 Buffalo exhibition of predominantly pictorialist work, and it is as if his years of collecting Japanese prints and his travels in the Orient gave him a consciously painterly outlook on photography, allowing him to think of it as an art of large masses and delicate tones. By contrast, his earthquake views – houses like leaning towers on Sutter Street, or firemen spraying a building, a great snake of hosepipe almost arbitrarily filling the foreground, or tents seen higgledy-piggledy in a refugee camp – possess a sharpness and a sheer presence that is sometimes lacking in the products of his more avowedly artistic work. But it would be a mistake to think of them as any less deliberate.

In 1932 the straight tradition was immeasurably strengthened by the formation, also on the West Coast, of 'Group f/64', membership of which included Ansel Adams, Imogen Cunningham and, most significantly, Edward Weston. They took that name because they habitually set their lenses at tiny apertures in order to get very detailed images and a high degree of definition over the whole field of vision, something the eye itself cannot do and the pictorialists had deliberately avoided.

In her 70 years as a photographer Cunningham did notable portraits – of *Martha Graham, Dancer* (1931), for instance, or *Gertrude Stein, Writer* (1937), or *Theodore Roethke, Poet* (1959) – as well as landscape, nudes, machines, still-life, indeed the gamut of photographic subject-matter. But perhaps the work most akin to that of other f/64 members, especially Weston, was her *Pflanzenformen*, a series of vibrant plant studies done in the late 1920s. In such pictures as *Black and White Lilies 3* the camera is very close, so that it is difficult to judge scale, and we register texture and almost abstract shapes for their own sake; but we do not mistake the

lilies for other forms. In this respect there is a marked contrast with the ostensibly similar work by Weston, his *White Radish* (1933), for instance, or his earlier *Pepper No. 30*. Much of the power of Weston's images, despite his protestations to the contrary in his journals, his *Daybooks*, seems to lie in their capacity to act as visual metaphors: in the peppers a suggestion of naked human back and buttocks, in the radishes an insinuation of twisted human limbs. In very many of his nudes there are intimations of massive land forms, and in his landscapes hints of

humanity. His camera caught things with such intensity that his photographs seem a seamless series of archetypal images, constituting in their totality a vision of the very structure of the organic world.[21]

Until the dispersal of Group f/64 in 1935, others – including Weston's son Brett – joined them, and the broader straight tradition was thereafter augmented by such documentarists as W. Eugene Smith and by more ethereal practitioners, including Wynn Bullock, Minor White and Harry Callahan. Though he did not identify himself as a conscious member of any group or movement, the photographer most celebrated as an exponent of the straight approach was, of course, Walker Evans. As T. S. Eliot saw with reference to poetry, the past and the future are changed by the present. The values of the straight approach – usually, as here, not expressed with any marked analytical precision – were institutionalized in the photographic exhibitions and publications of New York's Museum of Modern Art, especially as exemplified by the personal imprint of the long-serving photography curator John Szarkowski. Probably the single most influential text was Szarkowski's *The Photographer's Eye* (1966), in which the constituents of a way of seeing unique or distinctive to the camera were enunciated, and almost invariably illustrated by American examples. The book's cover has an image by an unknown American photographer, taken in about 1910, that depicts the interior of a bedroom – decorated, tellingly, with photographs.

Szarkowski emphasized 'the thing itself', concentration on actuality and 'the detail' (perhaps observable only by the camera) that could be made to tell. The photographer's work, he asserted, 'incapable of narrative, turned toward symbol'. Perhaps most obviously, he claimed that 'the frame' determines meaning, in that the relationships between parts of the image within the frame have a force quite separate from any relationship their reference might or might not have had in reality. He stressed the importance of 'time', the manner in which a photograph both attests to the passing of time and, simultaneously, seems to freeze a particular moment. Lastly, he underlined 'the vantage point', perhaps an unexpected one, from which the camera may be made to look.[22]

An image Szarkowski placed in 'the vantage point' section of the book was Harry Callaghan's *Heroic Figure, Chicago* (1961), in which the

102 John Szarkowski's book *The Photographer's Eye*, published by the Museum of Modern Art, New York, in 1966.

otherwise ordinary-looking woman walking in the street does appear 'heroic' – because seen from very low, about knee-height. But he might as well have situated the picture in any other section: the frame has been extended to take in a clock just within the top edge of the picture, which indicates 'time' in general – lunchtime in particular – and imparts a sense of haste to the scene, a sense exacerbated by such details as the odd angularity of the arms of the street light and the jumble of directions being taken by individuals on the crowded pavement. Does the woman, her eyes looking one way, her stride going in another, look anxious? There is no 'narrative', but the viewer is tempted to construct one.[23] Using Szarkowski's criteria, certain images by anonymous figures of the past, such as his chosen cover picture – perhaps taken with no artistic

intention at all – could be honoured, and known but hitherto neglected photographers could be rescued from oblivion. Thus such earlier figures as Hine and Johnston came to be located in the tradition.

The sense that there was indeed a 'tradition' is reinforced by two other factors. First, proponents and practitioners of straight photography frequently referenced the work of their predecessors, as may be registered from just five brief instances from the late 1960s to the '80s. Paul Caponigro looked to his landscapist forebears. His *Reflecting Stream, Redding, Connecticut* recalls Carleton Watkins's studies of water reflections in Yosemite and, given the near-universal association of life as a river, it also pays homage to the overtly symbolic landscapes of Minor White.

103 Paul Caponigro, *Reflecting Stream, Redding, Connecticut*, 1968, gelatin silver print.

Szarkowski, in outlining his sense of the development of the straight tradition during the previous twenty years, might have had this image in mind when, in 1978 – thinking about 'conceptions of what a photograph is' – he asked 'is it a mirror, reflecting a portrait of the artist who made it, or a window, through which one might better know the world?'.[24]

Michael Ormerod, in an untitled study of a broken picket fence, as Geoff Dyer observed, offered – or initiated – a commentary on Strand's innovative and semi-abstract *White Picket Fence, Port Kent, NY* (1916). Robert Mapplethorpe, despite being most celebrated for his subversive images of male homosexual desire and, less frequently, sadomasochism, also produced delicate flower studies akin to those made decades earlier by Imogen Cunningham. William Christenberry sought out Alabama subjects and scenes made special by Walker Evans during the 1930s when he was working towards *Let Us Now Praise Famous Men*. And Sally Mann, in her family photographs, evoked earlier depictions of the body; in *Popsicle Drips*, her view of her son Emmett, she visually recalled Edward Weston's study of the torso of his son Neil (illus. 6).[25]

The second factor reaffirming the sense of a tradition is that, as we have seen, aspects of the output of photographers who may be taken as representative of straight photography bear witness to such abiding themes of American history as those sketched in earlier chapters.

Mixed Modes

Despite the dominance of the straight tradition – and the emphasis of the present book – other approaches did not die out. In 1917, for example, Coburn, abroad in London, made his 'Vortographs' – abstracts deliberately created by photographing common objects reflected by three mirrors clamped together – and he produced some of them by concentrating on the face of his friend the American poet Ezra Pound. Others printed part or all in negative, printed from several randomly superimposed negatives, made double or triple exposures, cropped negatives, engineered composite prints and so forth. In the 1920s the expatriated U.S. citizen Man Ray made his 'Rayographs' in Paris, while in Germany Lázló Moholy-Nagy,

who was to emigrate to the U.S., created his 'Photograms'. Firmly within the U.S., in the final phase of his career, Weegee (real name Usher or Arthur Fellig) – most notorious in the 1940s for his tabloid exposures of murder victims, sensational fires, arrested mobsters and the hysteria sparked by pop idols of the time – experimented with 'trick' effects. Alexander Alland, perhaps encouraged by the polemical impact of John Heartfield's highly-wrought anti-Nazi collages made in Germany during the previous decade – and certainly aware of the less sophisticated efforts of FSA workers, such as Lange (illus. 105) – produced, for educational purposes, at least one 'Photocollage' (*c.* 1943), based on his own shots, to celebrate the multicultural nature of the USA.[26]

But the straight approach became so indelibly associated with American endeavour in the medium that such other methods, even by major figures, were often seen as foreign or peripheral. In fact, it was so overriding that in the eyes of such critics as Nathan Lyons, it came by the late 1960s and early '70s to seem a somewhat inhibiting orthodoxy that Jerry Uelsmann, Duane Michals and others would need to subvert. This they did – in the creation of gothic, absurd or fantastical images that exhibit a troubled approximation to recognizable fragments of physical reality, but a highly attenuated reference, as if arisen from some subterranean dream domain or anti-world. They are Szarkowski's 'mirrors' writ large. (At about the same time, as we have seen, to Sontag *all* photography, especially in the U.S. – whether 'straight' or otherwise – was coming to seem surreal, and vexing.) And, of course, in the world beyond art, advertising photography had for some time been creating alternative worlds. Most fascinating in this respect were the arresting flash-lit nightscapes of steam trains O. Winston Link made in the 1950s for his patron the Westinghouse Corporation.[27] They are 'realistic', but the viewer delights in the artifice of their staging.

A. D. Coleman, then photography critic for the *New York Times*, began in the 1970s to argue for a more appreciative understanding of pictorialist figures from the past, such as William Mortensen – who routinely orchestrated extraordinary scenes to uncanny effect, as in his famous King Kong-like *L'Amour* (1937), in which a slathering great ape lowers himself towards the semi-conscious figure of a bare-breasted

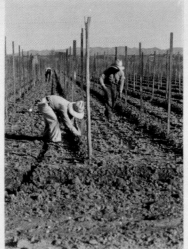

Filipinos working in pole peas.

~~cropped from~~ 3806 ZE.

from Texas

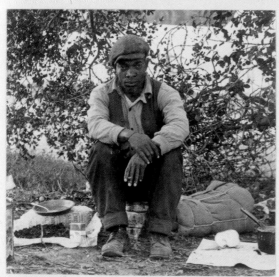

Pea picker from Texas.

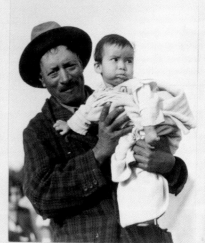

Future voter & his Mexican father

All races serve the crops in California

105 Dorothea Lange, draft of a poster, 'All races serve the crops in California', c. 1935. This image is from an album compiled by Lange's then-husband Paul Schuster Taylor, with whom she collaborated in producing the book *American Exodus* (1936).

woman. Coleman saw such works as products of what he dubbed 'The Directorial Mode'. In recent years he has gone on to claim, and with much justification, that this mode – supplemented by such other features as, in his words, 'the creation of photographic counterparts of famous works of visual art from other media, the pictorialist version of appropriation', 'the creation of complex still-lifes' and 'the making of deliberately and specifically politically symbolic imagery' – is now the mainstream of art photography.[28]

Evidence for such a view may be found in the work of both artists whose work overtly declares its construction, such as Carrie Mae Weems, and in that of more secretive practitioners. The text in the central panel of Weems's *Ebo Landing* (1992) tells a story:

> One midnight at high tide a cargo of Ebo (Ibo) men landed at Dunbar Creek on the island of St Simons. But the men refused to be sold into slavery; joining hands together they turned back towards the water, chanting, 'the water brought us, the water will take us away'. They all drowned, but to this day when the breeze sighs over the marshes and through the trees, you can hear the clank of chains and echo of their chant at Ebo Landing.

For the attentive viewer, the still trees in the accompanying pictures then seem to rustle with the reverberations of the story (illus. 14).

Weems's *Hampton Project* constitutes a revision of Johnston's documentary work. Troy Paiva, creator of the award-winning book *Night Vision: The Art of Urban Exploration* (2008), spent the previous ten years using extremely long exposures to create eerie views of abandoned military installations, factories and the like; they are not actually manipulated in any way, yet they appear to be, as he puts it, 'painted with light'. Also recently, Danish-born Peter Funch caused a stir with his wide-angle studies of New York street moments, some 'made' by the subjects – cops in pursuit, tourist madly photographing – but most made by the presence of Funch's camera at that corner, then. These *Babel Tales* seem to stop time in an extraordinary way, placing the viewer 'inside' the scene, one in which a pigeon may be alighting nearby, or someone exhales

159

cigarette smoke just beyond our reach, while, perhaps, another person, seemingly in mid-stride, has stopped to retie his shoe laces just in front of us (illus. 106).[29] In earlier, better-known directorial work by such artists as Gregory Crewdson we are placed at the brink of a very 'realistic' illusion; here the real becomes surreal.

Within the genre of portraiture, in which Americans had so excelled in the nineteenth century, there were many well-known figures that didn't *always* keep to the straight and narrow. In 1903 Steichen – by chance, he insisted – presented the financier J. Pierpont Morgan with his bullish head strikingly alert and his hand gripping a high-lit chair arm that looks remarkably like an unsheathed dagger. Steichen also framed film star Greta Garbo's flawless features in her own dark-clothed arms (1928), lent the face of fellow star Gloria Swanson an extra air of mystery by using an elaborate veil (1924) and quickened his portrait of the mercurial Charlie Chaplin (1931) by printing within the same frame shots made in rapid succession. Harlem photographer James VanDerZee superimposed an image of young children at the feet of a bridal couple in an otherwise conventional wedding picture to create *Future Expectations* (1926). Paul Strand was straighter, and the portraits first published in 1940 and reproduced in *The Mexican Portfolio* (1967) are some of his most memorable: young men with the determined chins of so many Emiliano Zapata lookalikes; young women with deep, timid eyes alongside other women bearing a family resemblance, but suddenly aged; a life-like wooden statue of Christ with the face of a Mexican villager below his crown of thorns, his body slightly leaning away (as if wincing) from the spiky leaves of a plant to the right.[30]

Irving Penn's photographs were often as visually austere as Strand's, but they contributed to the burgeoning consumer culture. This is obvious in the case of his highly successful fashion work, but may also be said of his portraiture, even when, as in his 1948 depictions of Duke Ellington, Truman Capote and others, he deliberately used the minimal setting of a containing triangular space. Dennis Stock by contrast dwelt on the setting, most famously in his depiction of a moody James Dean in a rainy Times Square (1955). Eve Arnold, too, made iconic images of such 'stars' but, as in the case of her study of Marilyn Monroe in a swimsuit reading

Ulysses (1954), hers are often quietly quirky. Arnold Newman specialized in portraying artists (including such photographers as Adams, Steichen and Strand) and tried to relate them to the characteristic forms of their own art. Pop artist Tom Wesselmann, for example, was captured wearing a hat which, in turn, was topped by an enormous female nipple, presumably belonging to one of the women in his own *Great American Nude* series (1962–4). The photograph gives the impression that the nipple simultaneously emanates from Wesselmann's head and frames it, giving him definition and being. Marie Cosindas exhibited a high degree of technical virtuosity alongside her artistry by making portraits early in the life of the instant Polaroid colour process, which gave both the sense of intimate immediacy that we might expect from such a medium *and* the quality of considered summation possessed by penetrating portraits in any medium. See, for instance, her 1965 renderings of radical writer Max Eastman in his tranquil and conservative old age or 'new journalist' Tom Wolfe, white-suited, as *enfant terrible*.[31]

Avedon's portraits – including his much reproduced *The Generals of the Daughters of the American Revolution* (*c.* 1963) – were not always complimentary to their subjects, as the title of one of his early books, *Nothing Personal* (1964), indicates. However, complimentary or not, depiction by him confirmed celebrity. He not only contributed to the fame of others, he became a celebrity himself – enough to be the model for the character of the photographer in the Fred Astaire-Audrey Hepburn film *Funny Face* (1957). A number of critics have expressed surprise that someone so devoted to glossy and flattering fashion work for *Vogue* and the like could also cast such a cold eye on the physical appearance of his less glamorous subjects. But in his project *In the American West* (1984), I would contend, he was both clinical *and* humane, licensing ordinary people – miners, clerks, drifters, beekeepers, abattoir workers, prisoners and numerous others – to perform for the camera against a plain white sheet.[32]

William Eggleston was the first predominantly colour photographer privileged with a show at the Museum of Modern Art, and the essay Szarkowski wrote in 1976 for *William Eggleston's Guide* conveys a sense of wonder that such commonplace 'private' pictures – ones that might

overleaf:
106 Peter Funch, *Hommage à Fischer*, 2008, Kodak light jet print. The title references the American chess player Bobby Fischer, who died in 2008. In a sense, the picture emulates the black-and-white patterns of the chessboard.

107 *William Eggleston's Guide*, published by the Museum of Modern Art, New York, in 1976.

be 'in a diary' – could also be so 'public' that they 'might be introduced as evidence in court' (illus. 107). We wonder about the precise relationship between a white man and the black man behind him, their standing stances seeming to indicate a family resemblance despite their obvious racial difference, or the true significance of a child's tricycle, seen from low-down, a tract house behind it. Eggleston's sense of colour and aspects of his offbeat viewpoint parallel the American output of Tony Ray-Jones, itself inflected by its consumerist subject matter (illus. 59). In black and white, Bill Owens's work for his *Suburbia* (1973) might initially seem more overtly documentary, and Owens claimed it was, but his use of captions, printed right alongside the pictures and taken directly from the mouths of those depicted in them, complicates it: 'I enjoy giving a tupperware party . . .'; 'Most people have the wrong attitude about sex . . .'. As with

Eggleston, we have to speculate as to whose viewpoint we are getting.[33]

From Cindy Sherman's celebrated *Untitled Film Stills* (1977–80) onwards, performance, especially the performative aspects of identity, and the slippery slope towards mediatized, often stereotypical ways of seeing encouraged by the prevalence of 'the image world', have been at the heart of her photography. The film stills relied on her depiction of herself – often identified by a tell-tale cable to the hidden camera – acting out roles that once upon a time were specifically U.S. popular culture versions of modern assignments for women (the bobbysoxer, the desperate suburban housewife). Her later work, more deeply disturbing, often grotesque in its intimation of sexual violation, initially seems reliant on female archetypes of a generalized 'Western civilization' – medieval milkmaids, classical madonnas or just mannequin body parts – and consequently could be considered as less rooted in the American scene per se.[34] On the other hand, in much of her most recent work, Sherman has returned fully to the American scene, producing a series of *California* stereotypes – *The Ex-Realtor*, *The Divorcee* and the like. Perhaps this personal oscillation between the national and the transnational is indicative of larger cultural trends that we have yet to understand in any depth. During the early stages of the 2007 banking furore that heralded the recession, a catchphrase summarizing the spread of the crisis was 'From Wall Street to Main Street', which pointed up the boundary-less nature of the financial world. Perhaps Sherman's later projects implicitly suggest, like other more recent American camera work, such as Funch's *Babel Tales*, that in photography, too, 'the world' is inseparable from 'America', and Wall Street and Main Street now encircle the globe.

References

Introduction

1 Roland Barthes, 'The Great Family of Man', in *Mythologies*, trans. Annette Lavers (London, 1973), pp. 107–10.

2 The term 'phautobiography' is from Jay Prosser, *Light in the Dark Room: Photography and Loss* (Minneapolis and London, 2005). Another recent work that markedly takes off from an autobiographical base is Rob Kroes, *Photographic Memories: Private Pictures, Public Images, and American History* (Hanover, NH and London, 2007). Edward Steichen, *A Life in Photography* (Garden City, NY, 1963). Nan Goldin's most raw work is *The Ballad of Sexual Dependency* (New York, 1986), but see also *The Devil's Playground* (London, 2008).

3 See Gerry Badger, *The Genius of Photography* (London, 2007). See also such works as those by Geoffrey Batchen in ref. 9 below.

4 Two samplings of visually oriented responses to the Abu Ghraib images are Stephen F. Eisenman, *The Abu Ghraib Effect* (London, 2007) and parts of essays in Mark Reinhardt, Holly Edwards and Erina Duganne, eds, *Photography and the Traffic in Pain*, exh. cat., Williams College Museum of Art, Williams, MA (Chicago, 2007).

5 See John Szarkowski, *E. J. Bellocq: Storyville Portraits* (New York, 1970). Bellocq featured as a mysterious character in Michael Ondaatje's novel *Coming Through Slaughter* (1976) and Louis Malle's film *Pretty Baby* (1977).

6 See Walker Evans, *American Photographs* (1938; New York, 1988); Alan Trachtenberg's comment is from a probing essay on Evans in his *Reading American Photographs: Images as History, Mathew Brady to Walker Evans* (New York, 1989), p. 283; for Evans's collecting, see Jeff Rosenheim, *Walker Evans and the Picture Postcard* (New York and Göttingen, 2009). British photographer Martin Parr has followed up on the latter interest in his edited collections *Boring Postcards* and *Boring Postcards USA* (both London, 2004).

7 Michael Lesy, *Wisconsin Death Trip* (New York, 1973). Susan Sontag, *On Photography* (1977; Harmondsworth, 1979), pp. 71, 73.

8 Sally Mann, *Immediate Family*, Afterword by Reynolds Price (London, 1992); interesting criticism of Mann includes Anne Higgonet, *Pictures of Innocence* (New York and London, 1996).

9 Andreas Bluehm and Stephen White, *The Photograph and the American Dream, 1840–1940* (Amsterdam, 2001). Geoffrey Batchen's work includes *Burning with Desire: The Conception of Photography* (Cambridge, MA, 1997), *Each Wild Idea: Writing, Photography, History* (Cambridge, MA, 2001), and *Forget Me Not: Photography and Remembrance* (Princeton, NJ, 2004).

10 Frederick Jackson Turner, 'The Significance of the Frontier in American History' (1893), reprinted, among many other places, in *The Turner Thesis: Concerning the Role of the Frontier in American History* ed. George Rogers Taylor (Lexington, MA, 1972), pp. 3–26.

11 J. Hector St John de Crèvecoeur, *Letters from an American Farmer*, Foreword by Albert E. Stone (New York, 1963), p. 63. David Riesman, with Nathan Glazer and Reuel Denney, *The Lonely Crowd: A Study of the Changing American Character* (1950; Garden City, NY, 1955), p. 23 and *passim*. A history of such theses is Rupert Wilkinson, *The Pursuit of American Character* (New York, 1988).

12 Herbert Croly, *The Promise of American Life* (New York, 1964), p. 3.

13 Maren Stange, *Symbols of Ideal Life: Social Documentary Photography in America, 1890–1950* (Cambridge and New York, 1989), pp. 101–5.

14 Richard Rorty, in *Achieving Our Country*, as quoted in Jim Cullen, *The American Dream* (Oxford, 2003), p. viii. For the Shakers, see Mick Gidley, with Kate Bowles, eds, *Locating the Shakers: Cultural Origins and Legacies of an American Religious Movement* (Exeter, 1990), especially the essays by Lyman Sargent and Paul Oliver. Linda Butler's Shaker work appears in *Inner Light: The Shaker Legacy*, with text by June Sprigg (New York, 1985).

15 The version of *Leaves of Grass* used is in *The Portable Walt Whitman*, ed. Mark Van Doren (New York, 1945); quotations, p. 29 and (from 'Song of Myself', section 24) pp. 89–90. For Whitman and photography, see Ed Folsom, *Walt Whitman's Native Representations* (Cambridge and New York, 1994).

16 Sontag, *On Photography*, pp. 47, 48. I would have liked to reproduce an Arbus image in visual refutation of Sontag's claims; ironically, her estate refused to permit publication.

17 Marilynne Robinson, *Housekeeping* (1981; London, 1984), p. 179. Wright Morris, *The Inhabitants* (1946; New York, 1972) and *The Home Place* (New York, 1948). Carrie Mae Weems, *Recent Work, 1992–1998*, with essays by Thomas Piché Jr and Thelma Golden, exh. cat., Everson Museum, Syracuse, NY (New York, 1998).

18 White, in Bluehm and White, *The Photograph and the American Dream*, p. 26. Two large and nearly comprehensive studies are, for the nineteenth century, the pioneering book by Robert Taft, *Photography and the American Scene* (1938; New York, 1964) and, for the twentieth century, Keith F. Davis, *An American Century of Photography, From Dry-Plate to Digital: The Hallmark Photographic Collection* (Kansas City, MO, 2nd revd edn, 1999).

one: Technologies

1 Information on this image from Beaumont Newhall, *The Daguerreotype in America* (New York, 3rd revd edn, 1976), p. 24. Unreferenced sources relied upon in this chapter are Robert Taft, *Photography and the American Scene* (1938; New York, 1964); Alan Trachtenberg, *Reading American Photographs: Images as History, Mathew Brady to Walker Evans* (New York, 1989); William Welling,

cited in no. 7 below, and M. M. Evans, ed., *Contemporary Photographers* (London, 3rd ed., 1995), Miles Orvell, *American Photography* (Oxford, 2003) and Louis Walton Sipley, ed., *Photography's Great Inventors: Selected by an International Committee of the International Photographic Hall of Fame* (Philadelphia, 1965).

2 Horace Greeley as quoted in Richard Rudisill, *Mirror Image: The Influence of the Daguerreotype on American Society* (Albuquerque, NM, 1971), p. 194. For more on the U.S. exhibits, see Marcus Cunliffe, 'America at the Great Exhibition of 1851', *American Quarterly*, III/1 (Summer 1951), pp. 115–27. The emphasis on U.S. technology here is cultural, and not meant to occlude European technical achievements that swept the world, such as the invention of the gelatin dry plate in the 1870s.

3 Merle Curti, 'America at the World's Fairs, 1851–93', *American Historical Review*, LV/4 (July 1950), pp. 833–56 (quotation, p. 840). Greeley, quoted in Rudisill, p. 194.

4 See William Culp Darrah, *The World of Stereographs* (Gettysburg, PA, 1977) and Edward W. Earle, ed., *Points of View: The Stereograph in America: A Cultural History* (Rochester, NY, 1979). Oliver Wendell Holmes, 'The Stereoscope and the Stereograph' (1859), reprinted in *Classic Essays on Photography*, ed. Alan Trachtenberg (New Haven, CT, 1980), pp. 83–9.

5 Robert Bartlett Haas, *Muybridge: Man in Motion* (Berkeley, Los Angeles and London, 1976) and Rebecca Solnit, *River of Shadows: Eadward Muybridge and the Technological Wild West* (New York, 2004).

6 See Michael L. Carlebach, *The Origins of Photojournalism in America* (Washington, DC and London, 1992), pp. 161–4, who also quotes Wilson, p. 165. Neil Harris provides a broader perspective in 'Iconography and Intellectual History: The Half-Tone Effect', *New Directions in American Intellectual History*, ed. John Higham and Paul K. Conkins (Baltimore, 1979), pp. 196–211.

7 See William Welling, *Photography in America: The Formative Years, 1839–1900* (New York, 1979), especially p. 289; Holmes, as quoted in Taft, *Photography and the American Scene*, p. 143.

8 Kodak data in these paragraphs is culled from Reese V. Jenkins, *Images and Enterprise: Technology and the American Photographic Industry* (Baltimore and London, 1976) and Douglas Collins, *The Story of Kodak* (New York, 1990). Siegfried Giedion, *Mechanization Takes Command* (1948; New York, 1988), p. 5.

9 Advertising slogans taken from James E. Paster, 'Advertising Immortality by Kodak', *History of Photography*, XVI/2 (Summer 1992), pp. 135–9. For the corporation as an American formation, see David E. Nye, 'Industrialization, Business and Consumerism', *Modern American Culture: An Introduction*, ed. Mick Gidley (London and New York, 1993), pp. 166–88.

10 Quotation from www.telegraph.co.uk/culture/donotmigrate/ 3671736/The-history-of-the-photobooth.html, in turn excerpted from the pioneering study by Nakki Goranin, *The American Photobooth* (New York and London, 2008).

11 Paul Strand, 'Photography and the New God', *Photographers on Photography*, ed. Nathan Lyons (Englewood Cliffs, NJ, 1966), pp. 138–44.

12 See *Life: The First Decade, 1936–1945*, with Introductions by Robert R. Littman, Ralph Graves and Doris O'Neil (London, 1980), which reproduces most of the images mentioned, and John Raeburn, *A Staggering Revolution: A Cultural History of Thirties Photography* (Urbana, IL, 2006), esp. the chapter on 'The Nation's Newsstands', which quotes Henry Luce, p. 208.

13 Gisèle Freund, *Photography and Society* (London, 1980), p. 124.

14 Arthur Rothstein, 'A Picture Magazine and its Editor', in *Photographic Communication: Principles, Problems, and Challenges to Photojournalism*, ed. R. Smith Shuneman (London, 1972), p. 335. Data on *Life*'s later years primarily taken from *Life, 1946–1955*, with an Introduction by Doris O'Neil (Boston, 1984). See also Wendy Kozol, *Life's America: Family and Nation in Postwar Photojournalism* (Philadelphia, PA, 1994).

15 See Glenn G. Willumson, *W. Eugene Smith and the Photographic Essay* (New York and Cambridge, 1992).

16 See Margaret Bourke-White, *Portrait of Myself* (1963; London, 1964) and, for a refreshingly sympathetic view, Raeburn, *A Staggering Revolution*, especially pp. 207–18.

17 See Jay Prosser, *Light in the Dark Room: Photography and Loss* (Minneapolis and London, 2005), pp. 96–122.

18 Lucia Moholy, *A Hundred Years of Photography* (Harmondsworth, 1939), pp. 169, 176, 178.

19 C. W. Ceram, *Archaeology of the Cinema* (New York, 1965), p. 16.

20 Don DeLillo, *White Noise* (1984; London, 1986). Robert A. Sobieszek, *The Art of Persuasion: A History of Advertising Photography* (New York, 1988).

two: **Histories**

1 Conor Cruise O'Brien, *New York Review of Books*, XV/8 (5 November 1970), p. 12. Unreferenced material in this section is from Robert Taft, *Photography and the American Scene* (1938; New York, 1964); Keith F. Davis, *An American Century of Photography, From Dry-Plate to Digital: The Hallmark Photographic Collection* (Kansas City, MO, 2nd revd edn, 1999); Alan Trachtenberg, *Reading American Photographs: Images as History, Mathew Brady to Walker Evans* (New York, 1989); Miles Orvell, *American Photography* (Oxford, 2003); Deborah Willis, *Reflections in Black: A History of Black Photographers, 1840 to the Present* (New York and London, 2000); and Richard Wright and Edwin Rosskam, *12 Million Black Voices* (1941; New York, 2002).

2 Abraham Lincoln, quoted in Taft, *Photography and the American Scene*, p. 195. See also Mary Panzer, *Mathew Brady and the Image of*

History (Washington, DC, 1997). For Roger Fenton, see *All the Mighty World: The Photography of Roger Fenton, 1852–1860*, exh. cat., Metropolitan Museum of Art, New York (New Haven, CT, 2004).

3 For further material, see *Carleton Watkins: The Art of Perception*, exh. cat., San Francisco Museum of Modern Art (New York, 1999); Murray Morgan, *One Man's Gold Rush: A Klondike Album: Photographs by E. A. Hegg* (Seattle and London, 1967); and Darius and Tabitha Kinsey, *Kinsey Photographer: A Half Century of Negatives*, 2 vols (San Francisco, 1975). Goldbeck's panorama is reproduced, at nearly half scale, in *A Nation of Strangers*, with essays by Vicki Goldberg and Arthur Ollman, exh. cat., Museum of Photographic Arts (San Diego, 1995), p. 73.

4 John Kouwenhoven, 'American Studies: Words or Things', *American Studies in Transition*, ed. Marshall Fishwick (Philadelphia, PA, 1964), pp. 15–35.

5 Oliver Jensen, Joan Paterson Kerr, Murray Belsky, *American Album* (New York, 1968).

6 See Alexander Gardner, reprint edition titled *Gardner's Photographic Sketch Book of the Civil War* (New York, 1964), captions and plates 40 and 41. Frassanito's discussion, more complex than my summary, and part-crediting Timothy O'Sullivan for these images, is *Gettysburg: A Journey in Time* (New York, 1975), pp. 186–95.

7 *The American Image*, with an Introduction by Alan Trachtenberg (New York, 1979); also Barbara Lewis Burger, ed., *Guide to the Holdings of the Still Picture Branch of the National Archives* (Washington, DC, 1990).

8 Toni Morrison, *Beloved* (New York, 1987), p. 15 and *passim*.

9 James Allen et al., *Without Sanctuary: Lynching Photography in America*, exh. cat., New York Historical Society (Santa Fe, NM, 2000); see also Dora Apel and Shawn Michelle Smith, *Lynching Photographs* (Berkeley, 2007). For more on photography and Civil Rights, see Juan Williams, *Eyes on the Prize: America's Civil Rights Years, 1954–1965* (New York, 1987); *Roads to Freedom: Photographs from the Civil Rights Movement, 1956–1968*, exh. cat., High Museum (Atlanta, GA, 2008); Danny Lyon, *Memories of the Southern Civil Rights Movement* (Chapel Hill, NC, and London, 1992); and Leigh Raiford, '"Come Let Us Build a New World Together": SNCC and Photography of the Civil Rights Movement', *American Quarterly*, LIX/4 (December 2007), pp. 1129–57. The Karales quotation was kindly provided by his widow, Monica Karales.

10 Works that explore black photographers include Deborah Willis-Braithwaite, *VanDerZee: Photographer, 1886–1983*, exh. cat., National Portrait Gallery, Smithsonian Institution (New York, 1993), Peter Galassi, *Roy DeCarava: A Retrospective*, exh. cat., Museum of Modern Art (New York, 1996) and Carrie Mae Weems, *Recent Work, 1992–1998*, with essays by Thomas Piché Jr and Thelma Golden, exh. cat., Everson Museum, Syracuse, NY (New York, 1998). *African American Vernacular Photography: Selections from the Daniel Cowin Collection*, with essays by Brian Wallis et al., exh. cat., International Center for Photography, New York (Göttingen, 2005); quotation from Kelley, p. 9.

11 Contextualizations of immigrant photographs are Allon Schoener, ed., *Portal to America: The Lower East Side, 1870–1925* (New York, 1967) and *A Nation of Strangers*. Unreferenced material in this section is from James Guimond, *American Photography and the American Dream* (Chapel Hill, NC, 1991) and Orvell, *American Photography*.

12 See, particularly, Peter Bacon Hales, *Silver Cities: The Photography of American Urbanization, 1839–1915* (Philadelphia, PA, 1984) and Douglas Tallack, *New York Sights: Visualizing Old and New New York* (Oxford and New York, 2005).

13 David Nye, *Image Worlds: Corporate Identities at General Electric, 1890–1930* (Cambridge, MA, 1985).

14 E. O. Hoppé, *Romantic America* (New York, 1927), p. 263; Karen Lucic, *Charles Sheeler and the Cult of the Machine* (London, 1991); Elspeth H. Brown, *The Corporate Eye: Photography and the Rationalization of American Culture, 1884–1929* (Baltimore, 2005); Robert A. Sobieszek, *The Art of Persuasion: A History of Advertising Photography* (New York, 1988); Edward Steichen, *A Life in Photography* (Garden City, NY, 1963); and Todd Brandow and William A. Ewing, *Edward Steichen: In High Fashion: The Condé Nast Years, 1923–1937* (New York, 2009). For more on Tony Ray-Jones, see Russell Roberts, *Tony Ray-Jones* (London, 2004).

15 Robert A. Weinstein and Larry Booth, *The Collection, Use and Care of Historical Photographs* (Nashville, TN, 1977), p. 3. For lithographs see, e.g., Harry T. Peters, *Currier and Ives: Printmakers to the American People* (Garden City, NY, 1942), and, for later print culture, including photo-reproduction, Joshua Brown, *Beyond the Lines: Pictorial Reporting, Everyday Life, and the Crisis of Gilded Age America* (Berkeley, Los Angeles, London, 2002).

16 A useful collection is Ellen Dugan, ed., *Picturing the South, 1860 to the Present*, exh. cat., High Museum, Atlanta (San Francisco, 1996).

17 Frederick Jackson Turner, 'The Significance of the Frontier in American History', *The Turner Thesis*, ed. George Rogers Taylor, (Lexington, MA, 1972) p. 27.

18 Susan Sontag, *On Photography*, (1977; Harmondsworth, 1979) p. 65. Unreferenced data in this section taken from Karen Current and William R. Current, *Photography and the Old West* (1978; New York, 1986), Weston Naef and John N. Wood, *Era of Exploration: The Rise of Landscape Photography in the American West, 1860–1885* (Boston, MA, 1975), Martha A. Sandweiss, *Print the Legend: Photography and the American West* (New Haven, CT, 2002) and *Crossing the Frontier: Photographs of the Developing West*, with essays by Sandra S. Phillips et al., exh. cat., San Francisco Museum of Modern Art (San Francisco, 1996).

19 Mick Gidley, *With One Sky Above Us: Life on an Indian Reservation at the Turn of the Century: Photographs by E. H. Latham* (1979; Seattle, 1985).

20 The Adams literature includes Jonathan Spaulding, *Ansel Adams and the American Landscape: A Biography* (Berkeley, 1998); a typical Sierra Club production is Nancy Newhall, *Ansel Adams: The Eloquent Light* (San Francisco, 1963). For Eliot Porter, *The Color of Wildness: A Retrospective 1936–1985*, with essays by Jonathan Porter et al. (New York, 2005).

21 Both Grabill photographs reproduced in Alan Fern, Milton Kaplan et al., *Viewpoints: A Selection from the Pictorial Collections of the Library of Congress* (Washington, DC, 1975), pp. 45, 122–3. See also Richard E. Jensen, et al., *Eyewitness at Wounded Knee* (Lincoln, NE, and London, 1991).

22 Roland Barthes, *Image, Music, Text* (London, 1977), p. 27.

23 Eugene Ostroff, *Western Views and Eastern Visions* (Washington, DC, 1981), p. 58.

24 Lee Friedlander, *The American Monument* (New York, 1976). One of Jim Alinder's series appears in Jim Alinder and Wright Morris, *Picture America* (Boston, MA, 1982), p. 43. Mark Klett, Ellen Manchester, JoAnn Verburg et al., *Second View: The Rephotographic Survey Project* (Albuquerque, NM, 1984). New Topographic work was named in William Jenkins, *New Topographics: Photographs of a Man-altered Landscape* (Rochester, NY, 1975). For Pfahl, see *A Distanced Land: The Photographs of John Pfahl* (Albuquerque, NM, 1990). Commentaries on this revisionism are Rob Silberman, 'Contemporary Photography and the Myth of the West', *The American West as Seen by Europeans and Americans*, ed. Rob Kroes, (Amsterdam, 1989), pp. 297–325, and Lucy R. Lippard, *The Lure of the Local: Senses of Place in a Multicentered Society* (New York, 1997), pp. 178–92.

three: Documents

1 Jacob A. Riis, quoted and commented upon in Alexander Alland, *Jacob A. Riis: Photographer and Citizen* (London, 1975), p. 11.

2 Photographically, an excellent reprint edition of *How the Other Half Lives* is that in the Bedford Series, ed. David Leviatin (Boston and New York, 1996).

3 Robert Bremner, *From the Depths: The Discovery of Poverty in the United States* (New York, 1956), p. 69.

4 Lewis W. Hine, *Men at Work* (1932; New York, 1977); Alan Trachtenberg, et al., *America and Lewis Hine: Photographs, 1904–1940* (Millerton, NY, 1977); and Judith Mara Gutman, *Lewis W. Hine, 1874–1940: Two Perspectives* (New York, 1974). For commentary, see Alan Trachtenberg, *Reading American Photographs: Images as History, Mathew Brady to Walker Evans* (New York, 1989), pp. 164–230.

5 Trachtenberg, *Reading American Photographs*, p. 198.

6 Roland Barthes, *Camera Lucida: Reflections on Photography*, trans. Richard Howard (London, 1981), pp. 50–51. The Hine photograph reproduced in *Camera Lucida* also appears in Gutman, *Lewis W.*

Hine, pp. 62–3 – which is probably where Barthes encountered it. In *Camera Lucida* it was used as the basis for Barthes's famous distinction between *studium* and *punctum*.

7 *The Hampton Album: 44 Photographs by Frances B. Johnston* with an Introduction by Lincoln Kirstein, exh. cat., Museum of Modern Art, New York (Garden City, NY, 1966). For commentary, see James Guimond, *American Photography and the American Dream* (Chapel Hill, NC, 1991), pp. 23–53.

8 See Judith Fryer Davidov, *Women's Camera Work: Self/Body/Other in American Visual Culture* (Durham, NC and London, 1998) pp. 167–72 and Laura Wexler, *Tender Violence: Domestic Visions in an Age of U.S. Imperialism* (Chapel Hill, NC, 2000), pp. 167–71.

9 Edward S. Curtis, *The North American Indian*, ed. Frederick Webb Hodge (Cambridge, MA, then Norwood, MA, 1907–1930); its images and text are on the Internet at, respectively, http://memory.loc.gov/ammem/award98/ienhtml/curthome.html and http://curtis.library.northwestern.edu/

10 For fuller discussion, see Mick Gidley, *Edward S. Curtis and the North American Indian, Incorporated* (1998; Cambridge and New York, 2000).

11 Unreferenced data in this section comes mainly from Carl Fleischauer and Beverly W. Brannan, eds, *Documenting America*, with essays by Lawrence W. Levine and Alan Trachtenberg (Berkeley, Los Angeles and Oxford, 1988); Pete Daniel, Merry Foresta, Maren Stange and Sally Stein, *Official Images: New Deal Photography* (Washington, DC, 1987); and F. Jack Hurley, *Portrait of a Decade: Roy Stryker and the Development of Documentary Photography in the Thirties* (Baton Rouge, LA, 1972). It has been increasingly realized that the FSA photo archive can be cut through and anatomized in several different ways – not only by photographer, but by location, date, subject-matter, sub-subject-matter, etc.

12 Typical 'shooting script' from Thomas H. Garver, *Just Before the War: Urban America from 1935 to 1941 as seen by Photographers of the FSA*, exh. cat., Newport Harbor Art Museum (Balboa, CA, 1968), n.p. Collier's comment is from an interview with the author, August 1980.

13 Modern editions of these publications are: Walker Evans, *American Photographs* (New York, 1988); Morris Wright, *The Inhabitants* (New York, 1972); James Agee and Walker Evans, *Let Us Now Praise Famous Men* (Boston, 2001); and Archibald MacLeish, *Land of the Free*, with Introduction by A. D. Coleman (1938; New York, 1977). For discussion of MacLeish, see Louis Kaplan, *American Exposures: Photography and Community in the Twentieth Century* (Minneapolis, MI, 2005), pp. 27–54.

14 Richard Pare, ed., *Court House: A Photographic Document* (New York, 1978).

15 Lee Friedlander, *The American Monument* (New York, 1976), n.p. The prints are removable for exhibition purposes.

16 See Lee Friedlander, *Self-Portrait* (New City, NY, 1970) and, for a

more recent near-comprehensive collection, *Lee Friedlander: Complete Work*, with essay by Peter Galassi (New York, 2005).

17 See Joel Meyerowitz, *Cape Light* (1979; revd edn, New York, 2002). As the co-author, with Colin Westerbeck, of *Bystander: A History of Street Photography* (Boston, 2001), Meyerowitz is also a somewhat scholarly authority on his chosen genre.

18 Meyerowitz, *Aftermath: World Trade Center Archive* (London, 2006). Conrad's *Observer* essay of Sunday 27 August 2006, is available at: www.guardian.co.uk/artanddesign/2006/aug/27/photography.september11

four: Emblems

1 Seymour Martin Lipset, *The First New Nation* (New York, 1963).

2 For commentary on the Iwo Jima image, see David Nye, 'Transnational Photographic Communication', *American Photographs in Europe*, ed. David Nye and Mick Gidley, (Amsterdam, 1994), pp. 33–8, and Robert Hariman and John Louis Lucaites, *No Caption Needed: Iconic Photographs, Public Culture, and Liberal Democracy* (Chicago and London, 2007), pp. 93–136.

3 See Louis Kaplan, *American Exposures* (Minneapolis, MN, 2005), pp. 1–24.

4 Elliot Erwitt, *The Private Experience: Personal Insights of a Professional Photographer*, with text by Sean Callahan (London, 1974), pp. 49–55.

5 For Jerome Liebling, see *Jerome Liebling Photographs* (Amherst, MA, 1982). For commentary on Robert Jackson's picture see John Faber, *Great News Photos and the Stories Behind Them* (New York, 1978), pp. 134–8. For Paul Fusco, see his *RFK Funeral Train* (rev. ed., New York, 2008) and the essay by Francisca Fuentes in Mick Gidley, ed., *Writing with Light* (Oxford, 2010).

6 Bruce Davidson, *East 100th Street* (Cambridge, MA, 1970). Robert Frank, *The Americans* (1959; Manchester, 1993).

7 William Carlos Williams, *In the American Grain* (1924; London, 1966). The quotation is from Williams's review of Evans's *American Photographs*, as reprinted in Jane M. Rabb, ed., *Literature and Photography: Interactions 1840–1990* (Albuquerque, NM, 1995), pp. 309–12. Terence Pitts, *Photography in the American Grain: Discovering a Native American Aesthetic, 1923–1941* (Tucson, AZ, 1988). Unreferenced data in this chapter comes from such standard works as Beaumont Newhall, *A History of Photography from the Beginnings to the Present Day* (revd edn, London, 1982), Keith F. Davis, *An American Century of Photography, From Dry-Plate to Digital: The Hallmark Photographic Collection* (Kansas City, MO, 2nd revd edn, 1999) and Miles Orvell, *American Photography* (Oxford, 2003).

8 This connection was first made for me by Mike Weaver, who also wrote about it, quoting Emerson's *Nature*, in his *The Photographic Art: Pictorial Traditions in Britain and America* (London, 1986), p. 8.

9 Grant B. Romer and Brian Wallis, eds, *Young America: the Daguerreotypes of Southworth and Hawes*, exh. cat., George Eastman House, Rochester (Göttingen, 2005). For Hawthorne and photography, see Alan Trachtenberg, *Lincoln's Smile and Other Enigmas* (New York, 2007), pp. 46–68, which also quotes Holgrave, p. 52.

10 Horace Traubel, *With Whitman in Camden* (Boston, 1906), p. 367; *The Portable Walt Whitman*, ed. Mark Van Doren (New York, 1945) pp. 269, 330; François Brunet, *Photography and Literature* (London, 2009), pp. 117–20. See also Ed Folsom, *Walt Whitman's Native Interpretations* and Gay Wilson Allen, ed., *The Artistic Legacy of Walt Whitman* (New York, 1970), pp. 127–52. Edward Weston, *Leaves of Grass by Walt Whitman* (1942; New York and London, 1976).

11 For Herbert Gleason, see Henry D. Thoreau, *The Illustrated Walden* (Princeton, NJ, 1973). On American literature and photography, see Carol Shloss, *In Visible Light* (New York and Oxford, 1987); Brunet, *Photography and Literature*; Gidley, ed., *Writing with Light*, which includes treatment of some connections made here; and Rabb, *Literature and Photography*.

12 For more on Elizabeth Bishop's photography, see Jay Prosser, *Light in the Dark Room: Photography and Loss* (Minneapolis and London, 2005), chapter 4.

13 Sherwood Anderson and Art Sinsabaugh is a rare text: *Six Mid-American Chants* (Highlands, NC, 1964). Jeff Wall's image is discussed in Brunet, *Photography and Literature*, p. 108. For Robert Frank and Jack Kerouac, see the essay by Neil Campbell in *Writing with Light*, ed. Gidley.

14 Data taken from such works as Elizabeth Lindquist-Cock, *The Influence of Photography on American Landscape Painting, 1839–1880* (New York, 1977).

15 Data in these paragraphs taken from issues of *Camera Work* (see *Alfred Stieglitz Camera Work: The Complete Illustrations 1903–1917* issued by Taschen in 1997) and such works as Waldo Frank, Lewis Mumford, et al., eds, *America and Alfred Stieglitz: A Collective Portrait* (Garden City, NY, 1934) and William Innes Homer, *Alfred Stieglitz and the American Avant-Garde* (Boston, MA, 1977).

16 Quoted in Robert Doty, *Photo-Secession: Photography as a Fine Art* (Rochester, NY, 1960), p. 24.

17 Charles H. Caffin, quoted in Doty, *Photo-Secession*, p. 17; emphasis added. For a more philosophical reading of the equivalents, see Olaf Hansen, 'The Impermanent Sublime: Nature, Photography and the Petrarchan Tradition', *Views of American Landscapes*, ed. Mick Gidley and Robert Lawson-Peebles (Cambridge, 1989; 2007), pp. 31–50.

18 Lewis Mumford, *Technics and Civilization* (1934; London, 1946), pp. 340–41.

19 Arnold Genthe, *As I Remember* (New York, 1936), p. 261.

20 Genthe, *Pictures of Old Chinatown* (New York, 1908), p. 3 and *The Book of the Dance* (Boston, MA, 1920), p. xvi. There is a similar feel to Genthe's purposefully blurred architectural studies of the palatial home of oil tycoon John D. Rockefeller in *The Gardens of Kijkuit*

(1919) and in the aptly named *Impressions of Old New Orleans* (1926).

21 See Margery Mann, ed., *Imogen Cunningham: Photographs* (Seattle and London, 1970). Nancy Newhall, ed., *The Daybooks of Edward Weston*, 2 vols (Millerton, NY, 1973) and the definitive Amy Conger, ed., *Edward Weston: Photographs from the Collection of the Center for Creative Photography* (Tucson, AZ, 1992).

22 John Szarkowski, *The Photographer's Eye* (New York, 1966), esp. pp. 6–12, and p. 42 for quotation. For more on Szarkowski, see the interview with him by Hilton Als, 'Looking at Pictures', *Grand Street*, LIX (Winter, 1997), pp. 102–21, and the obituary by Mark Haworth-Booth, *The Guardian*, 11 July 2007, p. 36.

23 For more on Harry Callaghan, see Sarah Greenough, *Harry Callaghan* (Washington, DC, 1996).

24 John Szarkowski, *Mirrors and Windows: American Photography since 1960* (New York, 1978), p. 25. For more on Paul Caponigro, see his *Paul Caponigro: Masterworks of Forty Years* (Carmel, CA, 1993).

25 Geoff Dyer, *The Ongoing Moment* (London, 2005), pp. 141–3. For Robert Mapplethorpe, see his *Flowers* (Boston, MA, 1994); for William Christenberry, Thomas W. Southall, *Of Time and Place: Walker Evans and William Christenberry*, exh. cat., The Friends of Photography (San Francisco, 1990), and for Sally Mann, *Immediate Family* (London, 1992).

26 See the 'Quest for Form' chapter of Beaumont Newhall, *A History of Photography from the Beginnings to the Present Day*, and for Alvin Langdon Coburn, Mike Weaver, *Alvin Langdon Coburn: Symbolist Photographer* (New York, 1986). For Alexander Alland, see *Reframing America*, with essays by Andrei Codescru and Terence Pitts, exh. cat., Center for Creative Photography (Tucson, AZ, 1995), pp. 18–29.

27 See Nathan Lyons, *The Persistence of Vision* (New York, 1967), which contains work by Jerry Uelsmann and others. For Winston Link, see *Night Trick: Photographs of the Norfolk and Western Railway, 1955–60*, ed. Rupert Martin (London, 1983).

28 A. D. Coleman's 'The Directorial Mode: Notes Toward a Definition' (1976) is reprinted in his *Light Readings: A Photography Critic's Writings, 1968–1978* (Albuquerque, NM, 1998), pp. 246–57, and the later summation quoted here is 'Return of the Suppressed: Pictorialism's Revenge', *Photoresearcher*, no. 12 (2009), pp. 16–23; quotation, p. 23.

29 More on Carrie Mae Weems may be found in Weems, *Carrie Mae Weems: The Hampton Project* (New York, 2001) and *Tracing Cultures*, exh. cat., The Friends of Photography, San Francisco (San Francisco, 1995). On the other figures, see Troy Paiva, *Night Vision* (San Francisco, 2008) and, for Peter Funch, *Babel Tales* (New York, 2010).

30 Edward Steichen, *A Life in Photography* (Garden City, NY, 1963); Deborah Willis-Braithwaite, *VanDerZee: Photographer, 1886–1983*, exh. cat., National Portrait Gallery, Smithsonian Institution (New York, 1993); Paul Strand, *The Mexican Portfolio* (New York, 1967) and Sarah Greenough, *Paul Strand: An American Vision* (New York, 1990).

31 Irving Penn, *Passage: A Work Record* (New York, 1991); Dennis Stock, *James Dean: Fifty Years Ago* (New York, 2005); Eve Arnold, *In America* (London, 1984); Arnold Newman, *Artists: Portraits from Four Decades* (London, 1980); Marie Cosindas, *Color Photographs* (Boston, MA, 1978).

32 Richard Avedon, *Nothing Personal*, with an Introduction by James Baldwin (Harmondsworth, 1964). Avedon, *In the American West* (New York, 1985); see also Mick Gidley, 'Topographical Portraits: Seven Views of Richard Avedon's *In the American West*', *Prospects: An Annual of American Cultural Studies*, 30 (2005), pp. 685–713.

33 William Eggleston, *William Eggleston's Guide*, with an essay by John Szarkowski (New York, 1976); quotations, pp. 10–11. Bill Owens, *Suburbia* (San Francisco, 1973).

34 Joanna Burton, ed., *Cindy Sherman* (Cambridge, MA, 2006).

Select Bibliography

African American Vernacular Photography: Selections from the Daniel Cowin Collection, with essays by Brian Wallis et al., exh. cat., International Center for Photography (Göttingen, 2005)

Agee, James, and Walker Evans, *Let Us Now Praise Famous Men* (1941; Boston, MA, 2001)

Alland, Alexander, *Jacob A. Riis: Photographer and Citizen* (London, 1975)

Allen, James, et al., *Without Sanctuary: Lynching Photography in America*, exh. cat., New York Historical Society (Santa Fe, NM, 2000)

The American Image, with an Introduction by Alan Trachtenberg (New York, 1979)

Anderson, Sherwood, and Art Sinsabaugh, *Six Mid-American Chants* (Highlands, NC, 1964)

Apel, Dora, and Shawn Michelle Smith, *Lynching Photographs* (Berkeley, 2007)

Arnold, Eve, *In America* (London, 1984)

Avedon, Richard, *In the American West* (New York, 1985)

——, *Nothing Personal*, with an Introduction by James Baldwin (Harmondsworth, 1964)

Badger, Gerry, *The Genius of Photography* (London, 2007)

Barthes, Roland, *Camera Lucida: Reflections on Photography*, trans. Richard Howard (London, 1981)

Batchen, Geoffrey, *Burning With Desire: The Conception of Photography* (Cambridge, MA, 1997)

——, *Each Wild Idea: Writing, Photography, History* (Cambridge, MA, 2001)

——, *Forget Me Not: Photography and Remembrance* (Princeton, NJ, 2004)

Bluehm, Andreas, and Stephen White, *The Photograph and the American Dream* (Amsterdam, 2001)

Bourke-White, Margaret, *Portrait of Myself* (1963; London, 1964)

Brandow, Todd, and William A. Ewing, *Edward Steichen: In High Fashion: The Condé Nast Years, 1923–1937* (New York, 2009)

Bremner, Robert, *From the Depths: The Discovery of Poverty in the United States* (New York, 1956)

Brown, Elspeth H., *The Corporate Eye: Photography and the Rationalization of American Culture, 1884–1929* (Baltimore, MD, 2005)

Brown, Joshua, *Beyond the Lines: Pictorial Reporting, Everyday Life, and the Crisis of Gilded Age America* (Berkeley, Los Angeles, London, 2002)

Brunet, François, *Photography and Literature* (London, 2009)

Burger, Barbara Lewis, ed., *Guide to the Holdings of the Still Picture Branch of the National Archives* (Washington, DC, 1990)

Burton, Joanna, ed., *Cindy Sherman* (Cambridge, MA, 2006)

Butler, Linda, with text by June Sprigg, *Inner Light: The Shaker Legacy* (New York, 1985)

Caponigro, Paul, *Paul Caponigro: Masterworks of Forty Years* (Carmel, CA, 1993)

Carlebach, Michael L., *The Origins of Photojournalism in America* (Washington, DC and London, 1992)

Carleton Watkins: The Art of Perception, exh. cat., San Francisco Museum of Modern Art (New York, 1999)

Coleman, A. D., *Light Readings: A Photography Critic's Writings, 1968–1978* (Albuquerque, NM, 1998)

——, 'Return of the Suppressed: Pictorialism's Revenge', *Photoresearcher*, no. 12 (2009), pp. 16–23

Collins, Douglas, *The Story of Kodak* (New York, 1990)

Conger, Amy, ed., *Edward Weston: Photographs from the Collection of the Center for Creative Photography* (Tucson, AZ, 1992)

Cosindas, Marie, *Color Photographs* (Boston, MA, 1978)

Croly, Herbert, *The Promise of American Life* (1909; New York, 1964)

Crossing the Frontier: Photographs of the Developing West, with essays by Sandra S. Phillips et al., exh. cat., San Francsco Museum of Modern Art (San Francisco, 1996)

Cullen, Jim, *The American Dream: A Short History of an Idea that Shaped a Nation* (Oxford, 2003)

Current, Karen, and William R. Current, *Photography and the Old West* (1978, New York, 1986)

Curtis, Edward S., *The North American Indian*, 20 vols and 20 portfolios, ed. Frederick Webb Hodge (Cambridge, MA, then Norwood, MA, 1907–1930); its images and text are on the www at, respectively, http://memory.loc.gov/ammem/award98/ienhtml/curthome.html and http://curtis.library.northwestern.edu/

Daniel, Pete, Merry Foresta, Maren Stange, and Sally Stein, *Official Images: New Deal Photography* (Washington, DC, 1987)

Darrah, William Culp, *The World of Stereographs* (Gettysburg, PA, 1977)

Davidov, Judith Fryer, *Women's Camera Work: Self/Body/Other in American Visual Culture* (Durham, NC and London, 1998)

Davidson, Bruce, *East 100th Street* (Cambridge, MA, 1970)

Davis, Keith F., *An American Century of Photography, From Dry-Plate to Digital: The Hallmark Photographic Collection* (Kansas City, MO, 2nd revd edn, 1999)

Doty, Robert, *Photo-Secession: Photography as a Fine Art* (Rochester, NY, 1960)

Dugan, Ellen, ed., *Picturing the South, 1860 to the Present*, exh. cat., High Museum, Atlanta (San Francisco, 1996)

Dyer, Geoff, *The Ongoing Moment* (London, 2005)

Earle, Edward W., ed., *Points of View: The Stereograph in America: A Cultural History* (Rochester, NY, 1979)

Eggleston, William, *William Eggleston's Guide*, with an essay by John Szarkowski (New York, 1976)

Eisenman, Stephen F., *The Abu Ghraib Effect* (London, 2007)

Evans, Martin M., et al., eds, *Contemporary Photographers* (London, 3rd edn, 1995)

Evans, Walker, *American Photographs* (1938; New York, 1988)

Erwitt, Elliott, *The Private Experience: Personal Insights of a Professional Photographer*, with text by Sean Callahan (London, 1974)

Faber, John, *Great News Photos and the Stories Behind Them* (New York, 1978)

Fern, Alan, Milton Kaplan et al., *Viewpoints: A Selection from the Pictorial Collections of the Library of Congress* (Washington, DC, 1975)

Fleischauer, Carl, and Beverly W. Brannan, eds, *Documenting America*, with essays by Lawrence W. Levine and Alan Trachtenberg (Berkeley, Los Angeles and Oxford, 1988)

Folsom, Ed, *Walt Whitman's Native Representations* (Cambridge and New York, 1994)

Frank, Robert, *The Americans*, with an introduction by Jack Kerouac (1959; Manchester, 1993)

Frank, Waldo, Lewis Mumford et al., eds, *America and Alfred Stieglitz: A Collective Portrait* (Garden City, NY, 1934)

Frassanito, William A., *Gettysburg: A Journey in Time* (New York, 1975)

Freund, Gisèle, *Photography and Society* (London, 1980)

Friedlander, Lee, *The American Monument* (New York, 1976)

——, *Lee Friedlander: Complete Work*, with essay by Peter Galassi (New York, 2005)

Funch, Peter, *Babel Tales* (New York, 2010)

Fusco, Paul, *RFK Funeral Train* (revd edn, New York, 2008)

Galassi, Peter, *Roy DeCarava: A Retrospective*, exh. cat., Museum of Modern Art (New York, 1996)

Gardner, Alexander, *Gardner's Photographic Sketch Book of the Civil War* (1866; New York, 1964)

Garver, Thomas H., *Just Before the War: Urban America from 1935 to 1941 as seen by Photographers of the FSA*, exh. cat., Newport Harbor Art Museum (Balboa, CA, 1968)

Genthe, Arnold, *As I Remember* (New York, 1936)

——, *Pictures of Old Chinatown* (New York, 1908)

Gidley, Mick, *With One Sky Above Us: Life on an Indian Reservation at the Turn of the Century: Photographs by E. H. Latham* (1979; Seattle, 1985)

——, *Edward S. Curtis and the North American Indian, Incorporated* (1998; Cambridge, 2000)

——, ed., *Modern American Culture: An Introduction* (London and New York, 1993)

——, *Writing with Light: Words and Photographs in American Texts* (Oxford, 2010)

Giedion, Siegfried, *Mechanization Takes Command* (1948; New York, 1988)

Goldin, Nan, *The Devil's Playground* (London, 2008)

Goranin, Nakki, *The American Photobooth* (New York and London, 2008)

Greenough, Sarah, *Paul Strand: An American Vision* (New York, 1990)

——, *Harry Callaghan* (Washington, DC, 1996)

Guimond, James, *American Photography and the American Dream* (Chapel Hill, NC, 1991)

Gutman, Judith Mara, *Lewis W. Hine, 1874–1940: Two Perspectives* (New York, 1974)

Haas, Robert Bartlett, *Muybridge: Man in Motion* (Berkeley, Los Angeles and London, 1976)

Hales, Peter Bacon, *Silver Cities: The Photography of American Urbanization, 1839–1915* (Philadelphia, PA, 1984)

Hariman, Robert and John Louis Lucaites, *No Caption Needed: Iconic Photographs, Public Culture, and Liberal Democracy* (Chicago and London, 2007)

Harris, Neil, 'Iconography and Intellectual History: The Half-Tone Effect', in *New Directions in American Intellectual History*, ed. John Higham and Paul K. Conkins (Baltimore, MD, 1979), pp. 196–211

Hine, Lewis W., *Men at Work* (1932; New York, 1977)

Homer, William Innes, *Alfred Stieglitz and the American Avant-Garde* (Boston, MA, 1977)

Hoppé, E. O., *Romantic America* (New York, 1927)

Hurley, F. Jack, *Portrait of a Decade: Roy Stryker and the Development of Documentary Photography in the Thirties* (Baton Rouge, LA, 1972)

Jenkins, Reese V., *Images and Enterprise: Technology and the American Photographic Industry* (Baltimore and London, 1976)

Jenkins, William, *New Topographics: Photographs of a Man-altered Landscape* (Rochester, NY, 1975)

Jensen, Oliver, Joan Paterson Kerr, Murray Belsky, *American Album* (New York, 1968)

Jensen, Richard E., et al., *Eyewitness at Wounded Knee* (Lincoln, NE, and London, 1991)

Johnston, Frances B., *The Hampton Album: 44 Photographs by Frances B. Johnston* with an Introduction by Lincoln Kirstein, exh. cat., Museum of Modern Art, New York (Garden City, NY, 1966)

Kaplan, Louis, *American Exposures: Photography and Community in the Twentieth Century* (Minneapolis, MN, 2005)

Kinsey, Darius, and Tabitha Kinsey, *Kinsey Photographer: A Half Century of Negatives*, 2 vols (San Francisco, 1975)

Klett, Mark, Ellen Manchester, JoAnn Verburg, et al., *Second View: The Rephotographic Survey Project* (Albuquerque, NM, 1984)

Kozol, Wendy, *Life's America: Family and Nation in Postwar Photojournalism* (Philadelphia, PA, 1994)

Kroes, Rob, *Photographic Memories: Private Pictures, Public Images, and American History* (Hanover, NH and London, 2007)

Kroes, Rob, ed., *The American West as Seen by Europeans and Americans* (Amsterdam, 1989)

Lesy, Michael, *Wisconsin Death Trip* (New York, 1973)

Liebling, Jerome, *Jerome Liebling Photographs* (Amherst, MA, 1982)

Life: The First Decade, 1936–1945, with Introductions by Robert R. Littman, Ralph Graves and Doris O'Neil (London, 1980)

Life, 1946–1955, with an Introduction by Doris O'Neil (Boston, MA, 1984)

Lindquist-Cock, Elizabeth, *The Influence of Photography on American Landscape Painting, 1839–1880* (New York, 1977)

Link, O. Winston, *Night Trick: Photographs of the Norfolk and Western Railway, 1955–60*, ed. Rupert Martin (London, 1983)

Lucic, Karen, *Charles Sheeler and the Cult of the Machine* (London, 1991)

Lyon, Danny, *Memories of the Southern Civil Rights Movement* (Chapel Hill, NC, and London, 1992)

Lyons, Nathan, *The Persistence of Vision* (New York, 1967)

——, ed., *Photographers on Photography* (Englewood Cliffs, NJ, 1966)

MacLeish, Archibald, *Land of the Free*, with Introduction by A. D. Coleman (1938; New York, 1977)

Mann, Margery, ed., *Imogen Cunningham: Photographs* (Seattle and London, 1970)

Mann, Sally, *Immediate Family*, Afterword by Reynolds Price (London, 1992)

Mapplethorpe, Robert, *Flowers* (Boston, MA, 1994)

Meyerowitz, Joel, *Cape Light* (1979; revd edn, New York, 2002)

——, *Aftermath: World Trade Center Archive* (London, 2006)

Moholy, Lucia, *A Hundred Years of Photography* (Harmondsworth, 1939)

Morgan, Murray, *One Man's Gold Rush: A Klondike Album: Photographs by E. A. Hegg* (Seattle and London, 1967)

Morris, Wright, *The Inhabitants* (1946; New York, 1972)

Mumford, Lewis, *Technics and Civilization* (1934; London, 1946)

Naef, Weston, and John N. Wood, *Era of Exploration: The Rise of Landscape Photography in the American West, 1860–1885* (Boston, MA, 1975)

A Nation of Strangers, with essays by Vicki Goldberg and Arthur Ollman, exh. cat., Museum of Photographic Arts (San Diego, CA, 1995)

Newhall, Beaumont, *The Daguerreotype in America* (3rd revd edn, New York, 1976)

——, *A History of Photography from the Beginnings to the Present Day* (revd edn, London, 1982)

Newhall, Nancy, *Ansel Adams: The Eloquent Light* (San Francisco, CA, 1963)

Newhall, Nancy, ed., *The Daybooks of Edward Weston*, 2 vols (Millerton, NY, 1973)

Newman, Arnold, *Artists: Portraits from Four Decades* (London, 1980)

Nye, David E., *Image Worlds: Corporate Identities at General Electric, 1890–1930* (Cambridge, MA, 1985).

Nye, David E., and Mick Gidley, eds, *American Photographs in Europe* (Amsterdam, 1994)

Orvell, Miles, *American Photography* (Oxford, 2003)

Ostroff, Eugene, *Western View and Eastern Visions* (Washington, DC, 1981)

Owens, Bill, *Suburbia* (San Francisco, 1973)

Paiva, Troy, *Night Vision: The Art of Urban Exploration* (San Francisco, 2008)

Panzer, Mary, *Mathew Brady and the Image of History* (Washington, DC, 1997)

Pare, Richard, ed., *Court House: A Photographic Document* (New York, 1978)

Parr, Martin, *Boring Postcards USA* (London, 2004)

Penn, Irving, *Passage: A Work Record* (New York, 1991)

Pfahl, John, *A Distanced Land: The Photographs of John Pfahl*, with an essay by Estelle Jussim (Albuquerque, NM, 1990)

Pitts, Terence, *Photography in the American Grain: Discovering a Native American Aesthetic, 1923–1941* (Tucson, AZ, 1988)

Porter, Eliot, *The Color of Wildness: A Retrospective 1936–1985*, with essays by Jonathan Porter et al. (New York, 2005)

Prosser, Jay, *Light in the Dark Room: Photography and Loss* (Minneapolis and London, 2005)

Rabb, Jane M., ed., *Literature and Photography: Interactions 1840–1990* (Albuquerque, NM, 1995)

Raeburn, John, *A Staggering Revolution: A Cultural History of Thirties Photography* (Urbana, IL, 2006)

Raiford, Leigh, '"Come Let Us Build a New World Together": SNCC and Photography of the Civil Rights Movement', *American Quarterly*, LIX/4 (December 2007), pp. 1129–57

Reframing America, with essays by Andrei Codescru and Terence Pitts, exh. cat., Center for Creative Photography (Tucson, AZ, 1995)

Reinhardt, Mark, Holly Edwards and Erina Duganne, eds, *Photography and the Traffic in Pain*, exh. cat., Williams College Museum of Art, Williams, MA (Chicago, 2007)

Riesman, David, with Nathan Glazer and Reuel Denney, *The Lonely Crowd: A Study of the Changing American Character* (1950; Garden City, NY, 1955)

Riis, Jacob, *How the Other Half Lives*, ed. David Leviatin (Boston and New York, 1996)

Roads to Freedom: Photographs from the Civil Rights Movement, 1956–1968, exh. cat., High Museum (Atlanta, GA, 2008)

Roberts, Russell, *Tony Ray-Jones* (London, 2004)

Romer, Grant B., and Brian Wallis, eds, *Young America: The Daguerreotypes of Southworth & Hawes*, exh. cat., George Eastman House, Rochester (Göttingen, 2005)

Rosenheim, Jeff, *Walker Evans and the Picture Postcard* (New York and Göttingen, 2009)

Rudisill, Richard, *Mirror Image: The Influence of the Daguerreotype on American Society* (Albuquerque, NM, 1971)

Sandweiss, Martha A., *Print the Legend: Photography and the American West* (New Haven, CT, 2002)

Schoener, Allon, ed., *Portal to America: The Lower East Side, 1870–1925* (New York, 1967)

Shloss, Carol, *In Visible Light: Photography and the American Writer, 1840–1940* (New York and Oxford, 1987)

Shuneman, R. Smith, ed., *Photographic Communication: Principles, Problems, and Challenges to Photojournalism* (London, 1972)

Silberman, Rob, 'Contemporary Photography and the Myth of the West', in *The American West as Seen by Europeans and Americans*, ed. Rob Kroes (Amsterdam, 1989), pp. 297–325

Sipley, Louis Walton, ed., *Photography's Great Inventors: Selected by an International Committee of the International Photographic Hall of Fame* (Philadelphia, PA, 1965)

Sobieszek, Robert A., *The Art of Persuasion: A History of Advertising Photography* (New York, 1988)

Solnit, Rebecca, *River of Shadows: Eadward Muybridge and the Technological Wild West* (New York, 2004)

Sontag, Susan, *On Photography* (1977; Harmondsworth, 1979)

Southall, Thomas W., *Of Time & Place: Walker Evans and William Christenberry*, exh. cat., The Friends of Photography (San Francisco, 1990)

Spaulding, Jonathan, *Ansel Adams and the American Landscape: A Biography* (Berkeley, 1998)

Stange, Maren, *Symbols of Ideal Life: Social Documentary Photography in America, 1890–1950* (Cambridge and New York, 1989)

Steichen, Edward, *A Life in Photography* (Garden City, NY, 1963)

Stock, Dennis, *James Dean: Fifty Years Ago* (New York, 2005)

Strand, Paul, *The Mexican Portfolio* (New York, 1967)

Szarkowski, John, *The Photographer's Eye* (New York, 1966)

——, *E.J. Bellocq: Storyville Portraits* (New York, 1970)

——, *Mirrors and Windows: American Photography since 1960* (New York, 1978)

Taft, Robert, *Photography and the American Scene* (1938; New York, 1964)

Tallack, Douglas, *New York Sights: Visualizing Old and New New York* (Oxford and New York, 2005)

Taylor, George Rogers, ed., *The Turner Thesis: Concerning the Role of the Frontier in American History* (Lexington, MA, 1972)

Thoreau, Henry D., *The Illustrated Walden*, with photographs by Herbert Gleason (Princeton, NJ, 1973)

Trachtenberg, Alan, *Reading American Photographs: Images as History, Mathew Brady to Walker Evans* (New York, 1989)

——, *Lincoln's Smile and Other Enigmas* (New York, 2007)

——, ed., *Classic Essays on Photography* (New Haven, CT, 1980)

——, et al., *America and Lewis Hine: Photographs, 1904–1940* (Millerton, NY, 1977)

Tracing Cultures, exh. cat., The Friends of Photography, San Francisco (San Francisco, 1995)

Weaver, Mike, *Alvin Langdon Coburn: Symbolist Photographer* (New York, 1986)

——, *The Photographic Art: Pictorial Traditions in Britain and America* (London, 1986)

Weems, Carrie Mae, *Recent Work, 1992–1998*, with essays by Thomas Piché Jr and Thelma Golden, exh. cat., Everson Museum, Syracuse, NY (New York, 1998)

——, *The Hampton Project*, with commentary by Deborah Willis (New York, 2001)

Welling, William, *Photography in America: The Formative Years, 1839–1900* (New York, 1979)

Westerbeck, Colin, and Joel Meyerowitz, *Bystander: A History of Street Photography* (Boston, 2001)

Weston, Edward, *Leaves of Grass by Walt Whitman* (1942; New York and London, 1976)

Wexler, Laura, *Tender Violence: Domestic Visions in an Age of U.S. Imperialism* (Chapel Hill, NC, 2000)

Wilkinson, Rupert, *The Pursuit of American Character* (New York, 1988)

Williams, Juan, *Eyes on the Prize: America's Civil Rights Years, 1954–1965* (New York, 1987)

Willis, Deborah, *Reflections in Black: A History of Black Photographers, 1840 to the Present* (New York and London, 2000)

Willis-Braithwaite, Deborah, *VanDerZee: Photographer, 1886–1983*, exh. cat., National Portrait Gallery, Smithsonian Institution (New York, 1993)

Willumson, Glenn G., *W. Eugene Smith and the Photographic Essay* (New York and Cambridge, 1992)

Wright, Richard, and Edwin Rosskam, *12 Million Black Voices* (1941; New York, 2002)

Acknowledgements

I would very much like to thank the institutions, rights-holders and, especially, the individual photographers who gave permission for me to reproduce their images in *Photography and the USA*, sometimes very kindly waiving or reducing fees. Their names, too many to list here, will be found in the captions. The collector and historian Stephen White made a major contribution in this respect, as did the National Media Museum, where in the initial stages of my picture searches Colin Harding and Brian Liddy went far beyond the call of duty. The good folk at the Center for Creative Photography were also particularly helpful. Harry Gilonis, Picture Editor at Reaktion, late on proposed the inclusion of a crucial image, for which I am especially thankful.

I am grateful to Vivian Constantinopoulos for commissioning and sticking with this book, and to the Exposures series editors, Mark Haworth-Booth and Peter Hamilton, who, like Vivian, made helpful comments. I would like to thank Donald Ratcliffe and Brian Lee, who first permitted me to take a broad brush to American photography for a pamphlet published in a series (now defunct) sponsored by the British Association for American Studies. I sometimes looked to that pamphlet for aid. I also learnt much of relevance to this book from working with David Nye (who also helped with a photograph) in the assembly of an essay collection, *American Photographs in Europe*. This collection came out of a happy experience as a Fellow of the Netherlands Institute for Advanced Study in the early 1990s, where I was a member of the theme group on the European Reception of American Mass Culture. That amicable group, ably led by Rob Kroes and Bob Rydell, helped me to see American photography in a transnational context.

As well as those already mentioned, a number of individuals have had a long-term influence on my understanding of photography: the late Graham Clarke, Olaf Hansen, Peter Humm, Richard Maltby, Miles Orvell, Berndt Ostendorf, Peter Quartermaine, Martha Sandweiss, Maren Stange, the late Philip Stokes, Douglas Tallack, Alan Trachtenberg, and Mike Weaver. I have benefited, too, from interaction with François Brunet, my colleague Jay Prosser, the members of the AHRC-funded Photo-book project, and the groups of students with whom I was privileged to share 'American Photo-Texts' for the MA in American Literature & Culture at the University of Leeds. The bibliography in this book indicates some of my debts to published scholarship – including works by persons already named – but I must single out the writings of Alan Trachtenberg as a principal source of knowledge and inspiration.

Several friends and colleagues have aided and encouraged my writing, sometimes unwittingly, in recent years: Caroline Blinder, Christine Bold, Alfred Bush, Susan Castillo, John and Holly Dorst, Mark Durden, Jackie Fear-Segal, Richard Gray, Dave and Gill Murray, Russell Roberts, Eric and Sue Sandeen, Heather Shannon, Andrew Warnes, and Richard West. The Thursday poets, convened by John Whale, have been a constant example. My brother-in-law, Jonathan Gordon, sent me images and ideas, and generally gingered up my thinking about the United States. My family has been wonderfully enriching, particularly of late my grandchildren, to whom the book is dedicated, and Nancy, to whom I owe everything.

Photo Acknowledgements

The author and publishers wish to express their thanks to the following sources of illustrative material and/or permission to reproduce it:

Copyright © Robert Adams, courtesy the Fraenkel Gallery, San Francisco and the Matthew Marks Gallery, New York: 69; © 1990 Amon Carter Museum, Fort Worth, Texas (Collection of the Center for Creative Photography, University of Arizona): 65; © Aperture Foundation, Inc. (Paul Strand Archive): 35; courtesy of Don Bartletti: 54; photo Jack E. Boucher/courtesy of the Library of Congress, Washington, DC (Historic American Engineering Record): 1; © Horace Bristol/CORBIS: 37; courtesy of Linda Butler: 12; © Paul Caponigro: 103; by permission of Carousel Research Inc., New York: 55; Collection of the Center for Creative Photography, University of Arizona, Tucson: 8 (© 1998 The University of Arizona Foundation), 13 (© 2003 Arizona Board of Regents), 56 (© 1998 Arizona Board of Regents), 64 (© 2009 The Ansel Adams Publishing Rights Trust), 101 (© 1981 Arizona Board of Regents); Chicago History Museum: 53, 93; © Elliott Erwitt/Magnum Photos: 94; © Lee Friedlander, courtesy of the Fraenkel Gallery, San Francisco: 3, 86; courtesy Peter Funch: 106; © Paul Fusco/Magnum Photos: 95; courtesy of George Bush Presidential Library and Museum: 92; courtesy of George Eastman House International Museum of Photography and Film, Rochester, New York: 28, 74, 98; © Collection of Nakki Goranin: 33, 34; © The Gordon Parks Foundation: 39; courtesy of Colin Harding: 18; © Harold and Esther Edgerton Foundation, 2010, courtesy of Palm Press, Inc.: 27; High Museum of Art, Atlanta (purchased with funds from the H. B. and Doris Massey Charitable Trust and Lucinda W. Bunnen for the Bunnen Collection; used with permission of the Estate of James Karales): 49; from E. O. Hoppé, *Romantic America: Picturesque United States* (New York, 1927), © E. O. Hoppé Estate Collection at Curatorial Assistance, Pasadena, California: 58; © Imogen Cunningham Trust: 100; courtesy of John Jensen and the National Media Museum, Bradford, West Yorkshire / SSPL: 40; courtesy of Tom Jones II: 10; courtesy of the Library of Congress, Washington, DC: 9, 22, 42, 47, 62, 63, 66, 67, 71, 72, 73, 75, 76, 77, 78, 79, 80, 81, 82, 83, 84 (Seagram County Court House Archives), 85 (Seagram County Court House Archives), 99, 105; © Danny Lyon/Magnum Photos: 50; courtesy of Sally Mann and the Gagosian Gallery, New York: 6; courtesy Joel Meyerowitz: 87, 89; courtesy of the National Media Museum, Bradford, West Yorkshire/ SSPL: 15, 16, 17, 19, 21, 23, 24, 27 (Royal Photographic Society Collection), 29, 30, 31, 32, 41, 43, 46, 48, 55, 59, 60, 90, 96, 103, 104; courtesy of National Museum of American History, Smithsonian Institution, Washington, DC: 20, 25 (Photographic History Collection); courtesy of John Pfahl: 70; private collections: 52, 57; reproduced with permission of Punch Ltd (www.punch.co.uk): 40; © Estate of W. Eugene Smith / Magnum Photos (Courtesy of the Center for Creative Photography, University of Arizona, Tucson): 38; Time-Life / Getty Images: 36, 88; reproduced from Rexford Tugwell, Thomas Munro and Roy E. Stryker, *American Economic Life* (New York, 1924): 11; courtesy of the U.S. National Aeronautical and Space Agency: 26; Vassar College Libraries, Poughkeepsie, New York (Special Collections): 97; University of Washington Libraries, Seattle (Special Collections) 44, 61; courtesy of Carrie Mae Weems and the Jack Shainman Gallery, New York: 14; courtesy of the Stephen White Collection: 2, 5, 7, 51, 68, 91; Whatcom Museum, Bellingham, Washington (Darius Kinsey Collection): 45; Wisconsin Historical Society, Madison, Wisconsin: 4.

Index